If you leave me
I'm not coming

Preface

Klaus Weber is an artist who strays through multiple disciplines and appears to take on various professional roles—from engineer to anthropologist, from bee-keeper to anatomist—in his ongoing exploration of natural and socio-political forces, questioning our social, physical, psychological and ontological relationships with the environments we live in. At Nottingham Contemporary Weber developed what became a single exhibition in two halves, from our original invitation to curate a 'group' exhibition from various national collections of different types alongside a solo exhibition of recent and newly commissioned works.

If you leave me I'm not coming was an extraordinary, comparatively minimal exhibition of recent works and new commissions, while *Already there!* was a dense and finely tuned assemblage of 176 borrowed artworks and assorted objects of different kinds (as well as some of his own artworks), many of which were displayed on idiosyncratic plinths and furniture that were themselves quasi-artworks. His unorthodox selection and arrangement of works of art by others, and things of a different order, functioned as a kind of backstory to his practice, while the example of his practice enabled him to pass through the walls that otherwise divide the disciplinary order of things.

Weber's artworks rarely have the appearance of art: instead they often look like pseudo-scientific experiments, transforming exhibition spaces into what look like wayward laboratories. Engaging various senses, and invoking a natural and social order in the process of breaking down, Weber turns Minimalism's phenomenological engagement of the viewer into a disorientating, even hallucinogenic experience. *Large Dark Wind Chime* (2008) is a vastly scaled-up version of a popular garden ornament, its chimes the size of organ pipes. Emitting long low sounds, whose depths are felt in the gut, this otherwise twee, post-hippie accessory somehow spreads a sense of dread, as if announcing the end of times (ecological, nuclear,

or otherwise). Weber's wind chime is tuned to the Tritone, a chord associated with Arabic music, which was at one time categorised as demonic and banned by the Vatican in Europe (it is a favourite of metal bands today). Its sense of dread and crisis is echoed in *Running man* (2011), a lifesize kinetic sculpture which perpetually ran off the edge of the roof of Nottingham Contemporary, like a kind of animated exclamation mark. *Running man* evoked the familiar cartoon trope of the road runner who has run off the edge of a cliff but remains suspended in mid-air for as long as he doesn't realise his predicament; the difference being, Weber has made something that is only possible in the realm of cartoons enter our own social and physical space. The resulting unease may suggest climate change denial or the disastrous illusions of a global economy bloated by financial speculation.

Weber's *Bee painting* series (2009-11) could, again, be seen to address a natural environment from which we are increasingly alienated by our actions. Although resembling action paintings by Jackson Pollock, or early scatological drawings by Cy Twombly, the works were made by actual bees: each year, when the bees first leave the hive, they perform a 'cleansing fight' when they excrete built-up waste, preferably onto clean white surfaces. Bees are essential for the human race—Einstein apparently predicted that the human race would be over just four years after bees became extinct. Like so many of Weber's works, his *Bee paintings* uncannily collide natural, cultural and political systems. As if warning of a larger natural disaster, an urban beekeeper, invited to speak during the exhibition, suggested that the bees that created Weber's *Bee paintings* were somehow "not right"; that unsettled digestive systems were causing particularly fluid, gestural splashes on the canvas—nature's loss being art's gain.

A combination of comedic gesture and dark suggestion is a recurring feature of Weber's works. *If you leave me I'm not coming* (2011), from which one half of the exhibition takes its title, also carries with it undertones of disillusionment and approaching crises. The front window of the gallery was transformed into a car window, on which windscreen wipers cleared a continual downpour of water— on the inside of the glass. This physical intervention within the fabric

of the institution appeared to turn it into a giant vehicle, seemingly making its way through the immediate built environment visible outside. The constant battle waged by the windscreen wipers on persistent rain suggested an allegory for exhausting and relentlessly futile activity, an idea shared with the *Running man* outside. In apparently closing the gap between the neutral disconnected space of art and the social contingency of the space outside, in the manner of institutionally-critical post-Minimalist installation art, Weber imagined a delirious melding of the two, where neither is what it seemed, and both imply systems (environmental, epistemological, ideological, governmental, etc.) that have alarmingly gone awry.

The recurring sense of systemic breakdown in Weber's work inspired our invitation to him to curate an exhibition from national collections, both cultural and scientific, as a cacophonous doppelgänger to his solo exhibition. The titles of the two halves of the exhibition suggest a call-and-response between lovers. This titular feedback also reflects his intention to undo the distinction between the role of artist and curator, producer and collector, and authorship conceived as singular or multitudinous. Weber took an intuitive and associative approach to conceiving and selecting *Already there!* His approach aimed at discarding any existing hierarchies or distinctions between art, utility and nature. While the results were fascinating and gave viewers great pleasure, it also made for a less easily identifiable and somehow subterranean sense of unease. Weber's curatorially irregular, diagonal routes through categories of things normally kept apart appeared to act as dissolving agents on the underlying structures that determine the possibilities of thought within our culture—for the sake of shorthand, a European mindset forged during the Enlightenment, whose legacies can be felt within the structuring principles of most national museums. Weber's temporary museum in Nottingham was instead reminiscent of a Wunderkammer, albeit one that had arrived from the future and whose epistemological key had been misplaced, rather than one from the Renaissance, structured by a worldview whose values became obscure at the onset of modernity. The apparent glimpse that Weber, like Borges and Foucault before him, opens onto the obscure, determining substructure of our collective thought rather

echoes the fact that on average 90% of what museums own is out of view—and in a sense unconscious—at any one time, much as Freud believed that the unconscious he discovered accounted for 90% of the mind. In that sense *Already there!* was a kind of attic of the museological mind.

Weber's work is often about making the impossible possible and some of the new commissions produced for his exhibition were technically challenging. Our sincere thanks to Gerald Busca, Terry Woolley and the staff of the Environmental Technology Centre at the University of Nottingham, for their engineering expertise in realising *If you leave me I'm not coming* and *Running man*, and also to Benson Lau and his students for help with *Sun Press (against nature)* (2011).

We would also like to specially thank all the lenders who contributed to *Already there!*: Ian Carroll at the Institute of Archaeology and Mark Carnall at the Grant Museum (both University College London); the Science Museum, particularly Selina Hurley; Tate, particularly Caroline Collier; and finally the Ashmolean Museum. We thank them all for their belief in the exhibition proposal.

We would not have been able to produce the new works in this exhibition or this ambitious publication without generous funding from The Henry Moore Foundation, the Goethe Institute in London and The University of Nottingham. We are grateful to all of them for their support. We are also grateful to Herald St (particularly Nicky Verber) and Andrew Kreps Gallery (particularly Timo Kappeller) for their financial contribution to the publication and enthusiastic commitment to the project. We are delighted that this publication includes two major new essays on Weber's work by Diedrich Diederichsen and Jörg Heiser, and we are also very grateful to Fraser Muggeridge studio (particularly Sarah Newitt), for their excellent design of the catalogue, and flexibility and forbearance over its long gestation.

Finally, we want to warmly thank Klaus Weber for this inspired, ambitious and memorable dual-facing exhibition. We look forward to this publication offering it the long legacy it deserves.

Abi Spinks, Curator & Lead Registrar
Alex Farquharson, Director

GALLERY 2

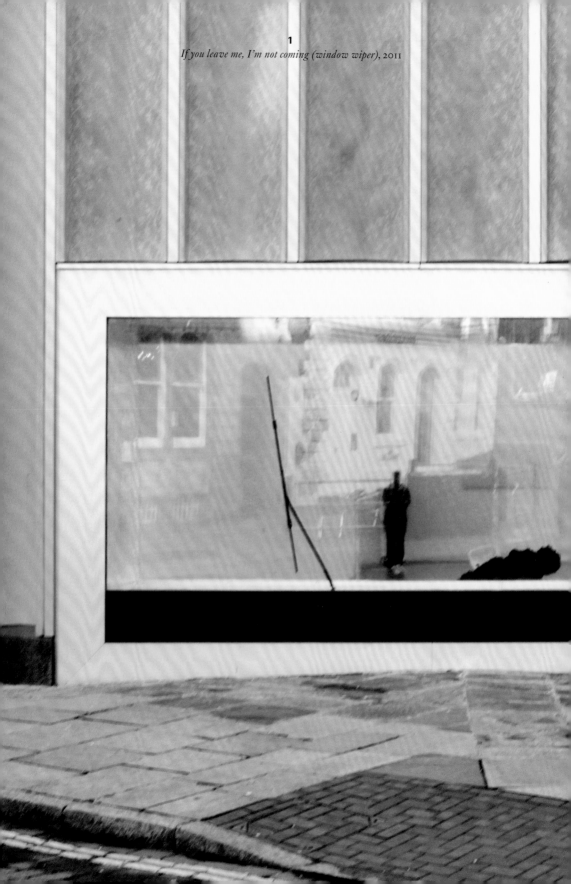

If you leave me, I'm not coming (window wiper), 2011

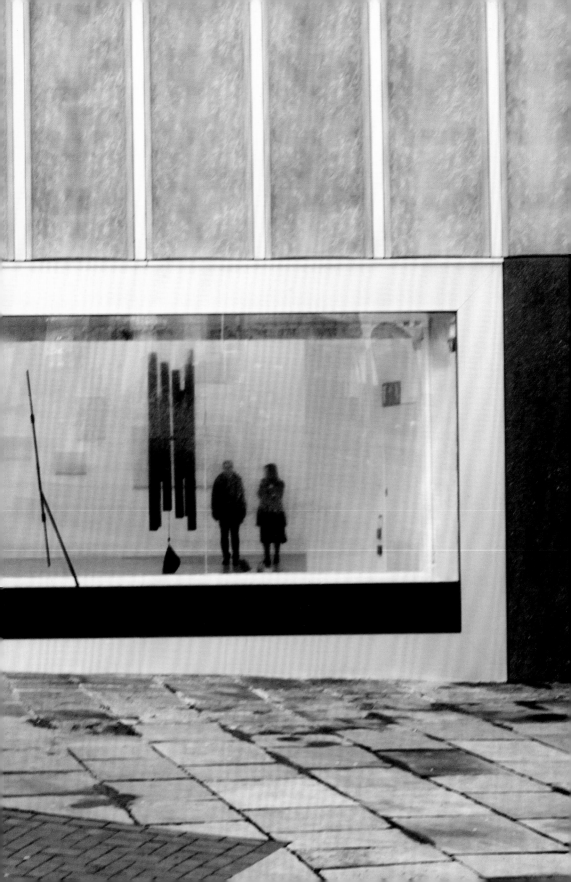

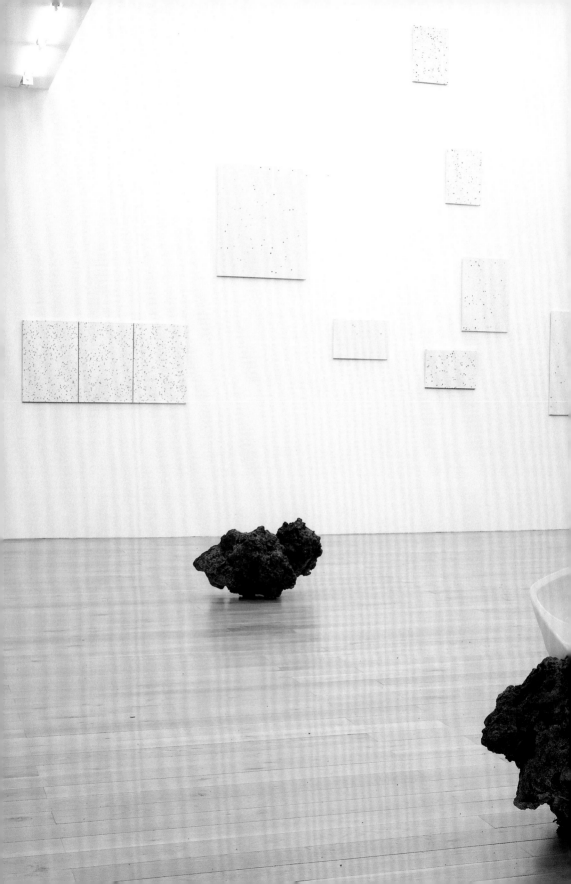

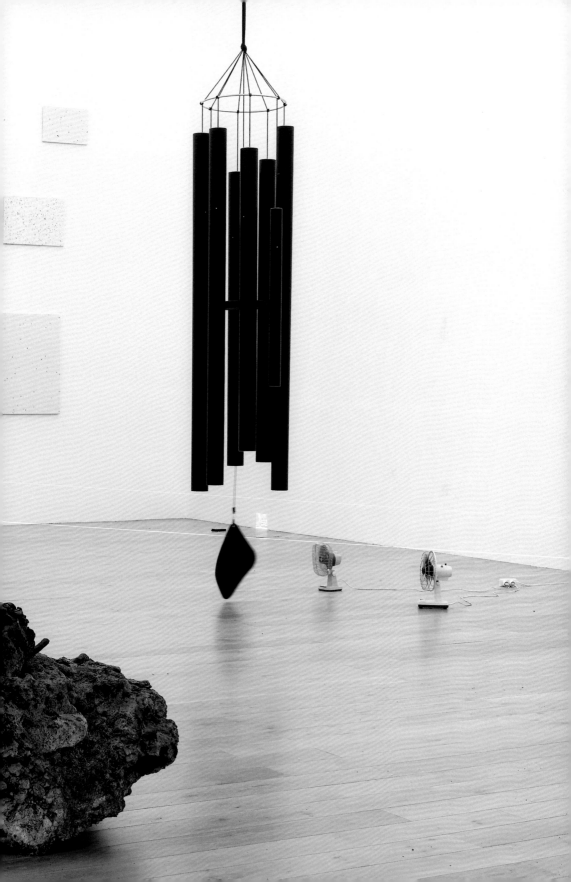

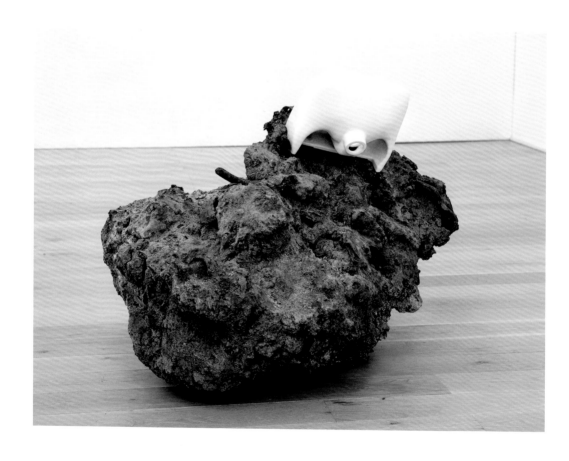

2
Untitled (Beckenstein), 2008

3

Bee painting S2, 2009

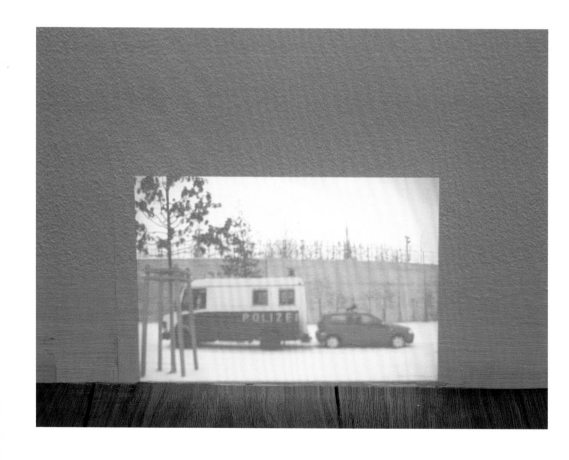

4

Demo Inverse, 2002

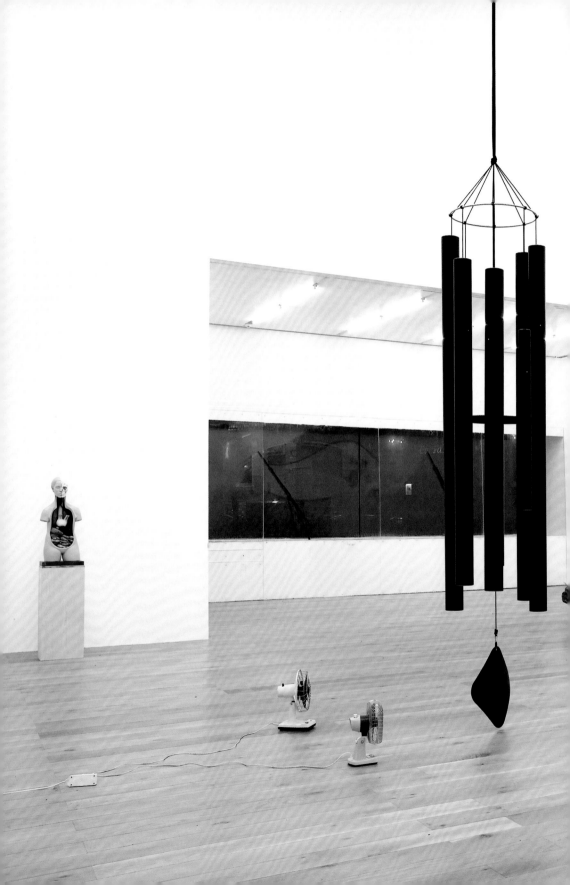

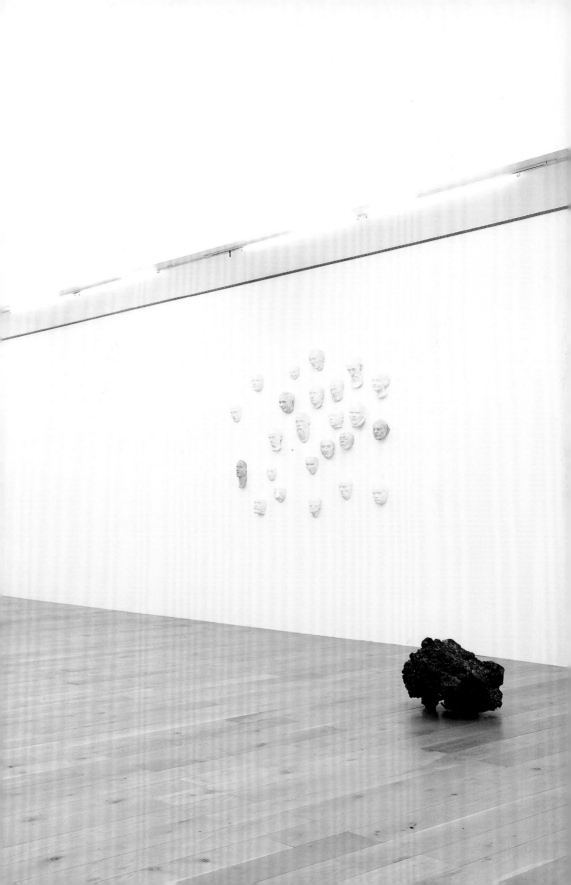

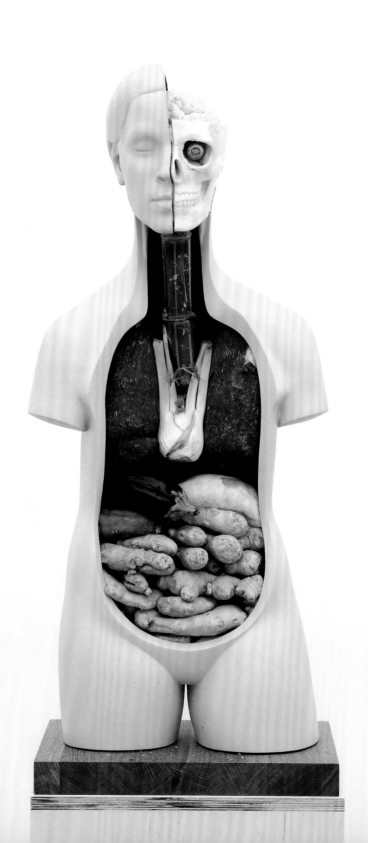

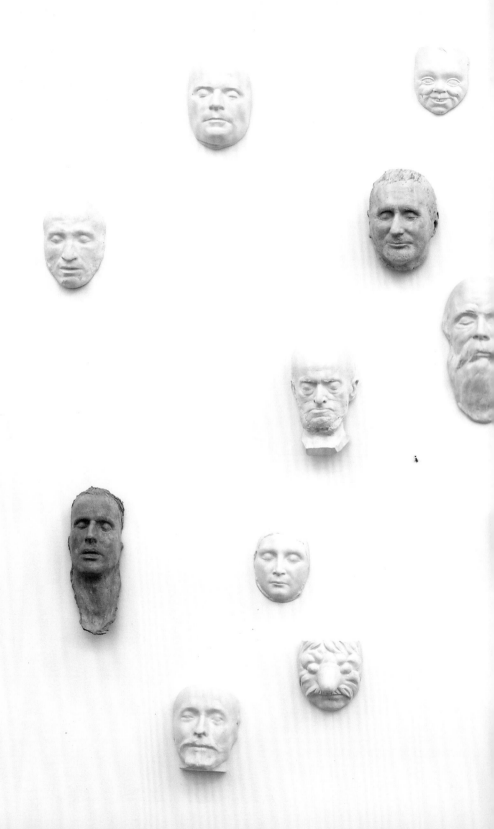

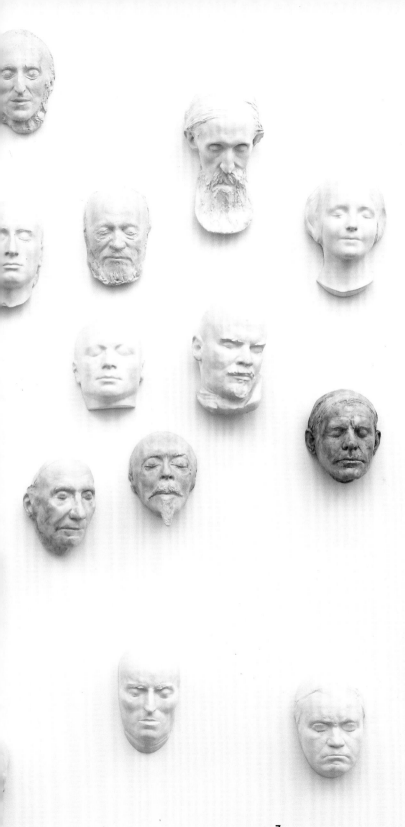

7
Trunk (death masks), 2011–12

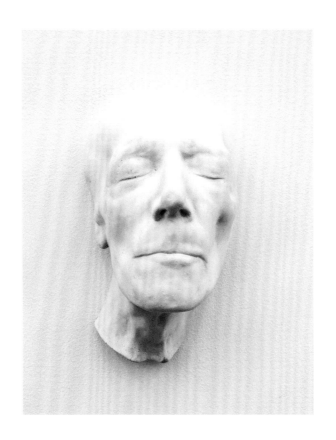

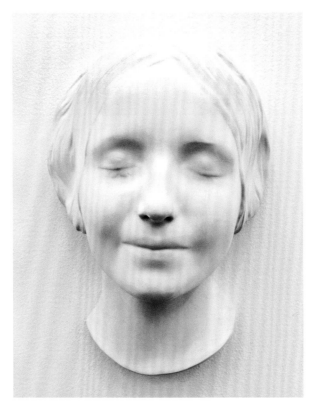

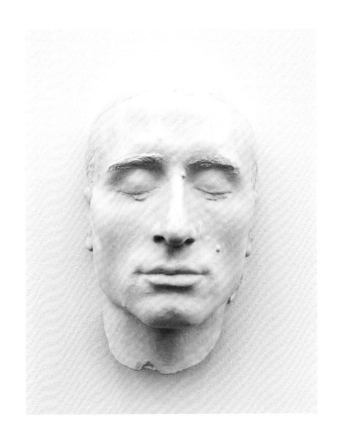

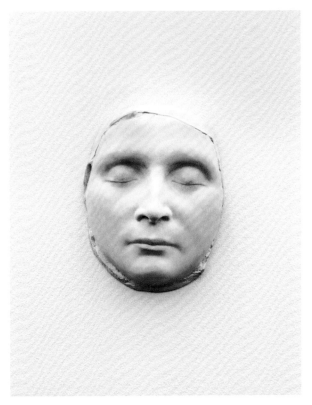

23

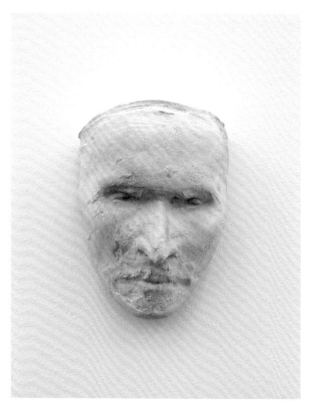

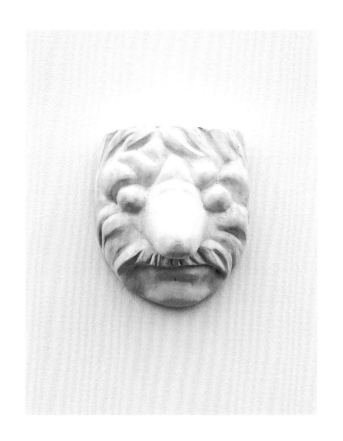

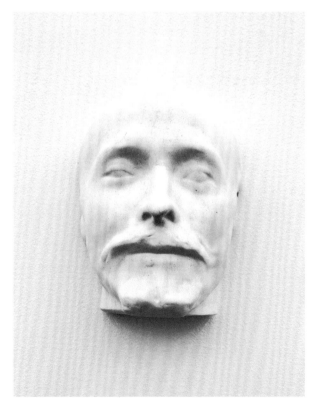

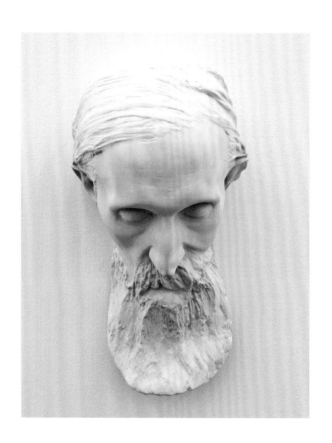

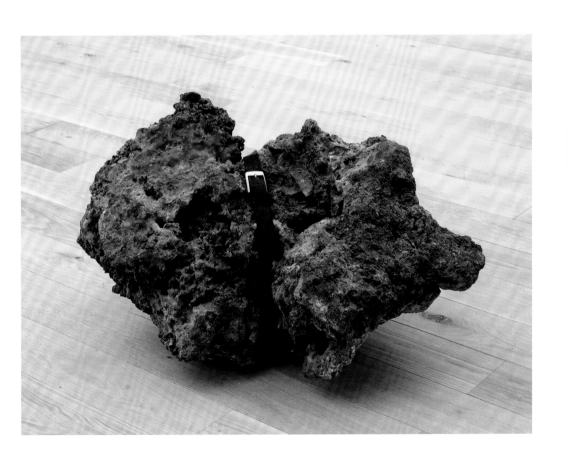

8
Untitled (Gürtelbrocken), 2008

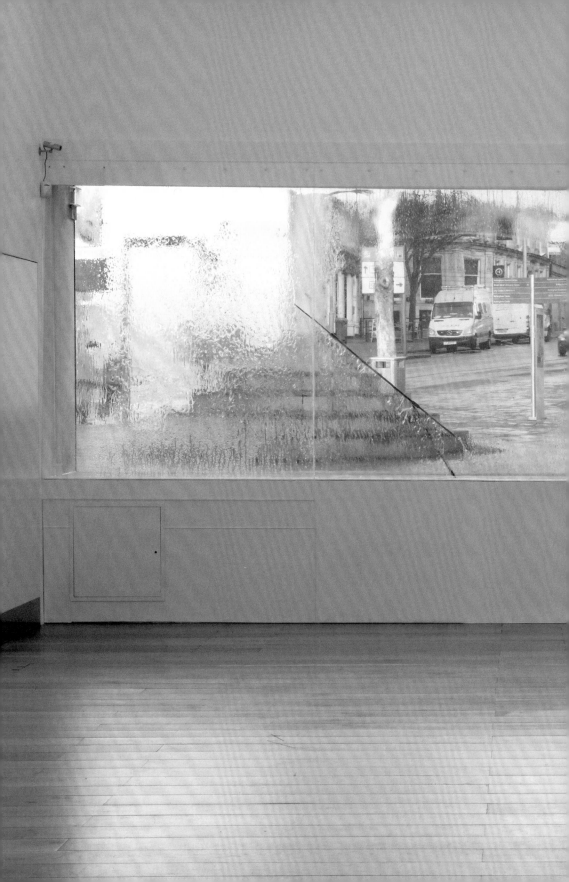

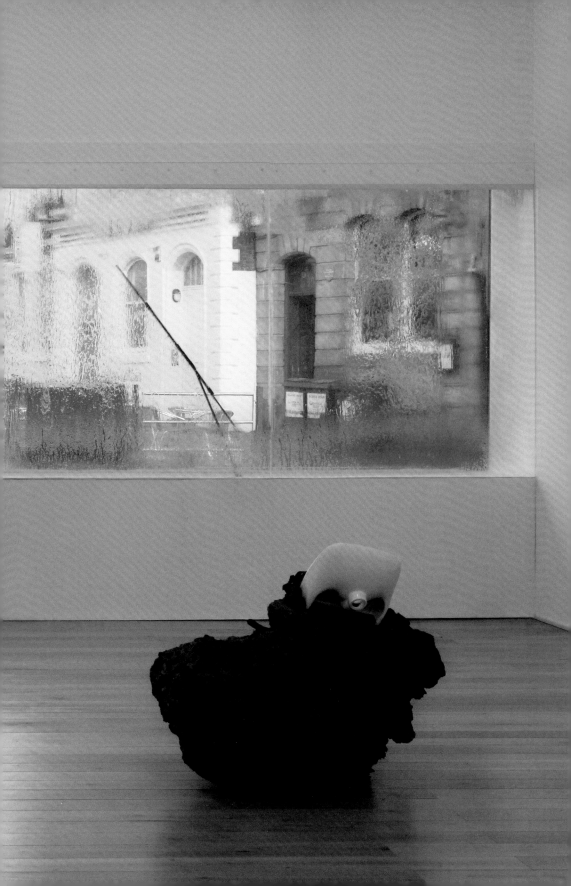

GALLERY 1

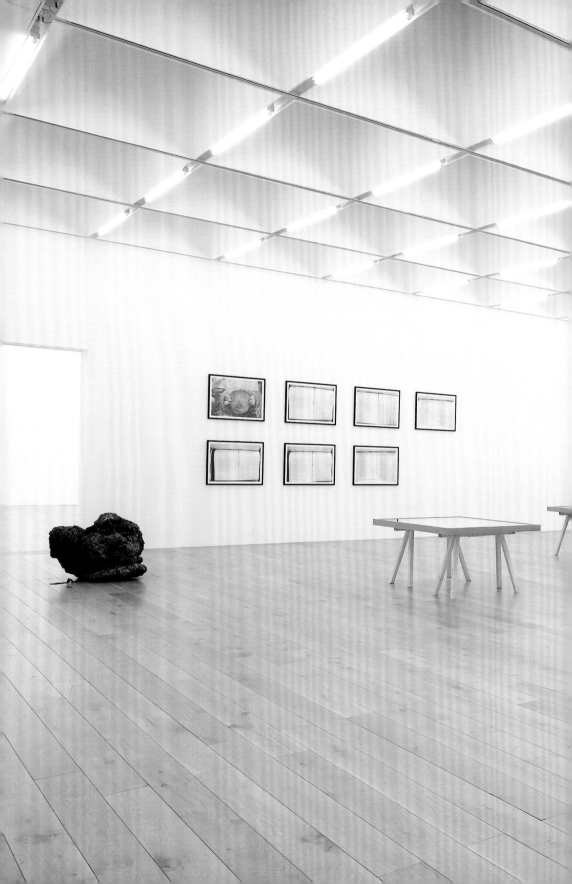

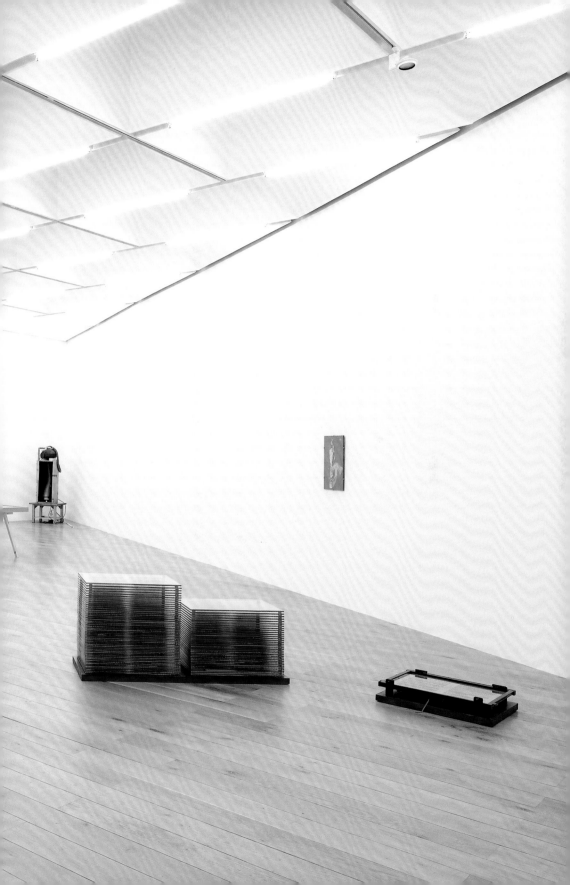

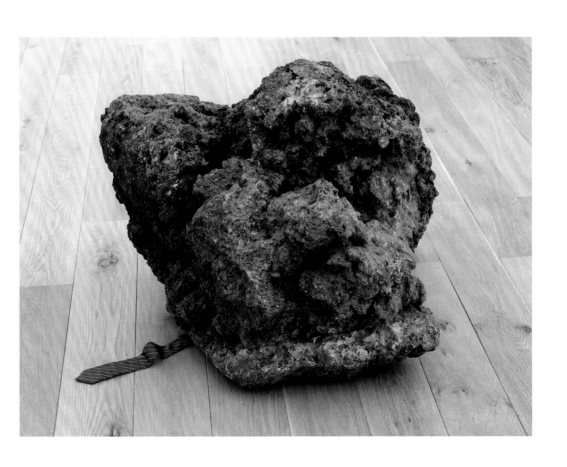

9

Untitled (Krawattenstein), 2008

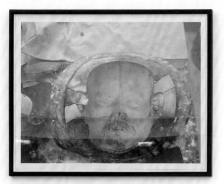

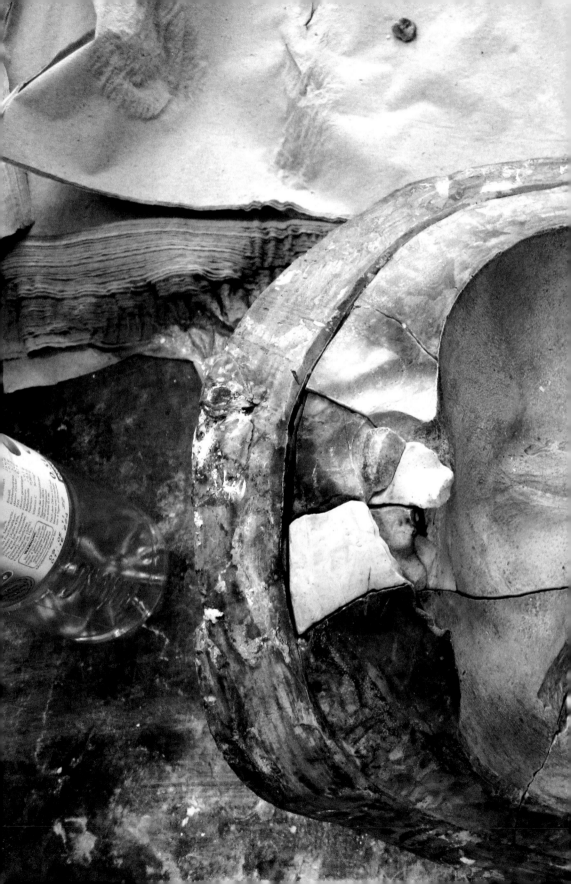

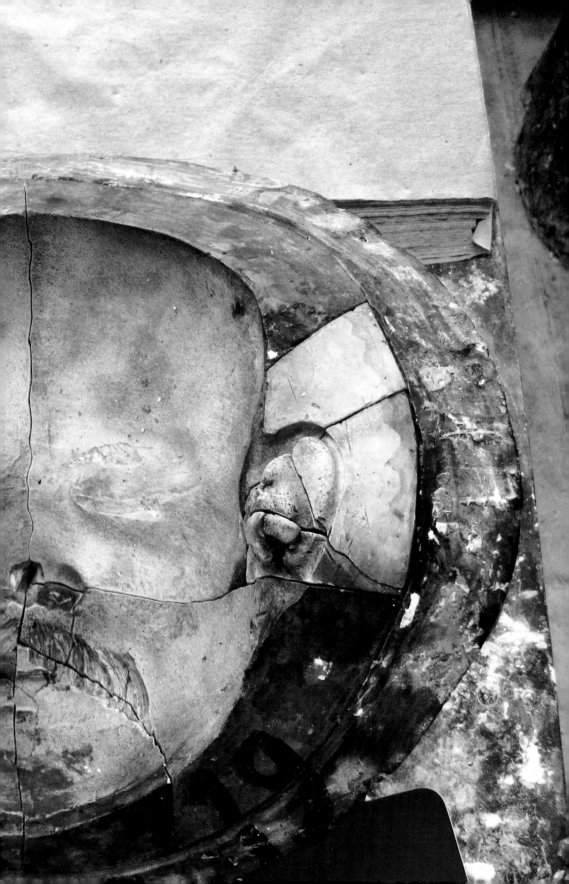

Lau-fende No.	No. der For-merei	Gegenstand	Material des Originals	Standort des Originals	
700	5351	Gesichtsmaske eines Mannes von ca. 20 Jahren, von der Rotu-mah-Insel (51)	Gips	Berl. Mus.	
701	5352	Gesichtsmaske eines Mannes von ca. 26 Jahren, von Matafele bei Apia (Samoa) (192)	desgl.	desgl.	2
702	5353	Gesichtsmaske eines Mannes von ca. 30 Jahren, von der Insel Tutuila (Samoa) (190)	desgl.	desgl.	1
703	5354	Gesichtsmaske eines Mannes von ca. 25 Jahren, von der Vavau-Gruppe (Tonga-Inseln) (52)	desgl.	desgl.	1
704	5355	Gesichtsmaske eines Mannes von ca. 20 Jahren, von der Niuë-Insel (53)	desgl.	desgl.	1
705	5356	Gesichtsmaske eines Mannes von ca. 27 Jahren, ebendaher (55)	desgl.	desgl.	1
706	5357	Gesichtsmaske eines Mannes von ca. 65 Jahren, von Neu-See-land (128)	desgl.	desgl.	1
707	5358	Gesichtsmaske ein. Burschen von ca. 17 Jahren, ebendaher (130)	desgl.	desgl.	1
708	5359	Gesichtsmaske eines Mannes von ca. 34 Jahren, ebendaher (125)	desgl.	desgl.	2
709	5360	Gesichtsmaske einer Frau von ca. 50 Jahren, ebendaher (127)	desgl.	desgl.	1
710	5361	Gesichtsmaske eines Mannes von ca. 20 Jahren, von Palembang (Sumatra) (201)	desgl.	desgl.	
711	5362	Gesichtsmaske eines Mannes von ca. 35 Jahren, von Bengkulen (Sumatra) (202)	desgl.	desgl.	1
712	5363	Gesichtsmaske eines Mannes von ca. 23 Jahren, von Banjer-massing (Borneo) (199)	desgl.	desgl.	1
713	5364	Gesichtsmaske eines Mannes von ca. 28 Jahren, von Segli (Atjeh) (200)	desgl.	desgl.	1
714	5365	Gesichtsmaske eines Mannes von ca. 25 Jahren, von Bonogiri (Java) (196)	desgl.	desgl.	
715	5366	Gesichtsmaske eines Mannes von ca. 35 Jahren, aus dem Kam-pong Batung (Java) (198)	desgl.	desgl.	
716	5368	Gesichtsmaske eines Mannes von ca. 27 Jahren, von Sumanap, Ost-Madura (195)	desgl.	desgl.	
717	5369	Gesichtsmaske eines Mannes von ca. 35 Jahren, aus dem Kam-pong Beleling (Insel Bali) (204)	desgl.	desgl.	

Laufende No.	No. der Formerei	Gegenstand	Material des Originals	Standort des Originals	Höhe in cm	Preis M. Pf.
718	5370	Gesichtsmaske eines Mannes von ca. 30 Jahren, von Atapupu, Insel Timor (194)	Gips	Berl. Mus.	17,6 —	6 —
719	5371	Gesichtsmaske eines Mannes von ca. 25 Jahren, von der Insel Saleyer (203)	desgl.	desgl.	18,6 —	6 —
720	5372	Gesichtsmaske eines Mannes von ca. 25 Jahren, von Santa Maria, Insel Luçon (7)	desgl.	desgl.	18,5 —	6 —
721	5373	Gesichtsmaske eines Mannes von ca. 25 Jahren, von Amoy, Süd-China (205)	desgl.	desgl.	18,2 —	6 —
722	5374	Gesichtsmaske eines Mannes von ca. 29 Jahren, von Nagasaki (8)	desgl.	desgl.	19,1 —	6 —
723	5375	Gesichtsmaske eines Mannes von ca. 33 Jahren, von Matupi (Neu-Britannien) (69)	desgl.	desgl.	20 —	6 —
724	5376	Gesichtsmaske eines Mannes von ca. 22 Jahren, ebendaher (71)	desgl.	desgl.	19,3 —	6 —
725	5377	Gesichtsmaske eines Mannes Ende der 40er, ebendaher (64)	desgl.	desgl.	19,4 —	6 —
726	5378	Gesichtsmaske eines Mannes von ca. 35 Jahren, ebendaher (77)	desgl.	desgl.	19 —	6 —
727	5379	Gesichtsmaske eines Mannes von 28 bis 30 Jahren, ebendaher (68)	desgl.	desgl.	19 —	6 —
728	5380	Gesichtsmaske eines Mannes von 25 bis 28 Jahren, ebendaher (75)	desgl.	desgl.	18,7 —	6 —
729	5381	Gesichtsmaske eines Mannes von 26 bis 28 Jahren, ebendaher (76)	desgl.	desgl.	18,9 —	6 —
730	5382	Gesichtsmaske eines Mannes von 22 bis 25 Jahren, ebendaher (70)	desgl.	desgl.	18,5 —	6 —
731	5383	Gesichtsmaske eines Mannes von 20 bis 22 Jahren, ebendaher (74)	desgl.	desgl.	18,6 —	6 —
732	5384	Gesichtsmaske eines Mannes von 18 bis 20 Jahren, ebendaher (72, 67)	desgl.	desgl.	18,5 —	6 —
733	5386	Gesichtsmaske eines Burschen von ca. 18 Jahren, ebendaher (73)	desgl.	desgl.	18,2 —	6 —
734	5387	Gesichtsmaske ein. Burschen von ca. 18 Jahren, ebendaher (58)	desgl.	desgl.	19,1 —	6 —
735	5388	Gesichtsmaske eines Burschen von ca. 15 bis 16 Jahren, ebendaher (63)	desgl.	desgl.	18,9 —	6 —
736	5389	Gesichtsmaske eines Burschen von ca. 15 bis 16 Jahren, ebendaher (65)	desgl.	desgl.	18,1 —	6 —
737	5390	Gesichtsmaske eines Knaben von ca. 9 bis 10 Jahren, ebendaher (61)	desgl.	desgl.	17,8 —	6 —

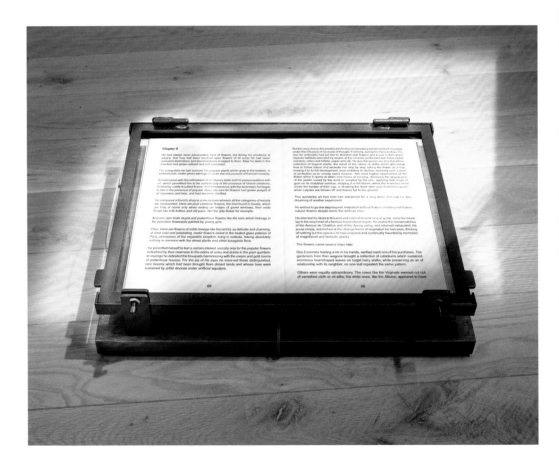

11

Sun Press (against nature), 2011

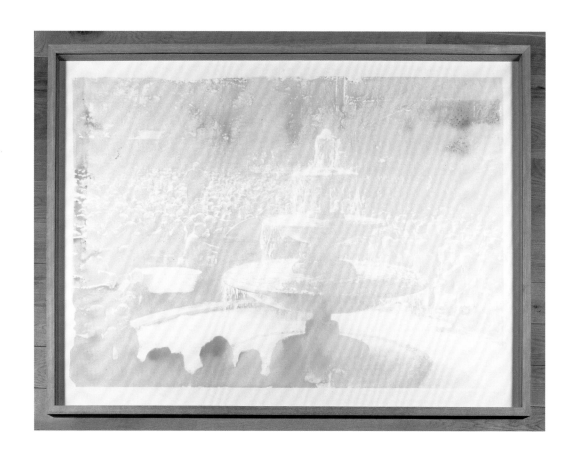

12
Honeyprint (Bierbrunnern Lübbecke), 2011

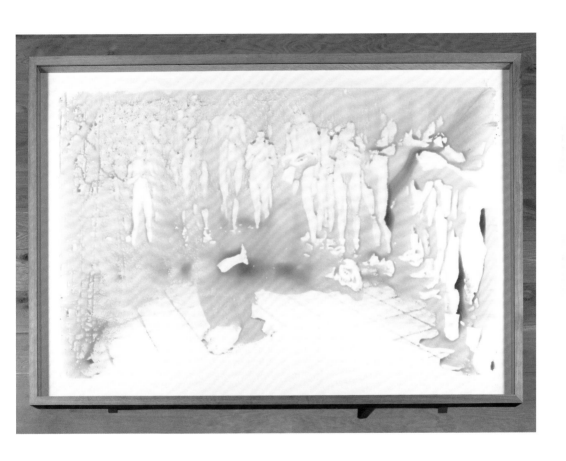

13
Honeyprint (fall), 2011

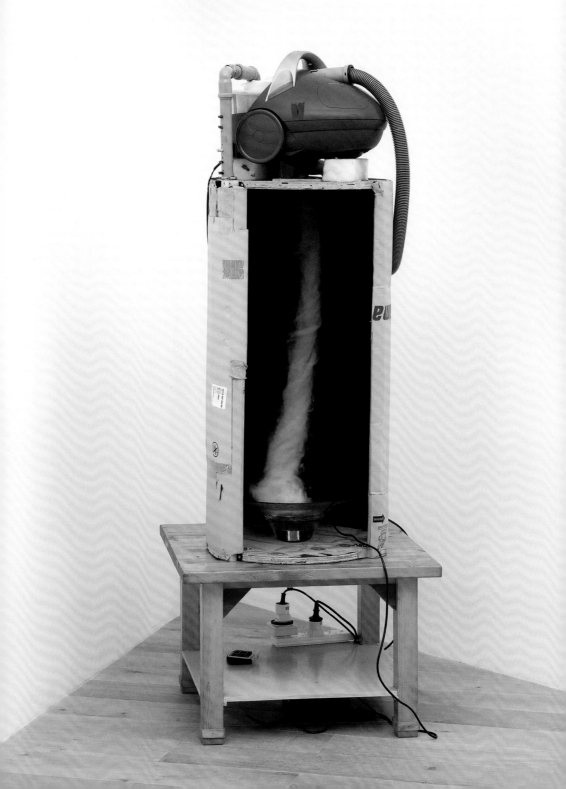

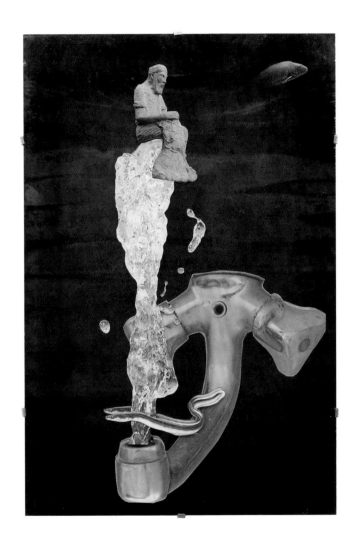

15
Fisherman's delight, 2010/11

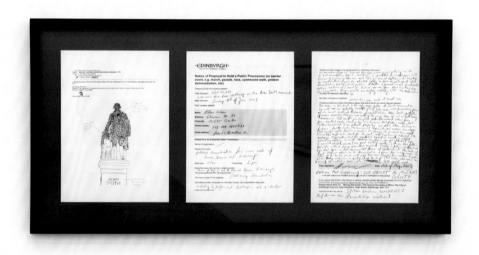

16
Bee king notification, 2009

Von: Klaus Weber <mail@k-weber.com>
Betreff: **"bee-king" - notification, political demonstration, Edinburgh, 7.6.09**
Datum: 1. Mai 2009 22:22:40 MESZ
An: morag.stevenson@edinburgh.gov.uk
1 Anhang, 126 KB Sichern ▾

to: **Morag Stevenson, The Council Secretary's Office, The City of Edinburgh Council, City Chambers, High Street, Edinburgh, EH1 1YJ.**

dear Morag Stevenson
attached is the notification for a political demonstration corner of High St and Parliament Square, Edinburgh on 7.6.09.
With warm regards, Klaus Weber

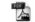

beeking_noti....pdf (126 KB)

·EDINBVRGH·
THE CITY OF EDINBURGH COUNCIL

Notice of Proposal to Hold a Public Procession (or similar event, e.g. march, parade, race, sponsored walk, protest demonstration, etc)

Please provide the following details:

Title of event : BEE KING 200 000 live bees gathering on the Adam Smith monument

Date of event : Sunday 4th of June 2009

Your contact details

Name: Klaus Weber

Address: Choriner Str. 36

Postcode: 10435 Berlin

Phone number : +49 148 1895556 4

Email address : fox22@online.de

(Please fill in on a separate sheet, if necessary.)

Name of organisation: /

Reason for event:
political demonstration for a new mode of human brains and economy

Start time: 11 am Finish time: 2 pm

Assembly area (for moving or static events):
Corner of High St. and Parliament Square, Edinburgh

The proposed route (for moving events): / Stationary demonstration

The return route (if this applies):

Estimated number of people (or vehicles, horses, etc) expected to take part:
including 2 professional beekeepers and a doctor

W2/Misc/NPHPP/MS2/0507/CE

50

Please provide details of arrangements for controlling the event:

The intervention of approx. 200.000 live bees swarming and gathering on the A. Smith monument on High St., Edinburgh, is controlled by 2 beekeepers with 50 years of beekeeping experience each. We are assured that they will employ the exact methods to provide absolute safety to both the participants of the demonstration and the general public. A doctor is present in case of underput allergic reactions of a bee sting. But we reassure you that swarming bees are very meek; sting incidents are highly unlikely within this demonstration

Number of stewards attending: 7

Number of buses or coaches: 1 minibus van and 1 small van

Please provide any extra information about the event which you think may be relevant:

The statue in Edinburgh is the only major public A. Smith monument in the world and was recently installed (4th of July 2008), in the premonitory pain of the current worldwide historic financial crisis. Adam Smith, godfather of modern economy theory, was creating the very ideas of what we call today economics. The moral philosopher deterritorialised value from pre-existent needs, showing how it is humans that produce value, but reterritorialised it on private property. We don't blame Smith as a figure, but the system the monument represents and restores nowadays. The symbol of the beehive used in the monument, on which his right (invisible) hand rests, stands for the 'good', well functioning industry. The metaphor implicates, that the capitalist system is something natural, something healthy in itself. Based on the modern concept of control and a general utilitarianism, the good working society, is the one that follows the order without being controlled anymore. Finally it follows its determined... We don't agree on this monumental desire of appeasement. The technical fact that we attach in the demonstration a queen bee in a cage under the chin of A. Smith, which will call 200.000 (female) bee-workers to gather on his body, makes him a proliferating bee king. This sudden alternative man is aiming at a collective hallucination: ~~...~~ We call and

Your signature: **Date:** 1st of May, 2009

embrace that Entgleisung: WE GREET the MUTANT BRUT!

• we will make sure that we give a copy of your notification to the police

If you would like further information or advice, please contact Morag Stevenson on 0131 529 4125 or by e-mail at morag.stevenson@edinburgh.gov.uk. Fax: 01314693913
Please return form to: Morag Stevenson, The Council Secretary's Office, The City of Edinburgh Council, City Chambers, High Street, Edinburgh, EH1 1YJ.

W2/Misc/NPHPP/MS31 May 2007/CE

System Wuchre, WUCHERE U
Auf das uns neue Nervenstränge wachsen!

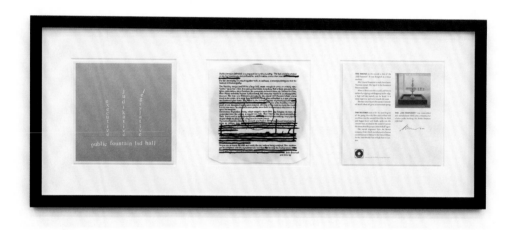

17
Tryptich (LSD record), 2004

THE SOUND on this record is that of the „LSD Fountain". It was designed as a music machine.

The 3 tiered Fountain is made from heavy Victorian crystal. The liquid in the fountain is Potentized LSD.

When it flows over the crystal, and hits its surface by tripping and dropping on the edge, a high bell-like melody can be heard. It is never repetitive and never sounds the same.

The first time I heard this sound, it reminded me of a flock of goats at a mountain spring.

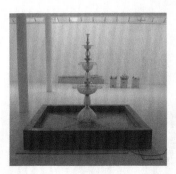

THE RECORD starts with the switching on of the pump, then the first dish is filled and overflows into the second then fills the third and biggest bowl and finally spills into the concrete base, to simulate the sound of rain on the street after the pump is switched off again.

The crystal originates from the British company Osler which manufactured a famous crystal fountain exhibited in the Crystal Palace, for the 1851 Worlds Fair in Hyde Park in London.

THE „LSD FOUNTAIN" was reassembled and manufactured 2003 as the centrepiece for a future public building, the „Public Fountain LSD Hall".

KW 02

mastered at THE EXCHANGE, 52 Bruges Place, London

Public Fountain LSD Hall is a proposal for a public building. The Hall could be created in any big western city and it should be realized rather sooner than later. ~~███████████████~~

For the developing I worked together with an architect, a neuropsychologist and the Institute of Homœopathy.

The building design itself is for a large hall, ample enough to cover an existing open "public" space like a box. It would accommodate everything that is there already, traffic lights, zebra stripes, street furniture, the pavement, decorative trees, etc. Isolated in a box, these objects suddenly become dysfunctional, like everyday objects in an ethnographic museum. The only new element is provided by the crystal LSD Fountain which would stand in the centre. It is made from Victorian crystal glass embedded in a new concrete and hardened glass basin. The liquid in the fountain consists of potentized LSD ~~████~~ The walls of the building would be made of one directional transparent material, allowing you to look out from the inside but not vice versa. In contrast to most public areas there is unrestricted admission to the space for everyone.

Carnivorous Nepenthes plants, which normally await their prey hanging on trees, are suspended from the ceiling at regular intervals. They improve the micro-atmosphere. Their leaves end in anthropomorphous, androgynous-looking, large jug-like shapes which are filled with a fragrance to attract insects.

The name Nepenthes (Greek for careless) goes back to Homer via botanist Linné and signifies an antique drug.

~~██~~

So you can sit inside the Hall and watch the city without being watched. This situation can be compared with the experiences of a traveller viewing the local practices ~~████~~ both distanced and close up

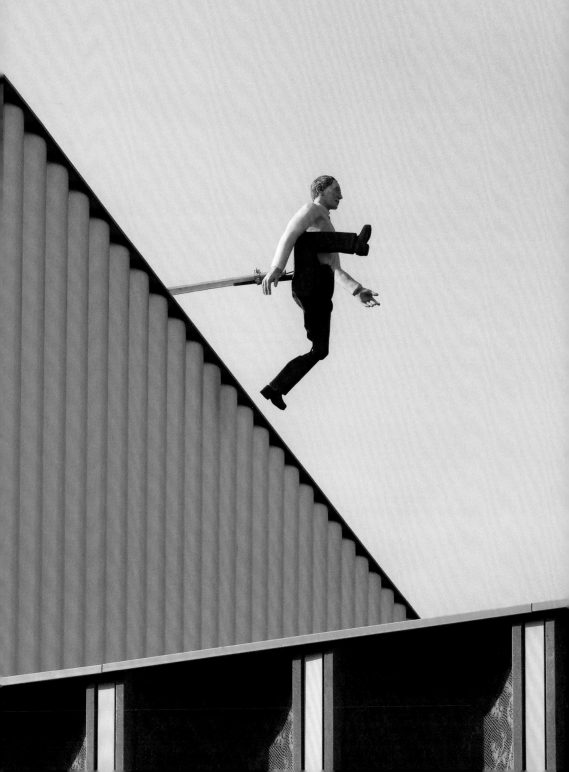

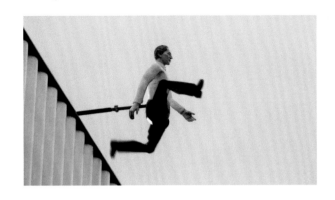

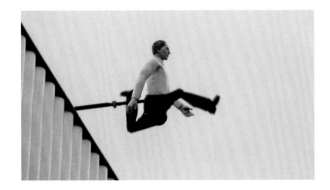

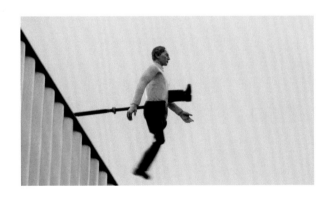

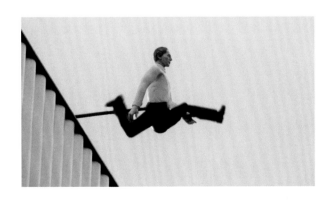

1

If you leave me, I'm not coming (window wiper), 2011, site-specific fountain, mixed media, dimensions variable

The 'window fountain' turns the whole museum into a vehicle that drives through the city. Following the idea of the building as a vehicle, the driver, in this case the visitor, is not capable of escaping from a rainy view of the world; like a donkey following a carrot, the museum carries its own bad weather around with it. But you could also flip the perspective so that the whole world is a vehicle penetrating the museum.

The installation is based on an earlier piece called *RAINISACAGEYOUCANDRIVETHRU* (2008). It also solves a practical issue. The large window is situated at street level and reveals the whole gallery, so the art can seem too exposed. The window wipers (like a venetian blind between the inside and outside world) encourage viewers to look into the space even more than if the window was simply clear.

2

Untitled (Beckenstein), 2008, slag, ceramic washbasin, 100 × 153 × 90 cm

These slag pieces (see also captions **8** and **9**) are a playful progression from an earlier work entitled *Big Giving* (2006–7, see p.66), a large fountain piece made from the same material. The slag is a by-product of processes in the steel industry which are highly energy consuming. When iron ore is melted, slag rises as black cream on top of the melting pot. It is an artificial lava, the product of modern alchemy. This piece is connected to the *Bee paintings* (see caption **3**), in that there is a metamorphosis of energies from one state to another. It was a joyful thing to change, with minimal intervention, these heavy, found objects (they weigh up to a ton) into an artwork. A simple and practical thing to do.

3

Bee paintings, 2009–11, bee droppings on canvas, various dimensions

These artworks are the result of a long chain of transformations—the translation of materials, energies and values. These Informel-like paintings are the outcome of a bio-aesthetic experiment, based on a biological phenomenon: the so-called cleansing flight that happens once a year in spring. Throughout the winter bees do not leave their hive. In spring they take a cleansing flight and defecate on anything that is unnaturally white: houses, cars, clean laundry…

When I read about this phenomenon it appeared to me like the humorous revenge of bees on man. Bees collect the nectar of flowers and transform it into honey by a process of pre-digestion and regurgitation, before they deliver it into the honeycomb. Many beekeepers take the honey in exchange for industrial sugar water. In winter, when they stay in the hive, bees eat sugar water and transform it into energy to keep the hive warm. They generally do not defecate in their hive, but hold it in their body until spring. In spring the beekeeper becomes the recipient of the bee droppings, a return on his sugar water.

In early spring 2009, I placed canvasses on a commercial beekeeper's yard in the city of Berlin. These canvasses were prepared for painting, transforming bee droppings into the painters' drippings.

4

Demo Inverse, 2002, video, 59 mins 7 secs

Demo Inverse was a demonstration march without demonstrators, which took place across six unpopulated but politically significant locations in Berlin. There were just two elements involved in the action: a car with a loudspeaker mounted on top and a police van. The police were obliged by law to accompany the demonstration as it had been officially registered. Each time the vehicles arrived at a deserted location, the car would line up with its back to the police van, so they mirrored each other, and an audio demonstration would be launched which lasted for four minutes. While attempting to manoeuvre into the desired position, the cars appeared to be involved in a sort of dance with one another, as if the performance of one spurred the movement of the other. A mixture

of text and song concerned with relations between space, subjectivity and authority was played through a megaphone: "Überall begegnen uns Polizisten als die allergrößten Urbanisten." (Wherever you go, policemen are the most fervent urbanists.) Initially *Demo Inverse* was also conceived as a practical didactic response after I had witnessed how—simply by subjective selection by officers—a bystander became the object of police control, and only then turned into a (dangerous) subject.

'We learn dances / sub-economical dances / We learn re-dun-dance / we learn dances / Redundant dances / like a brand new class' (Excerpt from audio of *Demo Inverse*, adapted from Iggy Pop's *Nightclubbing*)

In the exhibition, the video is screened like a mouse hole in the wall. The shrunken projection contrasts strongly with the oversized and loud *Large Dark Wind Chime* (see caption **5**). The megaphone text heard over the car's loudspeaker is played from the small video projector, and sounds like the voice of an angry, complaining mosquito.

5

Large Dark Wind Chime (Arab tritone), 2008, powder-coated aluminium, stainless steel, high-polymer plastic, fans, 430 × 76 × 76 cm (wind chime without fans)

This wind chime was designed to send out 'bad vibes'. In form and content it's the counterpart to the *Witch's Ladder* (p. 45 in *Already there!*) in the group exhibition. The vastly scaled up wind chime is made from tempered aluminium. Its composition is based on the tritone, which is known as the devil's interval, or the *diabolus in musica* (Latin for the devil in music). It is used to describe a musical interval consisting of three whole tones, comparable to the augmented fourth or diminished fifth. It is often used as the main musical interval of dissonance in Western harmony. In medieval times, the tritone was rejected by the Church. Some sources say the interval was outlawed as it was thought to evoke sexual feelings. There was a general belief that playing the interval aroused the devil. As a result it became associated with a great deal of superstition. Through this original symbolic association with Satan, the interval carried connotations of evil in conventional western culture or was otherwise representative of the 'other'. In heavy metal and particularly black metal the tritone is an important and well-used interval. It is also used in the theme tune for The Simpsons.

6

Veggieanatomy, 2011, vegetables, Jesmonite, paint, wood, 90 × 38 × 25 cm

7

Trunk (death masks), 2011–12, plaster casts, dimensions variable

Seemingly, one mask is missing leaving simply a dust outline and a screw in the wall. Most of these masks are death masks, but some were cast whilst the person was still alive and some are fully imaginary. What I find so intriguing about death masks is their intensity: taken at the very moment life has faded, they act as an imprint of time.

There is tension in the combination of these masks, which is enhanced by the fact that some have open eyes added after the cast was taken. Some look very relieved and happy, while in others the struggle of life and death has left deep imprints in the face. You can sense which are cast from life and which from death if you observe carefully, but the difference is minimal.

8

Untitled (Gürtelbrocken), 2008, slag, leather belt, 105 × 70 × 60 cm

GALLERY 1

9

Untitled (Krawattenstein), 2008, slag, silk tie,
80 × 110 × 100 cm

In the village where I grew up there was a stone
called Nonnenstein (meaning nun stone). It was
a large round rock lying on the side of a street, down
in the Danube Valley. As a child I was told a nun was
hit by a falling rock, burying her under it. Since the
stone was so heavy, they decided to turn it into the
nun's gravestone by adding a sign with her name on
the rock. I found this a smart and witty gesture. They
said the sign fell off and was never replaced, but the
nun is still under it.

From a certain perspective, the 'Krawattenstein'
(tie stone) seems to be a large head with two eyes, and
the tie becomes an expelled tongue (the way figures
in comic strips look when something heavy falls on
them.) Obviously it could also be read as a scene where
a businessman was hit by a stone and driven like a nail
into the ground. All these slag pieces (captions **2**, **8**
and **9**) are about metamorphosis and transformation.
Death being the ultimate transformation.

10

Ethnonegativ, 2011, 7 framed photocopies,
each 70 × 89 cm

These seven frames document the anthropological
and colonial journey Dr Otto Finsch made from
1879 to 1882. He travelled from island to island in the
South Seas and made casts of the people he found, of
various ages, gender and professions, in order to bring
them home to Germany. By accident I found these
negative casts, the moulds of all those faces, in the
basement archive of the Staatliche Gipsformerei
(Berlin state museums' plaster cast workshop). They
clearly had never been used to produce positive copies
of the faces, as I could still see traces of nose hair,
earwax and skin grease in the moulds. I realised
that if you take a photograph of the negative mould
from a certain perspective, the face, like a ghost or
a hologram, becomes positive. The framed lists are
the original lists of what Finsch cast, in a strict but
unsystematic order, including the cost of a copy.

11

Sun Press (against nature), 2011, mixed media,
dimensions variable

Sun Press is a device for printing books. A book
is printed over the course of the show by enhanced
aging. In the 'printing frame' is a book with empty,
dark-coloured pages of ordinary paper. Glass
panels printed with text are individually mounted,
one after the other on the device. The *Sun Press*
is exposed to natural sunlight, shining through
the skylight of the gallery. Wherever there is text,
the paper is protected from sunlight. The rest of
the paper gets bleached by the sun; after a while,
the contrast is great enough that the text is legible
on the paper (see the endpapers and p.82, *Flowers
(Sun Press collage)*). To enable the paper to be bleached
effectively indoors, there is a heliostat installed on
the roof of the gallery. This high-tech machine tracks
the sun and throws a permanent sun beam directly
onto the work throughout the exhibition. The text
in the book is *À Rebours* by Joris-Karl Huysmans,
(which translates as 'against nature'). The English
title reverberates with the action of *Sun Press*: the
sun-tracking mechanism is excessive, like using a
sledgehammer to crack a nut. The protagonist of the
book, a dandy, refines his taste and cultural passions
with the most radical gestures. In his way of thinking
and particularly in his interests, he seems to anticipate
a radical contemporary conceptual artist of today.

12–13

Honeyprint (Bierbrunnen Lübbecke), 2011,
silkscreen prints with forest honey on paper,
oak frame, toughened glass, trestles
78.5 × 163 × 110 cm (on trestle)
110 × 163 × 7 cm (framed print)

Honeyprint (fall), 2011, silk-screen prints with forest
honey on paper, oak frame, toughened glass, trestles
78.5 × 163 × 119 cm (on trestle)
119 × 163 × 7 cm (framed print)

The two scenes in the *Honeyprints* have something
in common: people are grouped in a circle, and
seem to be attracted to the centre like fruit flies
to a ripe fruit. *Fall* shows a group of male nudes
of different ages. They all wear sneakers and are
watching a person who is also wearing sneakers
but who is fully dressed. It is not clear if this
person is falling down or performing somehow.
It is a night scene.

Bierbrunnen shows people of all ages and gender gathering around and drinking from a public beer fountain in Lübbecke, in post-war Germany. Although these images are of seemingly innocent situations they are suggestive of something much more sinister; some form of primitive ritual. Like a visual Freudian slip, they seem to reveal the underlying nature of such groupings.

14

Basteltornado, 2007, vacuum cleaner, wood, PVC tube, cardboard, tar board, glass bowl, water, ultrasonic fogger, 245 × 60 × 60 cm

It is what you see: a real tornado, made from household tools and scrap. The mist emerges from a large glass bowl containing a humidifier of the kind more often used in esoteric or domestic contexts to produce atmospheric fog and improved air quality. The mist is sucked up in a twisting motion by a standard vacuum cleaner on top of the structure. It's very relaxing to watch the miniature storm: a form of updated lava lamp used to enable people to grow accustomed to catastrophes.

15

Fisherman's delight, 2010/11, glass panels, cut-outs from photographic prints mounted on different glass panels, 60 × 40 cm

This collage is the artwork for an invitation to a fictive exhibition, *Source of Abnegation*, due to run 22 September 2014 – 14 January 2015 at the Hayward Gallery, London. In the exhibition, the doors and windows of the gallery will be reinforced and sealed with silicon, then flooded with water to create a huge tank. On the outside of the building will be a monitor showing a dreamlike 'flight' along the building's stairways, gallery spaces, toilets, offices, etc. It will be filmed by a scuba diver. The inside of the gallery will be closed to the public throughout the exhibition. The only permanent visitors will be a couple of carp and eels. The closing event, on 14 January, is a public event where the building will be drained and visitors will be able to watch the contents of the gallery (including the carp and eels) running down the concrete stairways to unite with the River Thames.

16

Bee king notification, 2009, framed application, 60 × 40 cm

17

Triptych (LSD record), 2004, offset and silkscreen prints on paper, vinyl, 58 × 143 × 4 cm

The sound on this record is that of *LSD Fountain*. I designed it as a music machine in 2003 (see p.76). The three-tiered fountain is made from heavy Victorian crystal. The liquid in the fountain is potentised LSD. When it flows over the crystal, tripping and dropping on its surface, a high bell-like melody can be heard. It never sounds the same. Some people say it sounds like a flock of goats at a mountain spring. The heart of the fountain is made from antique Victorian glass manufactured by British company Osler, for the flamboyant Crystal Fountain at the 1851 Great Exhibition at Crystal Palace, in London. The Crystal Palace was an exuberant urban entertainment construction intended to give representative shape to colonial and industrial exploits; it might well be described as one of the world's first major shopping malls. *LSD Fountain* was assembled and manufactured in 2003, intended as the centrepiece of a future public building, the Public Fountain LSD Hall.

18

Running man, 2011, fibreglass, stainless steel, motor, paint, 180 × 100 × 150 cm

The man seems to have passed the edge of the roof of the gallery and although he continues to run in the air, he does not fall (his legs rotate 360 degrees, in three different speeds). We know this image from cartoons (for example Wile E. Coyote, created by Chuck Jones). As long as he is not fully aware that he has lost the ground under his feet, that he has passed his limits, the runner does not fall. He is in limbo. He is capable of transcending natural laws, simply by ignorance. That's what the 21st-century man is constantly doing; he is moving mountains without looking at the holes he leaves behind. But, just as it's up to you whether you use a knife to kill or spread butter, the air run is also linked to the potentiality of an optimistic, utopian state of mind: anti-academic and anti-capitalist, gaining new capabilities for acting and thinking by breaking customs, and ignoring standard rules and laws.

All artworks courtesy the artist, Herald St, London and Andrew Kreps Gallery, New York

Jörg Heiser

May new
nerve cords grow

A painting of a sleeping girl ...
the photograph of a woman lying on an iron bedstead, a man sitting next
to her ... a huge hand-cranked bellows on top of a coffin-like chamber fixed
to a hospital bed—an improvised iron lung ... miniature ivory anatomical
models of a man and a woman in coffin-like boxes ... antique amphorae
standing in plastic buckets ... an emptied-out abdomen model, side by side
with the mould of the death mask of a middle-aged man, the death mask
itself, and a dead grasshopper with long feelers made of human hair ...
a rope suspended from the ceiling, with feathers stuck into it horizontally,
as if forming a ladder ... antique oil lamps ... prehistoric axe heads shaped
like oil lamps ... flint stones shaped like axe heads ... a single stone with
colourful stripes painted onto it ... a plaster cast of a medieval statue largely
covered by a grey blanket—folds on top of folds ... a static film shot, on a
monitor, of two gentlemen sitting in club chairs getting more and more drunk
... a group of statues and figurines of varying sizes, each of them a version
of the same motif of a chimpanzee sitting on a pile of books and beholding
a human skull, striking a The Thinker meets Hamlet pose ... a vial of
adrenaline ... a film about an octopus ... an armadillo, its shell hovering
above its skeleton ... the replica of a human brain inside a glass box open
on one side, with a piece of tarmac about the size of the brain placed on
top of the box ...

... this is just a fraction of the many exhibits put on show by
Klaus Weber at Nottingham Contemporary under the title *Already*
there!. (Who's already there? The hedgehog or the hare?) Most of
them are artefacts on loan from science or history museums in the
UK, and from Weber's own collection, some are genuine artworks
on loan from art institutions (predominantly from the Tate): the
painting is a Balthus (*Sleeping Girl*, 1943), the photograph a Nan
Goldin (*Greer and Robert on the Bed, NYC*, 1982), the *Painted Stone*

is by Kurt Schwitters (1945–7), and the video of the increasingly drunk gents by Gilbert & George (*Gordon's Makes Us Drunk*, 1972). There is also a William Hogarth engraving (*Four Prints of an Election, plate 4: Chairing the Members*, 1758)—a satirical image of a Tory candidate being carried around on a chair after his victory. And there is more. There are not only historical works but also contemporary ones by Weber himself: placed underneath the Hogarth is *Doppelkaktus* (Double Cactus, 2006/8), a pair of cactuses horizontally fused into one at their tips, set on a small mirror-topped table. The blanket-covered statue is entitled *Elisabeth in folds* and dated 1245/2011, the former date referring to the year the original statue of John the Baptist's mother was made for Bamberg Cathedral in Germany. There are also some works by artists roughly of Weber's generation, such as Lucio Auri's taxidermied pigeon with a piece of toast around its neck like a ruff collar, as if the bird had picked at the slice so manically that it slipped over its head (*6.26am, 31.08, Leidesgracht, Amsterdam*, 2010); or a freestanding stop sign by David Shrigley which actually doesn't say 'Stop' but *Stop It* (2007). Did Weber include the piece to warn his imagination—running wild with different things that could be put into relation and allowed to resonate with one another—not to overstretch itself to the point of lunacy? As if to confirm that speculation, Shrigley's sign is paired with a 1985 triangular metal rabies warning sign from the collection of the Science Museum in London.

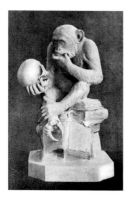

'Puzzled Ape'
a reproduction
of Hugo Rheinhold's
Affe mit Schädel (Ape with
skull, 1892) see p.130
Already there!

The apes are also an artwork by Weber himself (*Shape of the Ape*, 2007). It's an assembly of found variations of a motif initially introduced by German sculptor Hugo Rheinhold with his *Affe mit Schädel* (Ape with Skull, 1892); most of them, made of different materials such as plastic or bronze, are placed on glass pedestals except for the largest, larger than life-size chimpanzee placed on the floor in the middle, the head, skull, hands and feet of which lie on the floor like remnants of a leader's statue, toppled after a revolution. There are also a number of images and newspaper clippings (placed on the walls, around the sculptures) documenting, for

example, such a statuette being given to Lenin by an American businessman, or being lost by the Nazis when an airplane crashed and sank in an Austrian lake. In the context of *Already there!*, it begs the question of how you distinguish a 'genuine' Weber artwork consisting of an arrangement of found artefacts from what is 'only' an arrangement of artefacts (such as the oil lamps next to axe heads next to flint stones next to painted stone)? Disregarding the question of who owns the original components of such an arrangement, once that arrangement is titled and dated does it automatically become a genuine Weber piece? Or be 'declared' an artwork while remaining untitled, undated, and its components owned by others?

These questions may seem all the more begging to be asked as this exhibition of art and artefacts is only one part of the complex game Weber has played at Nottingham Contemporary, the other part of which is his solo show entitled *If you leave me I'm not coming—* which also includes a number of curious found objects, thus further blurring the line between Weber's 'genuine' artworks and the artworks and objects he chose. So where do you draw that line? For the moment, one can assert at least that Weber seems to revel in the idea that it becomes joyously difficult to distinguish art from artefact, or rather: that blurring that line is not so much in the service of making a point about the definition of what's art and what's not, but what's worth looking at.

As the question of distinguishing art from artefact recedes, what comes to the fore is the question of choice and association. Why, say, place a bust by Eduardo Paolozzi (*Plaster for 'Mr Cruikshank'*, 1950) in a little Perspex box right to the side of a tall pedestal on which sits a birdcage that was in use at a Sussex mental asylum between 1859 and 1939? The answer, one could think, is simply that the head of Paolozzi's bust has one quarter neatly cut out, as if from a cake, and placed next to one shoulder like a missing piece of a puzzle, allowing you to read the bust and the cage as two complementary allegories of insanity (the 'Mr Cruikshank' of the title was in fact the name scientists at MIT gave a wooden head used to measure the penetration of X-rays into the cranium—a literal equivalent to the destructive influences inflicted on inmates of lunatic asylums). But how could you describe the connection between a pewter tobacco

pipe with a curiously multi-looped stem, clay pipes, pipe cases, glass flasks with spherical bodies and funnelled necks, ceramic retorts which, due to their long downward-pointing neck, look like pipe heads, and a projectile-like cone (which actually is an odd piece of sewage pipe)? The answer probably is that the grouping mutates from functional similarity paired with formal difference to functional dissimilarity paired with formal similarity, and to lingual identity paired with functional difference (smoking pipe, sewage pipe). A pipe is not a pipe indeed.

In simply categorising the exhibits along the lines of these symbolical, literal or formal readings, we are considering them in terms of what Ludwig Wittgenstein, in his *Philosophical Investigations* (1953) called 'family resemblance'—"a complicated network of similarities overlapping and criss-crossing: similarities in the large and in the small".[1] This definition however will not produce anything close to a resolved reading of what overall effect these similarities produce, and what they tell us about Weber and the worlds he reflects on.

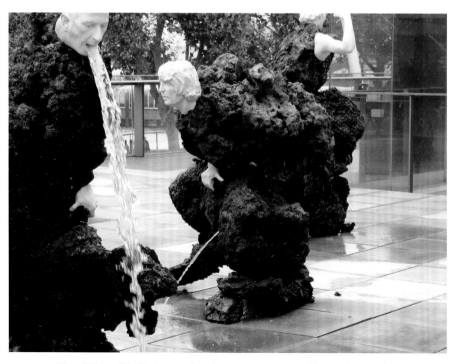

Klaus Weber, *Big Giving*, 2006–7, slag, stone cast, water. Photo: Klaus Weber

Aby Warburg's *Mnemosyne Atlas*, 1924-9

The 16th-century *Wunderkammer*, or cabinet of curiosities,
had been produced by a mixture of the scientific and the magical,
the artistic and the artisanal, the olden folkloristic and the newly
colonial: say, the tusk of a narwhal presented as the horn of a unicorn.
The easy, lazy way out therefore would be to say that Weber's wild
mixture of things, like the *Wunderkammer*, is simply meant to astound
and amuse. Nothing wrong with astonishment and amusement, yet
there's something else at stake, something that concerns the way
culture is structured.

In *Totem and Taboo* (1913), Sigmund Freud identified the two
principles of association: similarity (things or events that resemble
each other) and contiguity (things or events that occur close to
each other in space or time). Free association became the central
technique of psychoanalysis, and it is precisely the connection
between similarity and contiguity that also was formative for
another great discovery or invention of that period: Aby Warburg's

Mnemosyne Atlas (1924-9). Warburg, following an idea he initially had had in 1905, pegged 1,000 images onto large black canvases; this finite number of images produced infinite possibilities of combining them, in an attempt to explore the legacy of antiquity in the forms of the Renaissance and subsequent epochs up until Warburg's own time. Like with Freud interpreting a dream and Sherlock Holmes solving a case, the seemingly unimportant detail becomes important ("The Dear Lord nestles in detail", as Warburg put it[2]): images of Babylonian clay models of a sheep's liver, inscribed with instructions for soothsayers, next to an Etruscan find with a similar function, next to depictions of kings worshipping the stars; while on another canvas, cosmological maps circulate around zeppelins floating in the sky. The liver and the zeppelin become organs that reflect the cosmos as well as our humours—or fears and desires towards the future, written in the stars.

In his essay 'On the Mimetic Faculty' (1933), Walter Benjamin discusses the human capacity to identify similarities and abstract from them: "the mimetic element in language can, like a flame, manifest itself only through a kind of bearer"[3]. Warburg's atlas highlights how that flame passes between objects and images; the method of montage—as in film, as in a spread of Google image search finds, as in Freud's free association—is revealed as the means to incite it.

It's in line with this understanding of association when Weber, describing his method of choosing the artefacts and artworks for Nottingham Contemporary, writes: "I decided not to search but actually to find them."[4] In other words, Weber implies that he left what he ended up showing, at least partly, to chance and intuition. Or more radically put: he was not choosing the object, the object chose him. Another Freudian notion comes to mind—'object choice'—which he developed in regard to how partners choose each other, based either on the 'narcissist' principle of similarity or on what he calls *Anlehnung*, leaning-on. Here, with Weber, this is not about falling in love with a partner, but falling in love with the principle of object choice itself (the title *If you leave me I'm not coming* may exactly hint at that). Important is not only what happens to the object in question if transferred into the context of Weber and his

work, but also what in turn happens to Weber and his work. It's not just the artist choosing an amphora or a taxidermied object or a death mask (like other artists before him chose a urinal or a horse or whatever), but the object also choosing and changing him and his *oeuvre*, like a lover embraced or a drug taken. One could also introduce here the category of the workshop, the laboratory, the studio: *Already there!* includes arrangements—samples, experiments; like you would find them in those places (such as the combination of abdomen, mould, cast, grasshopper)—that are demonstrations of a thinking process rather than a statement in themselves.

Weber's 'wild mix' is an attempt to set into oscillation—and we should not confuse this with the claim, hackneyed by a myriad of museum wall texts, that a singular artwork supposedly 'questioned' or 'ruptured' our ways of seeing—the fundamental elements of a given cultural order. It's an exercise in deconditioning, a cultural technique that appears in contexts as diverse as behavioural psychology, religious rites and beat-generation-type countercultural activity. Hubert Fichte, one of the few important German writers of the 1960s and 70s to be considered part of the latter milieu, pointed to the Yoruba people of Brazil—"When Yoruba temples are inaugurated, there is a rite that is called *obrigaçao da consciência*: obligation of the consciousness, a rite in which the consciousness is broken, the everyday, profane consciousness in favour of a religious, godly one."[5]

This particular approach to object choice also implies the rejection of the notion that the creative process of the artist is simply to be equated with the systematic, skilful execution of an idea (or, in olden times, an act of genius). And it's also a rejection of the notion of the (quasi-)scientific process associated with much 'research-based art' as being that of a systematic test of a hypothesis. It is not a rejection however, just to make that clear, of the idea that the artist needs to realise the work with an insistence on getting it right, bringing it to the best possible fruition despite all odds. In any case, the curated part of Weber's Nottingham endeavour has bearings on the artist's methodology in general. So if the artist effectively rejects systematic execution or testing, what is it then that defines his methodology of choosing, his way of not searching but finding, or of not even finding but being found?

<div align="center">* * *</div>

If you ask the artist for major sources of inspiration, he'll readily hint at (amongst other sources such as Franz Kafka's stories 'Speech to the Academy' and 'Metamorphosis') two great literary works—Joris-Karl Huysmans' *Against Nature* (1884) and Gustave Flaubert's *Bouvard and Pécuchet* (1881). These two books differ quite radically in tone and type of main protagonist: one is the idiosyncratic monologue of a monkish dandy, the other a burlesque about a Laurel and Hardy-type odd couple. But they also have a lot in common. Both stem from the same period and place (Paris), and they share a similar narrative structure and main concern. To put it roughly, the protagonists in both books retreat to the countryside to venture, chapter by chapter, on a quasi-encyclopaedic exploration of various scientific and aesthetic experiences, in an attempt to find out what the 'good life' could be. In doing so, their outward retreat is in fact an inward journey—as if sending Robinson Crusoe on a mental Odyssey. As long as they desperately search solutions, they don't come to any; as soon as they let go, they find things.

What do these books really tell us about Weber's work, and art in general? Mainly three points. The first is the question of how artistic works respond to their time. Huysmans' book was a key work of the Decadence movement, his turn away from Zola's Naturalism—it pitted the artificial and idiosyncratically refined against supposedly 'faithful' representations of social realities in works of art (implying that these kinds of naturalist works may lead to moral hypocrisy and aesthetic stagnation). Decadence, here, is not just a word for perverse luxury indicating the downfall of a society, but an attempt to explore the limits of sensation and envision a new future amidst the ruins. Flaubert's work in turn was, essentially, a parodic stab at 'scientific knowledge' in the 19th century, pointing out the hilarious amount of self-defeating contradictions 'experts' produced in any field, from agriculture to medicine. Seen with these historic examples in mind, Weber's turn to a seemingly idiosyncratic and imaginative mode of art production, in relation to his roots in Berlin's activist art initiatives of the 1990s, is not a sign of escapism, but a consequential move, questioning an all too literalist,

Säen heisst wählen (to sow is to vote)
Weber spreading the culture of the edible *pavement mushroom* in Berlin, date unknown

determinist, 'naturalist' understanding of how change can be effected, of how criticising the status quo is weighed up against imagining other states of being.

The second crucial question concerns the methodologies implied. The method of Huysmans' character, Des Esseintes, is the refinement of different experiences to the brink, or over the brink, of exhaustion or disgust (which, incidentally, is a major aspect of Performance art since the 1960s). For example, he orchestrates a complex combination of distinctive perfumes, composed and played like on an organ, arousing memories and visions, heightening the sensitivity of his nostrils to the point where even opening the window will only make things worse, allowing even more scents inside. In another famous scene, he goes to the lengths of acquiring a large living tortoise and getting its shell encrusted with gold and jewels in order to resolve the difficult question of how to perfectly illuminate and match a precious oriental carpet—the tortoise dies. Des Esseintes radically surrenders himself to his explorations, following them through incessantly, devoting his body and senses to them, in an attempt to let the

artificial triumph over nature (while the artificial keeps being defeated). As the kind of climax of the book, Des Esseintes decides to cure his sensitive digestive system by exclusively absorbing nutrients by way of enemas—hence the title 'à rebours' (which literally translated means to do something, such as count or walk, backwards), it has been suggested, could also be translated as 'up the arse'.

The method of Bouvard and Pécuchet, counter to Des Esseintes', is all about inconsequential exploration—Flaubert in fact once said that "the book's subtitle would be, 'On the Lack of Method in the Sciences'"[6]. They always start things—whether it's pottery, making preserves or astronomy—but get easily confused or distracted by contradictory 'expert' knowledge they consult and all too readily follow, or fail to consult in the first place. Trying to get it right, they gloriously fail, but after a certain time they turn to a totally new subject which they explore with an equal mixture of fervour and dilettantism, producing yet another fine mess. You can always sense Flaubert's sympathy with his anti-heroes as they, like Laurel and Hardy, stumble from pratfall to pratfall—while his scorn is directed

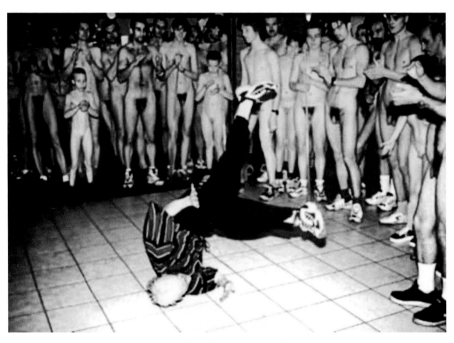

Amateur picture from the internet, author unknown

at the pseudo-scientific literature of his time, which he quotes throughout the book, exposing its at times mindlessly moronic, at times impudent and unfounded claims, indeed lacking method and assessibility.

Methodologically, Weber appears to combine aspects of both books. Like Des Esseintes, he is willing to stay true to what the conceptual parameters demand; even if it includes, like with Bouvard and Pécuchet, scenes of hilarious absurdity. Say, he'll decide to make a series of silkscreen prints with dark honey, of a 1950s beer-fountain festival in a German town (*Honeyprint (Bierbrunnen Lübbecke)*, 2011) and of a dressed breakdancer performing in front of a crowd of people wearing nothing but socks and trainers (*Honeyprint (fall)*, 2011). These two images have strong formal similarities: there is a central fluctuant attraction, surrounded by a circular social gathering. Both have obscure, primitive, even occult aspects to them, despite the fact that both scenes have a very quotidian cultural side to them as well. The use of honey as a 'print' material evokes the idea of honey as a substance of transformation (pollen being transformed into this particular liquid almost as if in an alchemical process), as well as a sensual quality of faded, blurry, sticky memories. Weber will stay true to the initial concept even if that causes major problems in regard to conservation and shipping (you can only display and transport the work horizontally, since the honey would otherwise run, and not set, but remain gluey).

Like Des Esseintes, Weber tends to invert or pervert the given convention towards a sense of excess or exhaustion; and like with Bouvard and Pécuchet, that leads to physical comedy: in 2001, for example, he launched *Demo Inverse*, an officially registered demonstration in Berlin, which involved a single car with a loudspeaker on its roof. As can be seen in the video (shown as a small 'mouse hole' projection at the bottom of a wall), the obligatory police van accompanying it was drawn into an absurd dance, as the car was navigated in such a way that it always pulled up close to the van, back to back with it, while the loudspeaker emitted an opaque mix between song and announcement playfully dealing with issues of public space. Of course, this inversion/perversion towards

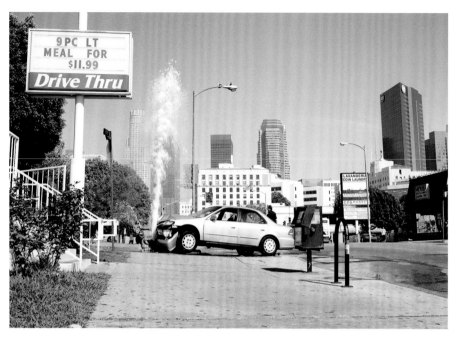

Klaus Weber, *Fountain Loma Dr/W6th St*, 2002, public space, Los Angeles. Photo: Katja Eydel

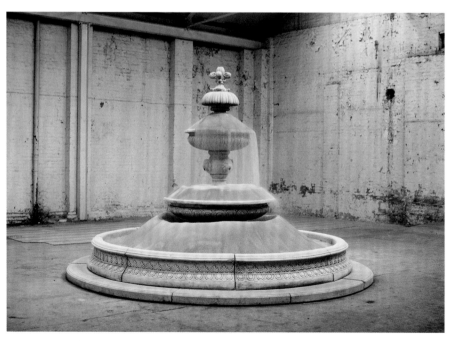

Klaus Weber, *Sandfountain*, 2012, prefabricated concrete fountain, sand
Commissioned by Frieze Foundation. Photo: Polly Braden

excess/exhaustion is not just a whim, but a response to the excessive privatisation of public space in the wake of new building projects in Berlin at the time, as well as the exhaustion of the classic demonstration format and the need for new forms of protest. At the same time, its entropic absurdity combines the slow moves of Des Esseintes' turtle with Bouvard and Pécuchet's slapstick mishaps.

The third crucial question that seems a defining factor for the protagonists in both Huysmans' and Flaubert's books—and for Weber—concerns the precarious relationship between analysis and intuition. How can we leap from existing knowledge to the creation of the new and hitherto impossible? Before we can eventually attempt to answer that question, we need to first understand the similarities and contiguities that were put on display with *If you leave me I'm not coming*. In short, they can be summarised under the tags 'fountain', 'imprint' and 'fable' (fable understood here in the wider sense of a principle of imagining allegorical or concrete replacement, alternation, role exchange, transubstantiation).

The fountain has been a recurring motif with Weber. Why the fountain? Let's put aside for once the ready references to Duchamp's urinal of that name (1917), or to Bruce Nauman's *Self-Portrait as a Fountain* (1966–7). Though Weber certainly navigates in the wide field of rethinking the art object via the Duchampian readymade, or post-minimalist studio practice in the wake of artists such as Nauman, he brings into play a crucial factor these works were not really concerned with: the urban public and social realm.

Weber's *Fountain Loma Dr/W6th St* (2002) was not—as is traditionally the case with fountains built to celebrate kings or nations—a monument to Weber's political importance and economic wealth (though that would be an entertaining way to see it) but to the power of Hollywood, its power to alter the very experience of public space. What passers-by on a street corner in the Westlake neighbourhood of Los Angeles saw was a familiar scene from a myriad of action movies: a fire hydrant spurting after a car had collided with it. It's common in LA that on the basis of a film permit the street becomes a set, and that off-duty or retired policemen act as policemen extras, playing themselves. Thus it was possible for the artist to set

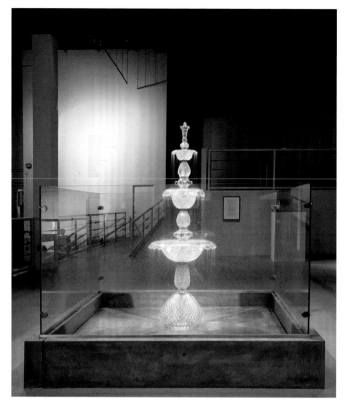

Klaus Weber, *Public Fountain LSD Hall/LSD Fountain*, 2003
Historic lead crystal, toughened glass, concrete, potentized LSD
Commissioned by Frieze Foundation

up the piece so it would blend into the regular goings-on of the
environment rather than disrupting it with a glaring 'Lights! Camera!
Action!' It could rely on a certain stoicism on behalf of passers-by
towards this kind of scenario—a rather ironic turn for the idea of
a public fountain.

Public Fountain LSD Hall (2003) extends this deadpan inversion
of public order towards potential mind expansion. The piece involves
a lead and glass fountain (made of bits and pieces left over from
the historic Victorian 'crystal fountain' fabricated for London's
Crystal Palace in 1851), with water spouting from a finial at the top,
overflowing into three increasingly larger tiers below, and eventually
into the pool base. The liquid in the fountain is homeopathically
potentised LSD. What homeopaths call the potentisation of a remedy
involves a process of serial dilution that—as in this case—can be
brought to a point where the actual substance is not present anymore.

The homeopathic argument is that water has 'memory', i.e. that the substance in question leaves a kind of 'imprint' on the water's molecular structure that thus can have an effect even or precisely because of the substance's absence. This assertion has been highly contested and largely rejected by the scientific community; nevertheless the idea that it *could* be possible becomes a thought that permeates the water spray around Weber's fountain like an actual hallucination.

The piece was originally conceived as a public monument involving a large building structure situated in an urban spot, allowing visitors to rest inside and watch the goings-on outside while the walls would shield them from being watched in turn by passers-by. Just as *Demo Inverse* and *Fountain Loma Dr/W6th St*, the piece cheekily works its way around legal boundaries, in this case the prohibition of narcotics: the drug being absent in legal terms yet present as an imprint and thought—like the demonstrators being present in legal terms yet absent in reality—inverts legislation in on itself. Weber issued an LP featuring recordings of the water purling down the tiers, on the cover of which there is a text collage (the version of the work on display at Nottingham Contemporary, see p.53): vertically the words 'executive', 'judicative' and 'legislative' spout from the horizontally placed *Public Fountain LSD Hall* like jets of water (this cover is an adoption of a similar design by Ian Hamilton Finlay, which uses the three vertical words 'Liberty, Equality, Fraternity' on top of the horizontal 'little fountain in three colours'). The classical *Trias Politica* is erected, and yet is deprived of its commanding rigidity. There is an old Cold War conspiracy story that in the early 1950s the CIA suspected Russian agents were planning to dump LSD in the New York City water supply so that hallucinating stock market brokers would bring the economy to collapse; in 1968 during the Democratic National Convention in Chicago, the Yippies put forth a tongue-in-cheek version of this story, threatening to put LSD in Chicago's tap water. Weber's take on this rather harsh scenario of de-conditioning thus is homeopathic in more than one sense: it turns compulsion into offer, threat into seduction (with the threat still symbolically present in the original installation, which includes a form of carnivorous nepenthes plant suspended from the ceiling above the fountain).

If you leave me, I'm not coming (window wiper) (2011) the work that gave the Nottingham Contemporary exhibition its title, turns the institution's panoramic window opening onto the city into a giant windscreen equipped with wipers clearing away drizzles of rain—another kind of fountain. As it turns out, the wipers as well as the water are inside, not outside the institution: as if the passer-by peering into the art space was looking at a rainy landscape from inside a bus or car. The work is not so much about the tired notion of 'addressing' institutional boundaries, but about a transformation of space per se: the window is turned into an imaginative membrane, visitor becomes passer-by and vice versa.

With Weber the fountain emerges not only as a classical imitation of nature (the artificial gushing spring or waterfall) but also as fluid counter-model to sculpture understood as a contained, solid volume. Over the last 60 years or so that traditional understanding of sculpture has already been questioned in many ways: flattened and rolled out like a dough towards landscape, riddled with holes and gaps towards installation, shaken and stirred towards kinetics and performance. Even what a contained volume might be in the first place can still be asked anew: as Jan Verwoert has persuasively

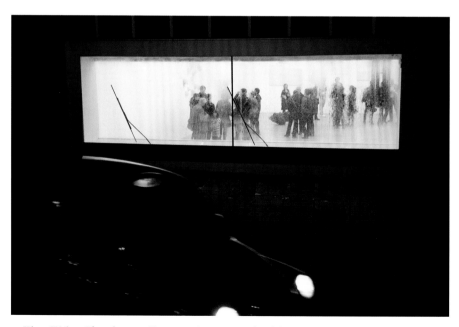

Klaus Weber, *If you leave me I'm not coming*, 2011, night of the opening. Photo: Peter Anderson

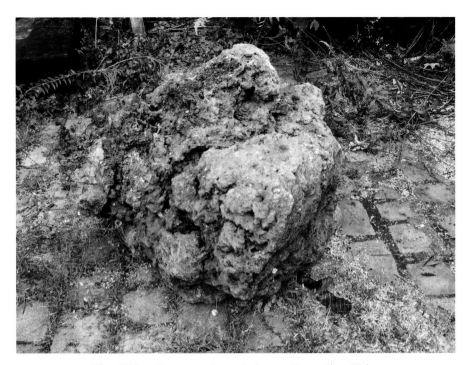

Klaus Weber, *Krawattenstein*, 2008, slag, tie. Photo: Klaus Weber

argued, it's maybe better to relieve sculpture, and the monument, of the demand to offer catharsis for the community in the form of an "erected lie that pretends to relieve us of our history and sins."[7] Instead we might think of it in terms of a dreamcatcher (usually a willow hoop with a loose net woven on it, and feathers attached to it, originating with the Native American tribe of the Ojibwe)—which "gives a material body to the connection between the dreamer and the dreamt"—or of a Ghostbuster's 'ghost trap'—the ghost is in the thing, but there is "no pretence that it has been dealt with once and for all. No redemption is promised; the ghost is still alive."[8] Some of Weber's exhibits precisely fulfil that definition. In the *Already there!* exhibition, there is a bottle of adrenaline put on display; the high-stress hormone, releasing creative as well as violent energies, is trapped inside a vial inside a vitrine. In the *If you leave me I'm not coming* exhibition, a large slag rock is placed on the floor, with a red tie with multicoloured stripes sneaking out from underneath it like a caterpillar (*Krawattenstein*, Tie Stone, 2008). Even though the piece turns a stone into a sculpture with minimal intervention,

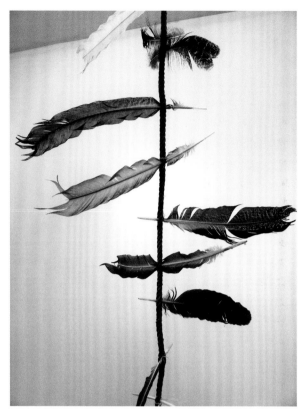

Klaus Weber, *Witches Ladder*, 2011

we immediately imagine a brutal cartoon scene in which the rock,
like a meteor, had hit a businessman, leaving him dead in the crater
of the impact.[9] Or take *Basteltornado* (DIY Tornado, 2007): a rotating
column of hazy air is captured inside a box open on one side, produced
with the help of a fogger—a device normally used to humidify air
with a touch of mystique—at the bottom and a vacuum cleaner at the
top. The sculpture-as-trap always involves energies fixed into or onto
a volume with the help of other energies.

But Weber's work substantially revolves around the idea that
the art object is not so much a container but a disseminator, releasing
resonances, fantasies and vibes like a fountain spouting water. The
aforementioned rope with feathers, included in *Already there!*, is a
perfect example: it's Weber's replica of a witch's ladder, that is, a rope
suspended from the ceiling with bird feathers wedged into it like
steps, a 'black magic' fetish meant to allow demons to enter a house

under the roof of which it is placed. It allows demons, nightmares and curses to use its steps to enter and flourish in an environment (notably, according to witchcraft folklore, the curse is lifted by throwing the ladder into running water).

The *Large Dark Wind Chime (Arab tritone)* (2008) is another case in point: it literally emits dark tonal vibrations. Suspended from the ceiling and gently ventilated by two fans placed on the floor, its long aluminium tubes produce an eerie drone—it is tuned to a tritone. The tritone is a restless-sounding interval of three whole tones; in the Western musical tradition it has been called *diabolus in musica*, and was largely banned from composition until Romanticism. The tritone carries a satanic connotation that Heavy Metal bands, from the 1970s on, have made extensive use of. With Weber's wind chime tuned to a tritone, based on an Arabic microtonal scale, the interval is further layered with anxieties that are present both in historic Western Orientalism and in contemporary Islamophobia.

Like a cross inverted to symbolise anti-Christian (as well as anti-scientific) sentiment, both the witch's ladder and the *Large Dark Wind Chime* share formal qualities with the dreamcatcher—all three include objects loosely connected by cords, suspended to hang freely—but to opposite effect: rather than capturing demonic vibes, they release them. Given this (imaginative) function, they become parallel features in Weber's tandem exhibitions; and though the witch's ladder is silent, the wind chime's drone lingering through Weber's 'solo part' is echoed in sound elements present in the 'group show' section: namely, the soundtracks of two video projections are mixed to haunting effect. One is Maya Deren's 14-minute black-and-white, feminist–surrealist classic *Meshes of the Afternoon* (1943–59), the other Mark Leckey's five-minute slide-show hit parade of the best and worst of London public art sculptures, *The March of the Big White Barbarians* (2005). Music fragments coming from the two works (in Deren's film, the Japanese music including gentle percussion, male humming and string instruments, and in Leckey's, the English-language chanting and 'tribal' drumming) blend to form an eerily fitting mash-up—another example of creating an entirely new experience by combining two existing works, and also incidentally an unorthodox answer to the group show dilemma of noise interference between works.

Of course none of these exhibits—witch's ladder, wind chime, the video projections—is a fountain, but they do share a quality of emitting liquid flows of resonance and vibes of a strangely haunting quality, as if one was experiencing all of this under water, in slow motion. In Weber's world, there is sound and the slow movement of suspended dangling objects—but there is also, in sharp but complementing contrast, the absolute silence of the immovable trace or imprint. Huysmans' Des Esseintes is seeking relief from the bustle of the city in the privacy of his isolated villa, nevertheless continuing to be exhausted by adventures of the senses and the mind. The careful slowness and refined laboriousness of some of his experiments is congenially matched in Weber's *Sun Press (against nature)* (2011): a heliostat positioned on the building's roof redirects and concentrates sunlight onto one spot in the gallery so that over the course of the exhibition the text of Huysmans' book is successively bleached onto blank paper spreads, stacked

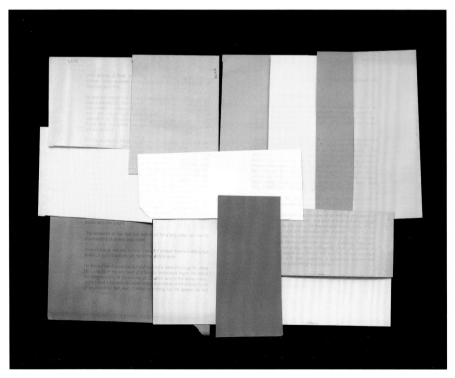

Klaus Weber, *Flowers (Sun Press collage)*, 2011, paper

between sheets of glass—an inverse process, *à rebours* so to speak, since the book is printed by way of the 'aging', i.e. yellowing of the pages.

This process of creating and collating imprints and traces to form a work reverberates with another piece that at first seems of an entirely different nature: it's a collection of death masks hung on the wall (*Trunk (death masks)*, 2011-12). Looking down at us with closed eyes, one has to think of the horror-flick motif of haunted souls' faces protruding from walls (which may be traced back to art predecessors such as Rodin's *Gates of Hell*). One can make out famous faces such as Lenin's and Bertold Brecht's, but also lesser known features, including a curiously comical-scary one with an extremely bulbous nose and extruding eyes—making clear that few if any of these masks actually were authentically taken from a dead person's face without further enhancement.

Hung directly back to back on the other side of the same wall at Nottingham Contemporary, there is another work involving facial castings, albeit in this case collated not by Weber but by German 19th-century ethnographer Otto Finsch. Weber had come across 200 castings—or rather, the moulds that could be used to produce a cast—in the storage of the Staatliche Gipsformerei (Berlin state museums' plaster cast workshop). Finsch had taken them of indigenous people in the Malay Archipelago and the South Sea in order to explore racial typology—a colonial, pseudo-scientific obsession typical of its time, foreshadowing 20th-century white supremacism. It must be precisely for this reason that Weber had problems getting permission to exhibit even one photograph of one of the moulds, presumably for fear of it reflecting badly on the museum (ironically, of course, it reflects even more badly on an institution if they try to make difficult parts of their history inaccessible). These photographs would have shown that many of the moulds still bear traces of life such as an eyelash or earwax, and that this uncanny aliveness is being heightened by an optical illusion, the hollow-face effect (i.e. the brains tendency to perceive a concave mask as a normal convex face). So instead, Weber decided to exhibit a photograph of just one of the moulds, accompanied by facsimiles of the meticulous listings Finsch had made of all the people he had

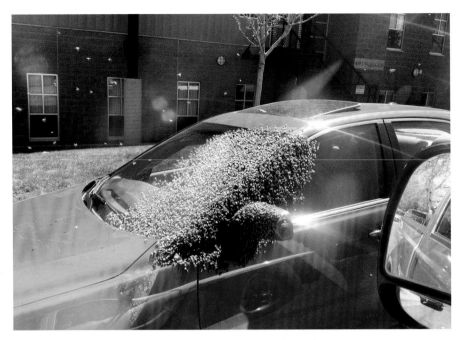

Amateur picture from the internet, author Robert Ray

used, indexing them according to gender, approximate age and place of origin (*ethnonegativ*, 2011). Displayed in six panels, the absolute silence of raw data—reminiscent of the kind of indexical work established in the wake of Conceptualism—proves to be more chilling than any number of death masks could ever be.

* * *

Capitalist economy tends to rely a lot on a similar kind of depersonalisation of the individual to raw data; all in all, what counts is what can be counted. If the 18th-century economist Adam Smith was right in stating that economy is ruled by an invisible hand, one may add—with the continuously widening gap between the rich and the poor in mind—that this invisible hand can feel pretty cold and dead. In 2008, just in time for the worldwide financial crisis, the world's first public monument of Smith was unveiled in his home town of Edinburgh, a 10-foot bronze statue showing him resting his hand, made partly invisible by his gown, on a globe forming part of a beehive. The beehive is a symbol of industry, but also a hint at

Klaus Weber, *Bee paintings*, 2009–11, bee droppings on canvas, work in progress

a major source of inspiration for Smith, Bernard Mandeville's poem *Fable of the Bees* (1705), which promotes the idea that corruption and vices, if kept in check by laws, actually contribute more to the prosperity of a state than pious righteousness. Weber registered a demonstration with the City of Edinburgh Council, filling out a form stating an event, a "political demonstration for a new mode of human brains and economy", and involving 200,000 live bees gathering on the Adam Smith monument, accompanied by two beekeepers and a doctor. He assured the council that these professionals would be able to protect the public from any danger connected to bee stings. Weber's plan continues to exist as an imaginative event and an actual proposal put on display, with its striking hand-drawn sketch of the swarm of bees covering the head and body of the figure: as if the fable of the bees had come back to haunt the father of economics, suggesting ambivalence between swarm intelligence and swarm threat.

Another strategy is to purposefully take the fable's mode of imitation or resemblance all too literally: with his *Bee paintings* (2009), rather than using bees as an allegory, Weber literally turned

them into painters. Taking advantage of the curious phenomenon of bees' 'cleansing flights' in early spring, during which they release faeces—accumulated during hibernation inside the hive—onto bright white surfaces, he provided just such surfaces by placing canvasses amidst a Berlin apiary. Smaller and larger drips of yellow and brown are distributed erratically across these canvasses. Thus they wryly comment on abstract-expressionist styles and genius cults as much as they continue the tradition of conceptualist delegation of production. Plus, they allow the bees—like in a fable—to express a 'human' sentiment: revenge. Beekeepers commit a shady deal when they replace the bees' honey with sugar water for the long winter, so in spring, in retribution the bees shit on every man-made white surface they can find. The witch's ladder also involves such a motif of 'animal revenge': the feathers used stem from birds kept in zoos that in response to having been imprisoned now help to release the demons.

Yet another strategy is to not only take the fable's logic literally (by letting animals perform a task associated with human beings, such as painting) but also to invert or reverse it: for example, letting a human figure perform a task associated with cultural representations

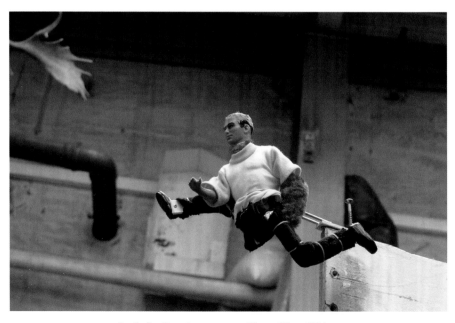

Study for *Running man*, 2011. Photo: Klaus Weber

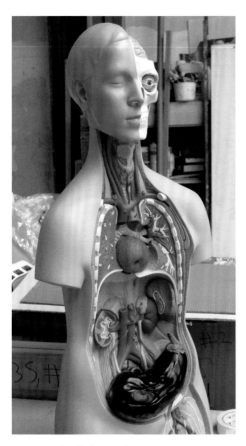

Study for *Veggieanatomy*, 2011
Photo: Klaus Weber

of animals, as in the case of the *Running man* (2011) installed on the edge of Nottingham Contemporary's roof. His frantically rotating legs recall Wile E. Coyote running off the cliff but not falling until he actually looks down to see the abyss underneath—a cartoon scene that has been interpreted by Slavoj Žižek as the perfect illustration of traumatic deferral, but could also be read as an allegory of Yves-Kleinian leaps into the void (of the future, of passing beyond a limit, or also of exhausting oneself beyond that limit). In any case, Weber's human dummy performs the act of a cartoon animal which in turn is interpreted as an allegory of human behaviour. Another example is *Veggieanatomy* (2011), a life-size anatomical model of a human torso whose detachable internal organs Weber neatly replaced, Arcimboldo style, with very similar-looking vegetables (the brain is a cauliflower, the liver an aubergine, the intestines ginger, etc.). Vegetables are turned into 'fables' not of human beings, but of their organs.

The principle of the fable proposes a productive mix-up: non-human entities are 'confused' with human beings in order to be able to playfully and freely comment on the latter's qualities. Weber dramatically accelerates this mix-up quality of the fable by replacing its linear narrative structure with a more liquid, non-linear, 'fountain-like' logic, producing—or collecting imprints or traces of—family resemblances, mirror effects, absurdity, hallucination. In order to achieve this, he employs chance operations (as in the case of the defecating bees) or chooses things from often wildly different contexts and reassembles them in such a way that they

Klaus Weber, *Untitled broken window*, 2012, coloured safety glass, sunlight.
14 November, 5.30pm, Herald St. Photo: Nicky Verber

can produce new experiences and meanings (which is the very
principle of both of the Nottingham Contemporary exhibitions).

But how to employ the 'right' kinds of operations, make the 'right'
kinds of choices to achieve the intended effect? One answer would be
to state that artists analyse systems of knowledge, draw conclusions
from that analysis, and then come to the decisions that determine
these operations and choices. But that is an all too voluntaristic
and mechanistic understanding of how artists work. Nevertheless
it keeps being reiterated. Therefore the question of intuition is
currently returning in cultural discourse. Until very recently in
art the very word 'intuition' induced allergic reactions, because
it was seen as more or less synonymous with the antiquated cult of
the genius: the artist supposedly tapping into an exclusive, occult
channel to the godly sphere from where he or she *intuitively* draws
the creative insights and ingredients that will form the work of
genius. This was rightly called into question in the wake of the
cultural shifts of the 1960s towards either depersonalised, 'cool'

production in Minimalism and Pop, or by the collective stance of leftist subculture and politics. But the question of intuition is returning precisely because it had been falsely answered by the genius myth, and falsely denied by many of those who opted for anti-genius models. Why falsely denied? Because (even under the guise of utopian models of collectivity) the artist is projected as a kind of engineer who manufactures scenes, situations, objects and installations that—even at moments where they imply extensive elements of chance and the uncontrolled—ultimately serve nothing but the logic of an unfolding *oeuvre*.

One of the major philosophical enquiries into this question of intuition is Henri Bergson's essay *An Introduction to Metaphysics* (1903)—a philosopher who, incidentally, set out on his metaphysical journey in France in the 1880s, at around the time when the decadence of Des Esseintes and the absurd comedy of *Bouvard and Pécuchet* was in the reading public's mind. "We call intuition here the *sympathy*", writes Bergson, "by which one is transported into the interior of an object in order to coincide with what there is unique

Klaus Weber, *Stocktaking stacking*, 2014, National Gallery, Tbilisi. Photo: Klaus Weber

and consequently inexpressible in it. Analysis, on the contrary, is the operation which reduces the object to elements already known, that is, common to that object and to others."[10] Needless to say that artists (just as philosophers) would seek to combine those two aspects. If you take the idea of intuition seriously, any notion of a master plan unfolding erodes (say, of an artist coolly displacing different categories of objects into art); and if you take the idea of analysis seriously, any notion of the artist's pure expression erodes as well (say, of an artist virtuously distributing bee droppings on a canvas).

Once sympathy with the object comes into play, the artist has to allow things to become the locus around which a communication (with other objects, other artists and the viewers) unfolds, the outcome of which remains open. The artist has to allow things to do things. The by now tired Duchampian act of choosing an existing object for it to be art—tired because it has too often been misunderstood as merely a self-important strategic distinction vis-à-vis art history, or as an excuse for lame puns, or both—is reanimated, brought back to life, by making it a reciprocal process.

Klaus Weber, *AGEMO*, 2013, Fondazione Morra Greco, work in progress. Photo: Klaus Weber

The point is to rescue the tried and tested methods of post-conceptualist practice (art as appropriation of things and acts, including curating, etc.) from complacency, to inject them with a dose of adrenaline, curiosity, excess.

At the end of the two-page demonstration application submitted to Edinburgh City Council, Weber included a hand-written statement in German. Effectively, it amounted to a purposeful suggestion of madness if included on a form otherwise filled out entirely in proper English. But the sentence should be taken completely seriously. It is a motto for the hallucinatory exuberance that characterises Weber's practice in general; it translates as, "May the system proliferate—proliferate so that new nerve cords may grow!"

1. L. Wittgenstein, *Philosophical Investigations*, Blackwell, Oxford, 2009, p.36.

2. Aby Warburg used the phrase as a guiding motto for his seminar of 1925 at the University of Hamburg, 'The Significance of Antiquity for the Stylistic Change in the Italian Art of the Early Renaissance' ('Die Bedeutung der Antike für den stilistischen Wandel in der italienischen Kunst der Frührenaissance'), cf. Davide Stimili, 'Aby Warburg's Pentimento', *The Yearbook of Comparative Literature*, Volume 56, 2010.

3. Walter Benjamin, 'On the Mimetic Faculty', in *Walter Benjamin. Selected Writings, 1932–34*, Michael William Jennings (ed.), Harvard University Press, Cambridge (USA), 2005.

4. Klaus Weber, 'MicroTate 23', *Tate Etc.*, Issue 23, Autumn 2011, retrieved 26 October 2011 <www.tate.org.uk/context-comment/articles/microtate-23>.

5. H. Fichte, 'Gott ist ein Mathematiker. Annäherungen an die traditionelle Psychatrie in Togo' [God is a Mathematician. Approaches to traditional psychiatry in Togo], *Psyche. Die Geschichte der Empfindlichkeit* [Psyche. The history of sensitivity], S. Fischer Verlag, Frankfurt, 1987, p.191. [Author's translation.]

6. Queneau, R., preface in Flaubert, G., *Bouvard and Pecuchet*, New Second edition, M. Polizzotti (trans.), Dalkey Archive Press, London, 2005, p.15.

7. J. Verwoert, 'The Devils Inside the Thing Speak to the Devils Outside', in E. Grubinger and J. Heiser (eds.), *Sculpture Unlimited*, Sternberg Press, Berlin, 2011, pp.82–97.

8. Ibid.

9. In fact, the artist told me the work was inspired by a story from the German village where he grew up—a large rock called Nonnenstein (Nun's Stone) allegedly once buried a nun, and her dead body was left below the rock, thus turning it into her gravestone.

10. Bergson, H., *The Creative Mind: An Introduction to Metaphysics*, Citadel Press, New York, 1992, p.161.

This book is published as
document of the exhibitions:

**If you leave me I'm not coming
& Already there!**
Klaus Weber

Nottingham Contemporary
22 October 2011 – 8 January 2012

If you leave me I'm not coming
Curated by Alex Farquharson with Abi Spinks
Project managed and organised by
Abi Spinks and Jim Waters
With assistance from Daniella Rose King
and Nadine Zeidler

Already there!
Curated by Klaus Weber with assistance
from Abi Spinks
Organised by Abi Spinks and Jim Waters
With assistance from Daniella Rose King
and Nadine Zeidler

The editors and publisher gratefully acknowledge
the permission granted to reproduce the copyright
material in this book. Every effort has been made
to trace copyright holders and to obtain their
permission for the use of copyright material. The
publisher apologises for any errors or omissions
in the above and would be grateful if notified of any
corrections that should be incorporated in future
reprints or editions of this book.

First published by:
Nottingham Contemporary
Weekday Cross
Nottingham NG1 2GB
www.nottinghamcontemporary.org

Edited by Abi Spinks, assisted by Bruce Asbestos
Copyediting and proofreading by Ariella Yedgar
Additional copyediting and proofreading by
Kathy Noble, Jim Waters, Daniella Rose King
and Bruce Asbestos

Designed by Fraser Muggeridge studio
Photography by Andy Keate and Klaus Weber
Printed by Grafiche SIZ

ISBN: 978-1-907421-03-7

Acknowledgements

Nottingham Contemporary would like to warmly thank our partners on this project:
Herald St
Andrew Kreps Gallery

Catalogue contributors:
Diedrich Diederichsen
Jörg Heiser

The exhibition's generous lenders and contributors:
The Ashmolean Museum, Oxford
Boots, Nottingham
British Film Institute
Grant Museum of Zoology, UCL
Institute of Archaeology, UCL
Mark Leckey
Les Documents cinématographiques, Paris
Lucio Auri
Luis Camnitzer and the Daros Latinamerica Collection
LUX, London
Science Museum, London
Tate

Others who have supported the exhibition:
Dr. Marc-Wilhelm Kohfink, Imkerei am Pflanzgarten
Lorenz Husterer, Exotic Farm
Annette Müller, Berliner Honig von Berliner Bärengold
Daniela Rüge, 3B Scientific GmbH
Daniela Seitz
Michael Dietrich

For the exhibition installation:
James Brouwer and David Thomas

For the Public Programme:
Siobhan Carroll with assistance from Daniella Rose King and Louise Goodwin

Nottingham Contemporary would also like to thank our generous Benefactors and Supporters:

Contemporary Circle

Benefactors
James Lindon; Jack Kirkland; Michael Kirkland; Alex Sainsbury and Elinor Jansz; Karsten Schubert; Adam Cohen; Eirian Bell; Valeria Napoleone.

Supporters
David Tilly; Brian Boylan; Francois Chantala and Victoria Siddall; Kate Robertson; Paul Greatrix; Alan Dodson; Tony Shelley; James Burgess; Cornelia Grassi and Tomasso Corvi-Mora.

Business Circle

Platinum:
Christie's; The Garcia Family Foundation; NET; Sotheby's.

Gold:
Browne Jacobson; CPMG Architects; Savills; Hugo Boss.

Silver:
Belmacz; Cartwright Communications and Rizk McCay; Daniel Hanson; EY; Experian; Innes England; Mercure Hotel; Polestar; Ryley Wealth Management; Smith Cooper; TDX Group; Universal Works.

Business Circle

David Zwirner Gallery; Maureen Paley Gallery; Sadie Coles HQ; Spruth Magers; Thomas Dane Gallery; Victoria Miro Gallery.

Endpaper image: detail from Klaus Weber, *Flowers (Sun Press collage)*, 2011, sun on paper

61

Cornelia Parker, *Object That Fell off the White Cliffs of Dover*, 1992, crushed silver plate teapot. Tate: Purchased 1998

62

Francis Barlow, *Monkeys and Dogs Playing*, 1661, oil on canvas, 105.5 × 132 cm. Tate: Purchased with assistance from the Friends of the Tate Gallery 1989

The blue of the dark sky in the painting's background was the source for the wall colour that forms the background for the *Shape of the Ape* installation at Nottingham Contemporary. As with most paintings of this genre, it has to be assumed that this is a portrait of specific dogs, commissioned by their owner.

Although the genre in which *Monkeys and Dogs Playing* is painted is trivial, the scenery seems to have a sinister undertone, like an apocalyptic but also utopian vision of animals playing in the not-yet-ruins of human culture.

63a–g

Klaus Weber, *Shape of the Ape*, 2007, mixed media installation, dimensions variable. Courtesy of the artist, Herald St, London and Andrew Kreps Gallery, New York

The starting point for this installation is a *Affe mit Schädel (Ape with Skull)* figurine made by the late-19th-century Jewish/German sculptor Hugo Rheinhold. The installation basically consists of three elements: an oversized but segmented reproduction in rusty and blackened iron of the ape with skull (entitled *Puzzled Ape*), surrounded by more than 30 different reproductions of the motif collected internationally. They are all placed on fragile glass pedestals, which are positioned quite close to each other, so that the viewer is always aware of the risk of knocking one over and causing a chain reaction of destruction. Although Rheinhold remained relatively unknown, his motif of an ape sitting on a stack of books (one of which carries Darwin's name) pondering a human skull became part of worldwide popular culture and was repeated in various versions. The variations are mainly gradual modifications as they are described in Darwin's evolutionary example of the finches. Similarly, the *Shape of the Ape* collection shows an anti-genius sculptural evolution.

The third element consists of five framed documents referring to the seemingly arbitrary traces the figurine has left in history, connecting an American capitalist with Lenin and Hitler. In short: the businessman Armand Hammer bought the ape in Berlin to give it as a present to Lenin before discussing the possibilities of doing business with the USSR. It stayed on Lenin's desk (see pp.134–5) during his whole reign (it's still there). In the last days of World War II, a plane flying on a secret mission for Hitler was carrying the figurine by the Jewish/German sculptor (see caption **63c**).

63a

Puzzled Ape, iron cast, stained and waxed, 4 elements: torso on a stack of books, 130 × 91 × 71 cm; ape head, 28 × 53 × 30 cm; human skull, 28.5 × 46 × 30 cm; legs, 27 × 63 × 41 cm

63b

Collection of 31 vintage figurines, date unknown, mixed media on glass pedestals

63c

Sensation am Attersee, photocopy, 133 × 84.5 cm

Translation of the newspaper article: "Attersee Sensation. The first find: An ape! A diving troop led by 'Blitztaucher' ('lightning diver') Millresch (left) is currently trying to recover a Ju 88 from Austria's deepest lake. The plane attempted to land on Attersee during the last days of the war and sank within seconds. Two men were saved but disappeared without a trace. It is believed that the plane flew on direct orders of the 'Führer' and carried secret documents and gold bars. The first object brought to daylight by Millresch, who can quickly adjust to pressure differences when diving, turned out to be … an ape. The bronze animal, which sits on the works of Darwin, was salvaged from nearby the wreck. The diving work continues. Photo: G. Bartsch"

63d

Ape on Pig, C-print, 98 × 126 cm

63e

American business leaders, photocopy and Japanese ink, 98 × 67 cm

63f

Coco letter, archival inkjet print, 80 × 63 cm

63g

Lenin's desk, C-print, 104 × 128 cm

installed on a layer of sand, at the same time such stones are a favoured weapon in street fights and riots. The slogan combines militancy and hedonism, firing the fantasy that a better world is sleeping under the thin surface of the profane reality which has to be deconstructed. When you pull out one of these artificial stones from the pavement and turn it upside down, it looks like something extraterrestrial, a comet or something ejected from the centre of the earth, a piece of volcanic lava. Under the pavement is indeed the *sur*-real.

56

Voice key H041, electrical unit made by Behaviour Apparatus Ltd., 1950–75, 15.5 × 14 × 14 cm. Science Museum, London

57

Gilbert & George, *Gordon's Makes Us Drunk*, 1972 video, 12 mins, black and white, sound. Tate: Purchased 1972

For this film, Gilbert & George added their names to the bottle's label. The artists are shown seated at a table, getting more and more drunk while repeating the phrase "Gordon's makes us very drunk" while keeping a straight face. The video is shown on a cube monitor which is placed next to the cuboid Voice key H041 unit by Behaviour Apparatus (see p.110).

In contrast to the story in *Report for an Academy*, by Kafka, where the evolution of an ape to man starts by sipping from a bottle of alcohol, these gentlemen remain gentlemen, and don't become wild.

58

Coloured wax models of a gentleman and a lady, half-skeletal, half-living, and dressed in Regency clothes, English, 1810–50, 28 × 4 × 6 cm and 27.3 × 6.4 × 6.2 cm. Science Museum, London

59a

Cast of skull of Piltdown Man, made by R. F. Damon and Co., 45 Hazlewell Road, London, SW15, England, 1939, plaster, with mandible, 23 × 18 × 13 cm. Science Museum, London

Piltdown Man was a hoax in which bone fragments were presented as the remains of a previously unknown early human. These fragments consisted of parts of a skull and jawbone, said to have been collected in 1912 from a gravel pit at Piltdown, East Sussex, England. The specimen was given the Latin

name *Eoanthropus dawsoni* ('Dawson's dawn-man', after the collector Charles Dawson). The significance of the specimen remained the subject of controversy until it was exposed in 1953 as a forgery, consisting of the lower jawbone of an orang-utan that had been deliberately combined with the skull of a fully developed modern human.

The Piltdown hoax is perhaps the most famous palaeontological hoax ever. It has been prominent for two reasons: the attention paid to the issue of human evolution and the length of time that elapsed from its discovery to its full exposure as a forgery (more than 40 years).

59b

Plaster copy of the skull of Johann Sebastian Bach (1685–1750), Germany, 1900–27, 24.5 × 14.5 × 15 cm. Science Museum, London

The self-taught composer Bach (English: brook) based his 'musical science' on the principle of Aristotle: art as imitation of nature. The skull was found in 1894, but its authenticity remains questionable.

59c

Marble skull, date unknown, 13.9 × 10.5 × 10.7 cm. Science Museum, London

59d

Animal figure, standing upright, Bronze Age: Akkadian to Babylonian Period terracotta, 7.5 × 4.6 cm. The Ashmolean Museum, Oxford

59e

Unknown Anthropomorphic figurine, Bronze Age: Akkadian to Babylonian Period terracotta, 13.3 × 8.6 cm. The Ashmolean Museum, Oxford

59f

Ivory bust of General Wallenstein, after 1634 *memento mori* of half-skull, half-head, mounted on an ebony and metal stand studded with stones from his tomb, 18 × 10 cm. Science Museum, London

60

Bubalus bubalis arnee, wild Asian water buffalo skull and horns, shipping crate, 151 × 156 × 45 cm. Grant Museum of Zoology, UCL

This enormous water buffalo was exhibited in its shipping crate. On the crate, like on vintage suitcases, you can see where it has travelled by the different stamps.

49

Jean Painlevé, *L'Hippocampe (The Seahorse)*, 1934, 35mm transferred to DVD, 15 mins, black and white, French with English subtitles. Courtesy of Les Documents Cinématographiques, Paris

A beautiful, poetic film, showing pregnant male seahorses giving birth. The fairytale-like anthropomorphic style of the film is involuntarily and brutally conflicted by a scene depicting the dissection of a seahorse. In the exhibition it is screened without sound but with subtitles, which enhances the very strong imagery.

In this gallery we have three water-related video projections on the wall and floor. Directing the moving images to nearly all dimensions in a dimmed-light situation is one reason, amongst others, one gets an agravic sense while walking through the installation—it's like diving under water.

50

Jean Painlevé, *Les Amours de la pieuvre (The Love Life of the Octopus)*, 1965, 35mm transferred to DVD, 13 mins, colour, French with English subtitles. Courtesy of Les Documents Cinématographiques, Paris

Projecting this film on the floor mimics a puddle, but even more it puts the visitor in a position depicted in certain movies: showing Greek gods watching men succeeding or failing in life. The Painlevé film presents the octopus as a very mystical and fantastical animal, again with an anthropomorphic style, like the future or the past of mankind.

It reminds me of Vilém Flusser's book *Vampyroteuthis Infernalis*. Flusser describes this specific octopus perceiving and accessing the world in deep-sea darkness by swallowing and releasing it; the octopus's mouth and anus are one organ. Painlevé's film focuses on the love life of the octopus, showing the male using one of his identical arms to copulate. This reminded me of Foucault describing, in *Friendship: A Way of Life*, Adam being able to use his penis like his fingers, and losing control of his body when he was turned out of paradise.

51

Sir Hamo Thornycroft, *The Mower*, 1888–90, bronze, 58.5 × 33 × 18.5 cm. Tate: Presented by Arthur Grogan 1985

An idealised sculpture of an agricultural labourer. His pronounced bum cheeks and boyish snub nose are very reminiscent of imagery used in gay pornography. He seems to be watching the film *The Love Life of the Octopus* (see caption **50**).

52

Triangular metal rabies warning sign, on stand, from Ministry of Agriculture, Food and Fisheries, c.1985, 120 × 71 × 41 cm. Science Museum, London

I was always fascinated by the symptoms of rabies. It renders the infected creatures totally unpredictable. As children we were told that if a fox, rabbit, deer or any other wild animal approaches us in a friendly or any unusual way it is quite likely to be infected with rabies, and we should run away. But think about it, what is more beautiful for a child than having the boundaries between it and nature broken down.

In my song *Kranker Fuchs (Sick Fox*, 2004)—the fox is the main carrier of rabies in Germany—I describe mental techniques to use if you find yourself an inextricable part of an unacceptable situation. At the same time it represents a selection of options available for acting productively within such a situation.

53

David Shrigley, *Stop It*, 2007, acrylic on metal, 142.3 × 90 × 95 cm. Tate: Purchased 2008

A counter-piece to the rabies sign.

54

Kenneth Anger, *Eaux d'Artifice*, 1953, 16mm transferred to DVD, 13 mins, tinted black and white, sound. Conceived, directed and edited by Kenneth Anger, licensed by BFI

It was screened without sound in the exhibition.

55

Artificial paving-stone made from slag, 21st century, found object. Courtesy of the artist

These artificial paving stones are slightly radioactive as a result of production. Slag is a by-product of the steel industry. The current German Chancellor Angela Merkel (back when she was Minister for the Environment) said that using radioactive paving stones in public spaces is not a problem as people are not expected to stay long enough in one site to be exposed to critical levels of radioactivity. This tells us more about the concept of public space than about the effects of radioactivity on humans.

These paving stones are a secret weapon against homeless people and punks. It brings to mind the slogan from the May 1968 protests in France, accredited to the Situationist International: "Sous les pavés, la plage" (Under the paving stones is the beach). It is based on the fact that paving stones are usually

45c

Klaus Weber, *Tarmac Brain*, 2008, glass box, human brain model, tarmac, 19 × 22 × 15 cm

In combination with the floating carapace one step above it on the plinth, this object seems to suggest that tarmac, which divides our cities from nature, is the skull of human culture. Our streets are the symbolic armour that protects us from cultural death. But you could also read the heap of tarmac simply as a 'dumb' brain.

45d

Nine-banded armadillo skeleton and carapace in a glass case, 46 × 14 × 28 cm. This specimen came to the Grant Museum from the University of London Loan Collection in 1909-10. Grant Museum of Zoology, UCL

A great object: in a surreal way, it seems to visualise that the carapace is protecting the armadillo from death. The carapace was lifted. The posture of the head makes the armadillo seem surprised.

46

Klaus Weber, *Hiking sticks*, 2002-8, collected objects, dimensions variable

47a–c

The deflated fish is above the 'thinking coral', which is above the human bust on which words such as 'hope', 'calculation', 'imitation', 'language', 'time', 'agreeableness' and 'spirituality' are written. The labels and written words describe an additional and parallel text on top of the direct appearance of the objects.

47a

Triodon macropterus, three-toothed puffer fish taxidermy specimen (deflated), 42 × 52 × 16 cm. Donated to the Grant Museum from Imperial College London in the 1980s. Grant Museum of Zoology, UCL

47b

Diploria labyrinthiformis, grooved brain coral, height 36 cm, diameter 23 cm. Grant Museum of Zoology, UCL

47c

Phrenological bust by Lorenzo Fowler, from the British Phrenological Society, 1860-1900, 29 × 14.5 × 16 cm. Science Museum, London

Phrenology is a pseudoscience primarily focused on measurements of the human skull. It is based on the concept that the brain is the organ of the mind, and that certain brain areas have localised specific functions. Developed by German physician Franz Joseph Gall in 1796, the discipline was very popular in the 19th century. Moreover, phrenological thinking was influential on 19th-century psychiatry and modern neuroscience. Gall's assumption that character, thoughts and emotions are located in the brain is considered an important historical advance toward neuropsychology.

48a–d

Klaus Weber, *Untitled vitrine*, 2011, mixed media, 92 × 170 × 57.5 cm. Courtesy of the artist, Herald St, London and Andrew Kreps Gallery, New York

48a

Cut-out abdomen of anatomical model. When I took all the teaching organs out, it seemed a face was staring at me—an anthropomorphic mask—but concave, almost a negative.

48b

Negative mould of a death mask

48c

Positive plaster cast of a death mask. The person who was cast here is a Dutch man who escaped from a lunatic asylum on a bike and was hit by a car. The grandfather of a friend of mine, who was a sculptor, found him lying in the street and, fascinated by his face, took a cast of it.

48d

Grasshopper with human hair as feelers. The grasshopper was lying dead in front of my studio at the end of summer 2011, its legs crossed like arms or like insignia crossed on Tutankhamun's sarcophagus, keeping its vital green colour. I brought it inside and replaced the antennae with human hair, after they had fallen off. This insect is often associated with astral travel, but also with evil spirits and menaces: the film *Exorcist II* starts with an impressive flight of grasshoppers. Another cultural reference is *The Grasshopper and the Ant*, an Aesop fable concerning a grasshopper that has spent the warm months singing while the ant worked hard to store food for winter. When that season arrives, the grasshopper finds itself dying of hunger, and upon asking the ant for shelter and food is only rebuked for its idleness.

42

César, *Thumb*, 1965, polyester resin, 40.6 × 14 × 20.3 cm, Tate: Presented by the artist 1966

This oversized thumb is an entrance piece, a sort of show-stopper for Gallery 4. It's actually the thumb that marks the journey from the ape to civilised man. The opposable thumb has helped the human species develop more precise, fine motor skills. It is also thought to have directly led to the development of tools. Man's thumb ensured that important human functions such as writing were possible. Here the thumbs up is also a warning: 'everything is OK (so far)'. The outstretched arm, with the thumb pointing up (and one eye closed) is a simple method to measure and compare dimensions and proportions of objects. In the context of this exhibition, the scaling up and scaling down refers to altered states of mind. It appears on several occasions, for example in the bird cage, placed just behind the large thumb, but also in the *Witch's Ladder* in Gallery 3 and the *Large Dark Wind Chime* in the *If you leave me I'm not coming* exhibition.

43

Birdcage, from a ward at the Sussex Lunatic Asylum, Brighton County Borough Asylum, 1859–1939, 88 × 56.6 × 54.3cm. Vintage label reads, 'PARROT CAGE, Major Meek presented the female patients with four fine parrots.' Science Museum, London

A birdcage in a lunatic asylum, is a cage within a cage. A mirror in a mirror. But as it is empty, there might have been an escape like in Kafka's story *A Report for an Academy* (1917). The ape in this story escapes from his cage by mimicking human language and behaviour and finally becoming human. Because he mocked human attitudes, some sailors took him out of the cage and made him a mascot, but later he had a successful career in the academic world. The parrot is also able to mimic and repeat human language.

The parrot cage has a fascinating shape: it is somehow oversized, while having the proportions of a 'normal' one. Standing in front of this cage you feel you start to shrink, you alter, becoming a child, a parrot, a ghost in the evolutionary cell.

44

Sir Eduardo Paolozzi, *Plaster for 'Mr Cruikshank'*, 1950, plaster and pencil, 29 × 29 × 20 cm. Tate: Transferred from the Victoria and Albert Museum 1983

'Mr Cruikshank' is the name scientists at the Massachusetts Institute of Technology gave to a dummy that was made to measure radioactive penetration into man's brain. Paolozzi saw images in a newspaper article of the bust and copied it in plaster. In the exhibition, the segmented Mr Cruikshank is linked to the segmented ape in the background, and represents a typical human behaviour: gaining knowledge about things by cutting them open and destroying them. A fundamental mindset, as fundamental as lunatic asylums are for the development of societies which are constituted on an idea of the normal.

Plaster for 'Mr Cruikshank' is also linked to the artificial paving slab (see p.84), which is slightly radioactive.

45a–d

Klaus Weber, *Untitled (stairway plinth)*, 2011, mixed media, 165 × 225 × 45 cm. Courtesy of the artist, Herald St, London and Andrew Kreps Gallery, New York

45a

Rope hank for use in reconstruction of dissecting table, Europe, 1900–30, dimensions variable. Science Museum, London

When we found this object in the archive of the Science Museum, staff told us that it had been used to hang a man. We don't know why the official description says different, but the 'dissecting table' is as good in the context of the *stairway plinth* (see previous caption). Now the ambiguity is actually even better than the one-dimensional and horrific hangman's rope. The dissecting table for humans closes the circuit with the other taxidermy objects. It obviously echoes the sinuosity of the snake skeleton above it in the display, and feeds back on its mortality theme.

45b

Python sp., python skeleton, 44 × 63 × 23 cm. Grant Museum of Zoology, UCL

The snake, a symbol of lethal danger, is represented in a state that symbolises death: the skeleton. It is somehow a tautological object. The dust adds the rest. The theme of mortality is echoed several times in the object; the layers amplify each other. Its echo jumps over to the snakelike rope a step lower on the plinth.

33

Cristofano Allori (1577-1621), *Studies of a Young Man*, 16th/17th century, black chalk on paper, 39 × 28 cm. The Ashmolean Museum, Oxford. Presented by Sir Karl Parker, 1938

34–35

This sequence builds a very strong amalgam, so you get the feeling they have been made for each other. A large confrontation; density; institutional power. The correct response is bottled, synthetic adrenaline, exhibited on a plinth close to the paintings (see pp.70-2).

34

John Armstrong, *Tocsin III*, 1967, oil on canvas, 71.1 × 91.4 cm. Tate: Presented by the Trustees of the Chantrey Bequest 1968

35

Philip Guston, *Cornered*, 1971, oil on paper laid on board, 76.9 × 101.7 cm. Tate: Presented by the family of Frederick Elias in his memory through the American Federation of Arts 1987

36

After Andrea Andreani, *Emblematical Monument to Death*, 17th century, pen and brown ink with brown wash, heightened with white (partly oxidised) on paper, 49.4 × 34.3 cm. The Ashmolean Museum, Oxford. Bequethed by Francis Douce, 1834. Attributed to Emanuel de Critz

37

Bottle of local anaesthetic containing adrenaline, by Astra Pharmaceuticals Ltd., Kings Langley, Hertfordshire, United Kingdom, 1990-4, 6.3 × 3.2 cm. Science Museum, London

38

Sir George Howland Beaumont, title unknown, c.1800, pencil on paper, 15.7 × 13.1 cm. Tate: Purchased as part of the Oppé Collection with assistance from the National Lottery through the Heritage Lottery Fund 1996

A great and fancy, nearly comical drawing. I have been told it depicts an idiot.

39

Wiring test, England, 1930-40, 5 × 30 × 24 cm. Science Museum, London

"Vocational aptitude testing was used extensively during the first half of the 20th century to assess individuals' fitness for particular industrial jobs. This wiring aptitude test consists of a wooden board with 36 holes for dowels, 15 numbered raised staples, two metal 'eyes', seven raised screws and three coloured lengths of string. The aim was to thread the coloured string through hoops and pegs. Complex instructions stated the strings were not allowed to cross the black line or 'share' a hoop. The test was used at the National Institute of Industrial Psychology (NIIP). The typed instructions are marked 'Mather and Platt limited'. This probably refers to the Lancashire-based textile and engineering manufacturer who may have used this test on potential employees." Science Museum website, Wiring aptitude test, England, 1930-40, retrieved 20 July 2012, www.sciencemuseum.org.uk

This 'idiot' test reminded me very much of an early Sigmar Polke piece. In this context it responds directly to the drawing by Sir George Howland Beaumont (see p.74).

40

Sigmar Polke, *Figure with Hand (I Am Made Dizzy by a Carpet of Rose-Petals…)*, 1973, lithograph on paper, 43.2 × 20.3 cm. Tate: Purchased 1988

41

Klaus Weber, *Elisabeth in folds*, 1245/2011, original cast from medieval sculpture, plaster, shipping blankets, 190.5 × 76 × 69 cm. Courtesy of the artist, Herald St, London and Andrew Kreps Gallery, New York

The original medieval sculpture was placed at the gate of Bamberg Cathedral, Germany. The depicted figure is Saint Elisabeth, mother of John the Baptist, although she looks like an old man. The dress of medieval saint sculptures was made with many folds, so deep and numerous that anatomically it wouldn't make sense. The figures are sort of bodyless. This points to a metaphysical element.

This photo by Nan Goldin is very painterly; it works perfectly with the atmosphere and colours in the painting by Balthus. Look at the similar arm gestures of the sleeping girl, the reading poet and Greer. Greer and Robert seem to have just taken some heavy narcotics. The animal masks in the background start to build a grand connection to the animal appearances in Gallery 4 and the collection of masks in *If you leave me I'm not coming*. This is the first time that the photograph has been loaned by the Tate.

26

Louis Anquetin, *Girl Reading a Newspaper*, 1890, pastel on paper, 54 × 43.2 cm. Tate: Presented by Francis Howard 1922

What is the light cloud above the woman reading? Is it the mind of the reading person, like ghosts accidentally caught on amateur photos?

27

Paul Nesbitt, *Untitled (Aimée and Bill)*, 2006, 42 × 30 cm

This is a great photograph showing exhibition staff at Inverleith House taking down the William Eggleston show. It looks like the woman on the Eggleston image is taking herself down. A cyclical situation and I thought it would make a great meta comment on *Already there!* itself. A comment on the making of a show and the anticipation of its end during installation. It's also a play on the idea that the objects have a life of their own: autonomous objects that chose the curator, and now they even take themselves down at the end of the show. The photo mirrors Maya Deren's film, physically in space and structurally as a drawn out performance.

28

Klaus Weber after Luis Camnitzer, *This is a mirror you are a written sentence (1966-1968)*, 2011, painted metal plate, 50 × 60 cm. Courtesy of Luis Camnitzer and the Daros Latinamerica Collection

This is a cover version of Camnitzer's early hit, with minor variation. Luis Camnitzer used vacuum-formed polystyrene letters mounted on a synthetic board, I guess a sort of announcement board where you can alter the text. The cover version was made by a company that manufactures licence plates and traffic signs. It was a joy for me to send the company the sentence, asking them to print it on a plate.

29

Richard Wentworth, *Yellow Eight*, 1985, galvanised steel and brass, 32.3 × 58.5 × 34 cm. Tate: Presented by Charles Saatchi 1992

This piece actually came to us by mistake. The Tate placed it on the loan list by accident. What a nice accident, it has created a great link between the antique vessels, the ivory anatomical couple and the Camnitzer piece. Also it worked like a rubber band to connect the two large table plinths.

30

Maya Deren, *Meshes of the Afternoon*, 1943, 16 mm transferred to HD video, 15 mins, black and white, with sound. Courtesy of LUX, London

A great surreal and psychological film by Maya Deren, in which household objects play an important and magical role. It builds, in the mix with the sound of *The March of the Big White Barbarians*, the animist sound-background for Gallery 3. The original film had no score, which makes sense. The spherical, experimental soundtrack influenced by Japanese music was added 16 years later. So now, 68 years later, it was given a new score which was extended to be the soundtrack for the wider surreal scenery in the whole exhibition space. The film has a cyclical structure and a hallucinogenic appeal. It was shot with her psychiatrist father's 16 mm camera. One gets the feeling the psychiatrist's camera shot the film itself. The cloaked figure that appears in the movie is mirrored by the cloaked sculpture *Elisabeth in folds* (see p.77), which stands at the entrance to Gallery 3. The motif of the open hand, offering a key that suddenly turns into a knife, is echoed in the robber's hand showing coins in the painting next to the video projection (see pp.64-5).

31

Sir William Allan, *Tartar Robbers Dividing Spoil*, 1817, oil on mahogany, 64.1 × 52.1 cm. Tate: Presented by Robert Vernon 1847

I thought at this point it would be time to sit down and do as the Tartars and see what we have got, being halfway through the show.

32

André Breton, *I Saluted at Six Paces Commandant Lefebvre des Noëttes (Poem Object)*, 1942, mixed media collage on paper, 34 × 26.7 cm. Tate: Purchased 1983

18

Louise Bourgeois, *From Topiary: The Art of Improving Nature, Tree with Woman*, 1998, etching on paper, 76 × 55.3 cm. Tate: Purchased 2002

What a great title, reminds me of grafting.

19

Clive Barker, *Zip I*, 1965, screen print on paper, 76.2 × 49.5 cm. Tate: Presented by Rose and Chris Prater through the Institute of Contemporary Prints 1975

20

Amphorae from ancient Palestine (Tell Fara Tomb and Tell el-'Ajjul Tomb), c.2000–700 BC, in modern plastic buckets, dimensions variable. Institute of Archaeology, University College, London

This is how the very fragile antique amphorae are stored in the archive of the Institute of Archaeology in London. I thought it would be intriguing to present them in exactly the same way I saw them in the basement of the Institute. The amphorae once performed the job of plastic buckets: a mass-produced object to carry and store liquids. By simply displaying the backstage of the museum or displacing it into the exhibition, the container in the container gets demystified to reveal something about itself and value in general. It also tells us a lot about museum display and handling: for obvious reasons this is a pragmatic way to store and display the amphorae.

21a–b

The bent arm of the two antomical figures anticipates sequence **23–25** (see pp.55–9) with Balthus, Nan Golding and Gertrude Hermes.

21a

Ivory anatomical figure male, with some removable organs, lying on cloth-covered bier in a wooden box, probably Italian, 17th–18th century, 22.7 × 7 × 4.7 cm. Science Museum, London

21b

Ivory anatomical figure, a pregnant female with some removable organs in elaborate wood, glass and metal box, lead seal tied around neck of figure, 17th–18th century, 24.2 × 8.5 × 9.5 cm. Science Museum, London

22

Custom-built iron lung consisting of wooden chamber fixed to iron bedstead, and ventilated by means of hand-cranked leather forge bellows mounted on top, Cardiff, Wales, 1941–50, 165 × 104 × 198 cm. Science Museum, London

I was told by staff at the Science Museum that this was built by a son for his father. The father remained lying in the wooden box—a mixture of bed and coffin. It must have been extremely energy consuming to make this huge artificial lung work. When the son had a breather, the father would stop breathing: an inverse-Oedipus machine.

23–28

The sequence **23–28** is about physical volatility, thought and language mise en scène by the leitmotif of an angulated female arm. The ensemble has as its starting point the sculpture of Kathleen Raine reading, and from there can be read to the left to the Luis Camnitzer piece or to the right to Balthus.

23

Gertrude Hermes, *Kathleen Raine*, 1954, bronze, 50.8 × 49.5 × 33 cm. Tate: Presented by Miss Kay M. Murphy 1959

It's a great formal idea using the arms as the stand for the upper body; the rest of the body exists only in the mind. Gertrude Hermes wrote about the sittings with poet Kathleen Raine (12 April 1959):

"It was spread over a period of two months perhaps and she came in once or twice a week. Living just along the road it was fairly easy, and that is the way I saw her working in her own room, through the window from the street, so I asked her if she could transport herself into my studio sometimes and go on with her work—which she did. It was very enjoyable for me." Published in: Mary Chamot, Denis Farr and Martin Butlin, *The Modern British Paintings, Drawings and Sculpture*, London 1964.

24

Balthus, *Sleeping Girl*, 1943, oil on board, 79.7 × 98.4 cm. Tate: Presented by the Friends of the Tate Gallery 1959

25

Nan Goldin, *Greer and Robert on the bed, NYC*, 1982, photograph on paper, 69.5 × 101.5 cm. Tate: Purchased 1997

11

Plaster objects mixed with a ceramic object (date and origin unknown), dimensions variable. Institute of Archaeology, University College London

12a

Kurt Schwitters, *Painted Stone*, 1945–7, paint on stone, 3.5 × 8 × 31.3 cm. Lent by Geoff Thomas 1991. Tate: Purchased 2008

12b

Olduvai Gorge lithics, Lower Palaeolithic Era, 1,600,000–800,000 BC, dimensions variable. Institute of Archaeology, University College, London

12c

Collection of stone axe heads from Scandinavia Late Neolithic Era, 7,000–1,700 BC, dimensions variable. Institute of Archaeology, University College, London

12d

Collection of ceramic lamps from Egypt and other locations in the Roman Empire, dimensions variable. Institute of Archaeology, University College, London

13a–f

Here we have a sequence of 'same same but different'. Some things are on the plinth because they look like tobacco pipes, while others are there, or more precisely under it, because they share the name 'pipe'.

13a

Collection of earthenware and chemical retorts, Europe, 1801–1930, dimensions variable. Science Museum, London

13b

Found clay public underground water pipe, 21st century, 73 × 28 × 28 cm. Courtesy of Klaus Weber

13c

Collection of glass flasks, European, 19th century, dimensions variable. Science Museum, London

13d

Collection of pipe cases with coloured velvet lining for meerschaum pipes, Europe, 1850–1920, dimensions variable. Science Museum, London

13e

Collection of clay tobacco pipes, English, 1615–1790, dimensions variable. Science Museum, London

13f

Pewter tobacco pipe, novelty piece, double-loop or coiled stem, modelled on clay pipe of mid-19th century, English, 1840–90, dimensions variable. Science Museum, London

14

George Fullard, *Infant with Flower*, 1958, cast 1960, bronze, 76.2 × 41.9 × 38.1 cm. Tate: Presented by the Trustees of the Chantrey Bequest 1981

15

Lucio Auri, *6.26am, 31.08, Leidesgracht, Amsterdam*, 2010, mixed media. Courtesy of Lucio Auri

The title names the exact time and place where the artist has witnessed this particular scene.

16

Klaus Weber, *Witch's Ladder*, 2011, found rope, collected feathers, dimensions variable. Courtesy of the artist, Herald St, London and Andrew Kreps Gallery, New York

The *Witch's Ladder* is the centrepiece of *Already there!* and makes a counterpart and connection to the *Large Dark Wind Chime* in *If you leave me I'm not coming*. The ladder is an oversized version of a 'historical' witch's tool (see p.47), supposedly hung secretly in the attic of houses to introduce and release bad spirits. Here it brings in some anti-Christian, anti-Western and anti-scientific culture vibes, to help open out the reading of this part of the show: the ladder functions like a lightning rod; it's a catalyst. It is sort of the reverse object to the well known dreamcatcher that is supposed to catch bad dreams and dispose of them. The witch's ladder stands for confronting problems instead of soothing them, like sleeping pills, 'good' books or dreamcatchers do.

17

Philip Guston, *Curtain*, 1980, lithograph on paper, 79 × 103 cm. Tate: Presented by the American Fund for the Tate Gallery, courtesy of a private collector 1996

5

Henri Michaux, *Untitled, Chinese ink drawing*, 1961, ink on paper, 74.6 × 109.9 cm. Tate: Purchased 1963

Michaux was a poet and a painter. His drawings are calligraphic in character, often suggesting indecipherable writing. He experimented with working under the influence of the drug mescaline. The early results were obsessively detailed, while the ink drawings show an intense repetition of slashing marks. Below is my paraphrased version of an art critic's opening speech at one of Michaux's exhibitions:

"Michaux is an artist of contradictions and from contradiction. A painter who makes Tachist paintings but does not love Tachism. One who writes and doubts the words, their soundness and reach. One who seeks out the zone of the subconscious and yet mistrusts its fantasy. One who consumes herbal drugs and yet does not believe in narcotics. Perhaps we ought to connect these assertions not by means of an 'and' and prefer to say 'because' instead: Michaux paints because he does not love the stains. He writes because he doubts the words. He entrusts himself to the subconscious because he is not a fantasist. He consumes the drug because he is not under its spell."

The way the critic was describing the escapist methodology is great, and although I was never a fan of the visual outcome of Michaux's experiments, I can very much identify with the description of how and why they get created, and it echoes the way this exhibition was produced.

6

William Hogarth, *Four Prints of an Election, plate 4: Chairing the Members*, 1758, etching and engraving on paper, 40.3 × 54 cm. Tate: Transferred from the reference collection 1973

This plate depicts the victory procession that was undertaken for new members of Parliament. You can also see pigs and an ape riding a bear in the picture, echoing my photographic print *Ape on Pig* (see p.131), which is part of the installation *Shape of the Ape*.

7

Klaus Weber, *Doppelkaktus*, 2006/8, two grafted San Pedro cacti, blued iron, mirror, 30 × 75 × 115 cm Courtesy of the artist, Herald St, London and Andrew Kreps Gallery, New York

Grafting is a standard procedure in cactus cultivation. You combine two qualities of two different cactuses into one, a sort of refinement. Normally there is a robust base cactus with roots and you graft another one on its top. In the case of the *Doppelkaktus*, there are

two cactuses of the same species grafted together—to make one entity with two pots. Somehow this cactus has two beginnings but no end. The San Pedro cactus naturally contains mescaline.

8

Mark Leckey, *The March of the Big White Barbarians*, 2005, video, 5 mins, colour, sound. Courtesy of Mark Leckey and LUX, London

The video consists of a ritualised call-and-response between musicians and static public sculptures in London. Some main repetitive phrases which stand out in the song are: "Classical, classical, classical (Rock) … Bye Bye leader! Take him away, take him away". This functioned like a meta-comment in Gallery 3 of the exhibition. Leckey's video and Maya Deren's film were programmed to be played loudly, in fragments, through speakers; to build an acoustic mix, a background sound for the show, a driving rhythm, an incantation; to pour acoustic oil onto the visual fire.

9

Reg Butler, *Working Model for 'The Unknown Political Prisoner'*, 1955-6, forged and painted steel, bronze and plaster, 223.8 × 87.9 × 85.4 cm. Tate: Presented by Cortina and Creon Butler, 1979

Butler won an international competition in London in 1953 for a public monument. The project was dropped after it caused strong controversies, including a physical attack on the working model. Ernst Reuter and Hans Scharoun made another attempt to build the monument in the late 1950s, in Humboldthain Park in the Wedding district of Berlin. It was to be built from the remains of two huge reinforced-concrete bunkers which were used as flak towers during World War II. It was a good idea, but also did not happen. Since the monument wasn't realised, the towers have been covered with rubble from bombed Berlin and planted over with grass and trees. On New Year's Eve it is a favourite place to watch the sometimes quite martial fireworks over Berlin, which you can never watch without thinking about the war. I have always found the controversies surrounding the monument of Reg Butler much more intriguing than the sculpture. So I see it as a successfully realised piece.

10

Paul Neagu, *Ceramic Skull*, 1973, ceramic and glaze, 23.5 × 18 × 20.5 cm. Tate: Purchased 2000

If this sculpture had not been available for the show, I would have produced a skull constructed from sugar cubes to replace it.

EXPANDED LIST OF WORKS

GALLERY 3

Klaus Weber

1–7

This first sequence of works is 'sewn' together; it is a sequence that moves forward, but here and there goes back to pick up threads, stitching a tight and dense fabric. It's a form of preface for this group show. After being warned of the fire by Enrico Baj's creature, you come to an infernal ink drawing from 1609, showing *The Punishment of the Prideful* where the ignorant get dispatched to hell by a winged demon. This is followed by another ink drawing, where the wing shape is echoed (but upside down) in a framed Rorschach ink-blot test, traditionally used in psychiatry to test associative recognition.

Next, an image of a chaotic, violent urban scene, also from the psychiatrist's toolbox, and used to examine your visual memory. Then another black-ink drawing, by Henri Michaux, who was known to make experimental drawings under the influence of the hallucinogenic drug mescaline.

Michaux's Tachist drawing is connected to the ink stain which creates the Rorschach—the term Tachism is derived from the French word *tache*, meaning stain. This is followed by another chaotic urban scene, this time a print from the 18th century by William Hogarth. Under this print sit two San Pedro cactuses (a species which contains mescaline) grafted together. The way they are grafted creates a mirror image of the plant, and links to the Rorschach test, an ink blot folded to form a symmetrical pattern.

Looking at the last three images in a row—the eidetic image, Michaux's Tachist drawing and the Hogarth print—gives a sense that, besides their contextual connections, they are also formally interconnected. You get the feeling that the structural dynamic of single compositions spill over from one image to the other: in the eidetic image, the movement of the wagon echoed in the falling suitcase and the swinging umbrella, continues in the surging ink patterns of Michaux, which then seem to be answered by a counter-wave of violence in Hogarth's print, which surges to the left to keep it all together—like an ebb and flow.

1

Enrico Baj, *Fire! Fire!*, 1963–4, oil and Meccano on tapestry, 128.6 × 97.2 cm. Tate: Presented by Avvocato Paride Accetti 1973

When you enter *Already there!* you are instantly welcomed by a shouted warning from a wild creature, which seems to be stepping out of a forest as it emerges from a floral tapestry design. This is the first sign in the exhibition that everyday objects come alive and start to communicate with you and each other. It is hard to believe it was the first time this awesome work (like many others in the exhibition), was loaned by Tate.

2

Federico Zuccaro, *The Punishment of the Prideful*, 1609, pen and brown ink with grey and pink watercolour washes on paper, 14.6 × 25.4 cm. The Ashmolean Museum, Oxford. Bequeathed by Francis Douce, 1834

3

Card II from Behn-Rorschach test material made by Verlag Hans Huber Bern, Switzerland, 1941, 24.5 × 17.1 cm. Science Museum, London

The Rorschach test is a psychological test in which subjects' perceptions of ink blots are recorded and then analysed using psychological interpretation. Some psychologists use this test to examine a person's personality characteristics and emotional function. It has been employed to detect underlying thought disorders, especially in cases where patients are reluctant to describe their thought processes openly. The test is named after its creator, Swiss psychologist Hermann Rorschach (1884–1922).

4

E. R. Jaensch's picture for eidetic imagery, no maker listed, 38 × 30.4 cm. Science Museum, London

Eidetic imagery (commonly referred to as photographic memory) is a medical term, popularly defined as the ability to recall images, sounds or objects in memory with extreme precision and in abundant volume. The word eidetic comes from the Greek *eidos*, meaning 'seen'. Eidetic images are subjective visual phenomena which assume a perceptual character and which resemble negative or positive after-images in that they are 'seen' in the literal sense of the word. The individual who possesses the ability to see eidetic images, i.e. images of hallucinatory clarity, is in general a so-called normal and healthy person.

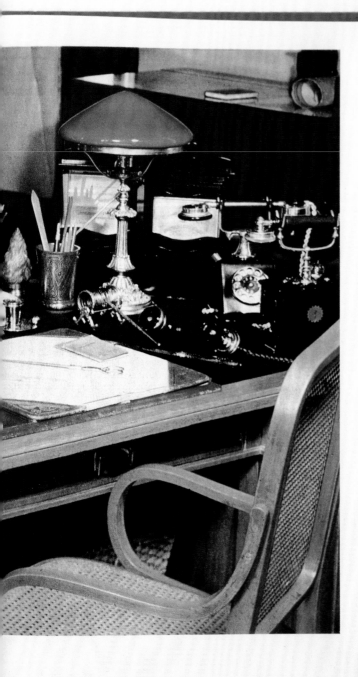

Кабинет В. И. Ленина　　Lenin's Study　　　　35

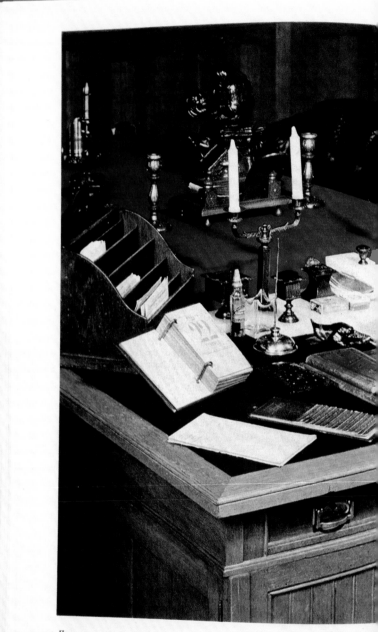

Письменный стол В. И. Ленина
Lenin's desk

OFFICE OF THE SOCIETY,

NO. 141 MONTAGUE STREET.

HENRY R. JONES, President. ALEXANDER MUNN, Secretary. GEORGE L. PEASE, Treasurer.
ROBERT J. WILKIN, Superintendent.

Brooklyn, N.Y., April. 7th. 1891 18

Darwin W. Esmond. Esq.

 Secretary etc.

Newburgh, N.Y.

 My dear Sir:

 I beg herewith to inform you that this Society has
prevented the children advertised in connection with the "Reilly
& Wood's New Classic Vaudeville Co." from appearing in this City
as "Joco and Coco", and in the Royal Xylophonists,- viz:

 Charles Wincott, 15 years old, as "Coco", the human monkey,and

 Jennie Wincott, 13 years old, xylophone performer.

 This notice is sent in accordance with resolution adopted
by the convention of delegates from societies held at Albany,
October, 1st. 1890.

 Sincerely yours.

 Robert J Wilkin

 Supt. etc.

63f

Coco letter, 2007

63e

American business leaders, 2007

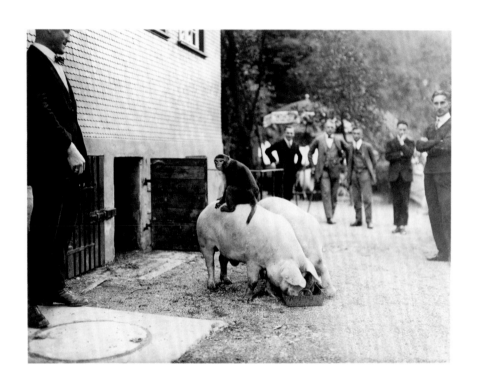

63d

Ape on Pig, 2007

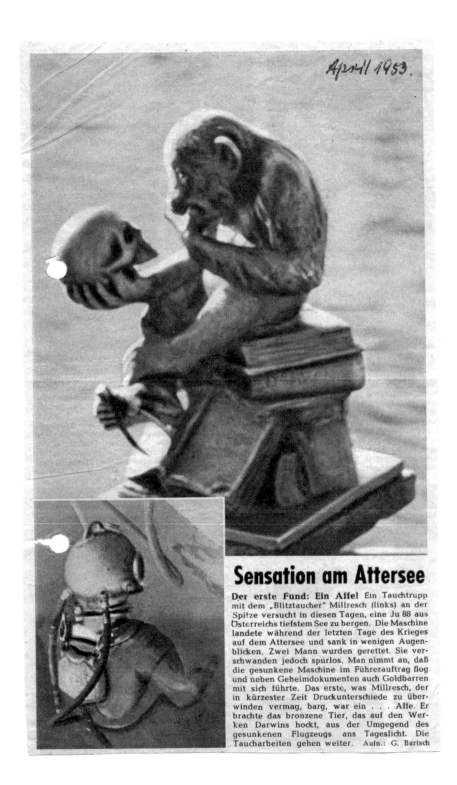

April 1953.

Sensation am Attersee

Der erste Fund: Ein Affe! Ein Tauchtrupp mit dem „Blitztaucher" Millresch (links) an der Spitze versucht in diesen Tagen, eine Ju 88 aus Österreichs tiefstem See zu bergen. Die Maschine landete während der letzten Tage des Krieges auf dem Attersee und sank in wenigen Augenblicken. Zwei Mann wurden gerettet. Sie verschwanden jedoch spurlos. Man nimmt an, daß die gesunkene Maschine im Führerauftrag flog und neben Geheimdokumenten auch Goldbarren mit sich führte. Das erste, was Millresch, der in kürzester Zeit Druckunterschiede zu überwinden vermag, barg, war ein . . . Affe. Er brachte das bronzene Tier, das auf den Werken Darwins hockt, aus der Umgegend des gesunkenen Flugzeugs ans Tageslicht. Die Taucharbeiten gehen weiter. Aufn.: G. Bartsch

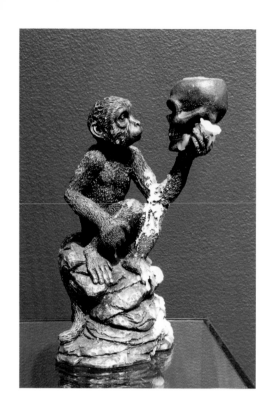

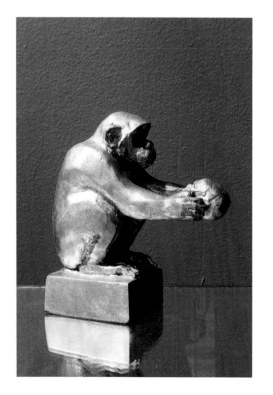

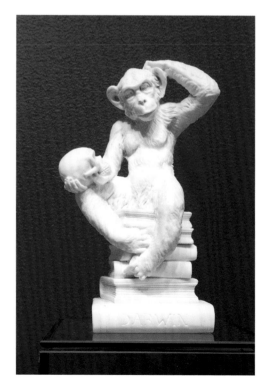

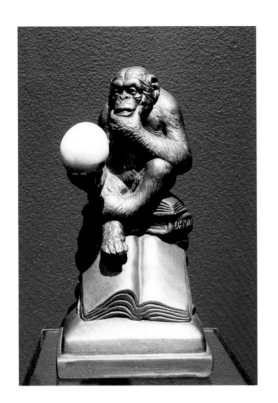

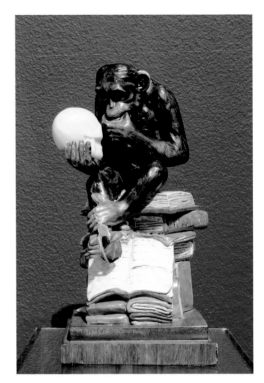

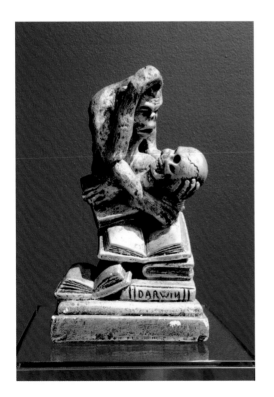

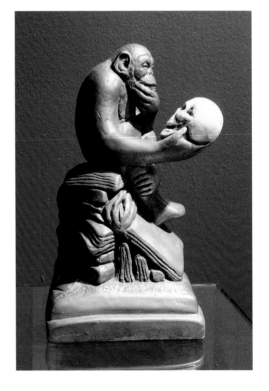

63b
Collection of vintage figurines (selection), dates unknown

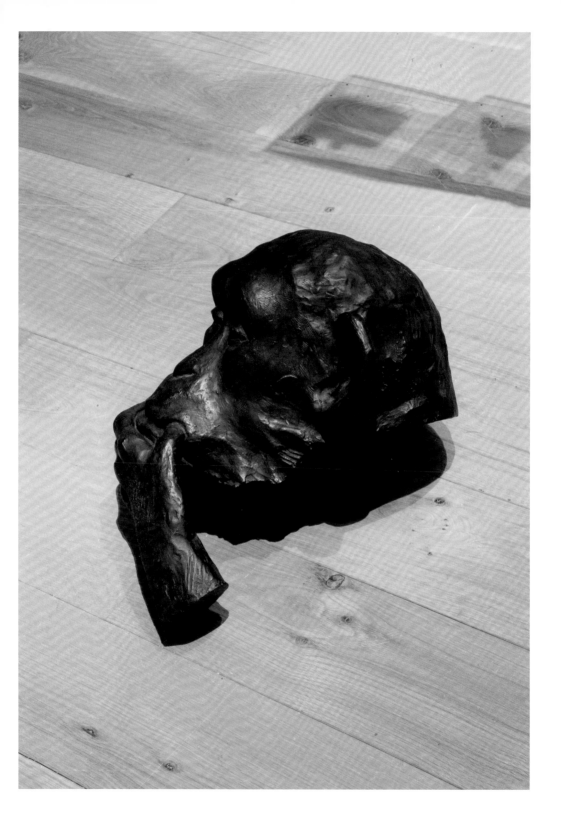

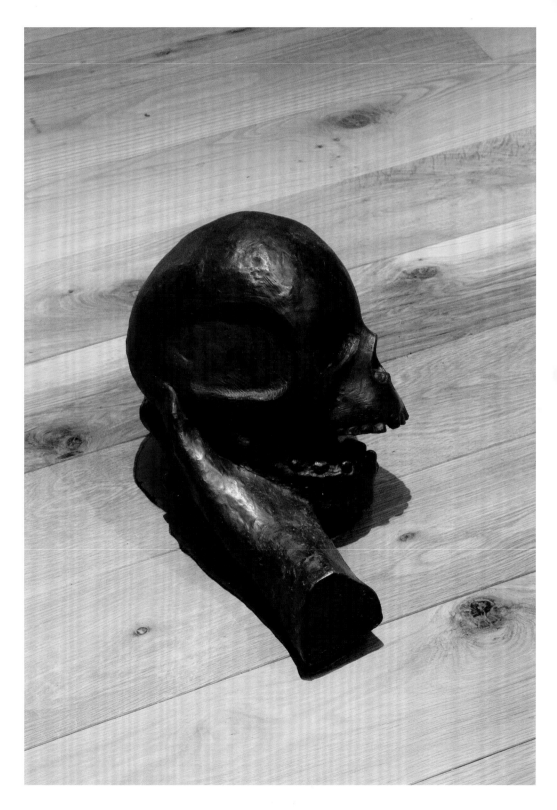

63a

Puzzled Ape (details), 2007

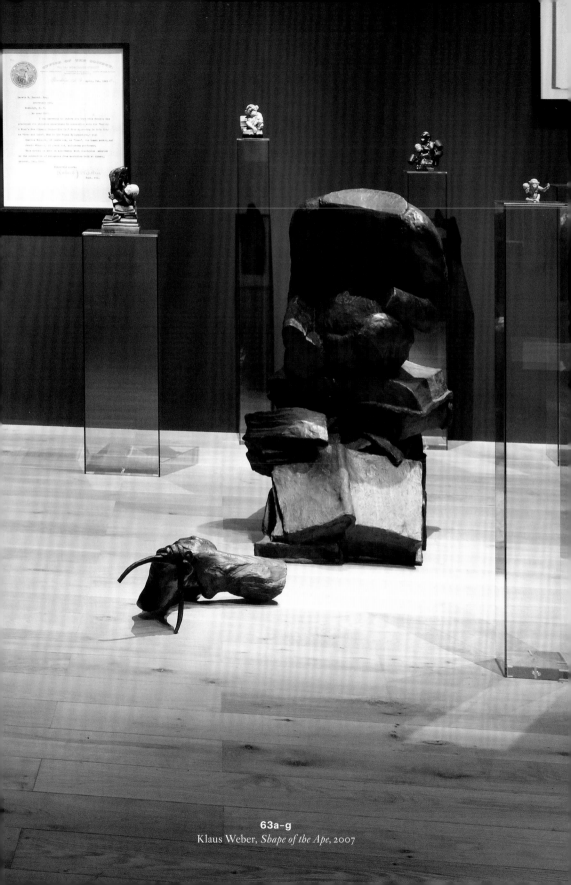

63a–g
Klaus Weber, *Shape of the Ape*, 2007

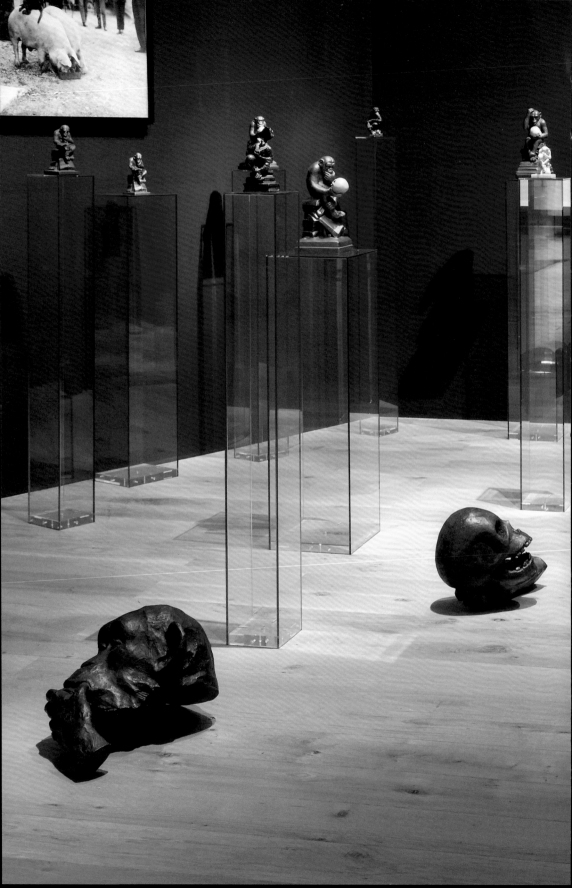

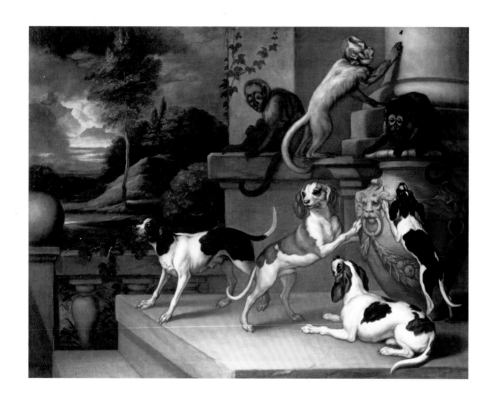

62

Francis Barlow, *Monkeys and Dogs Playing*, 1661

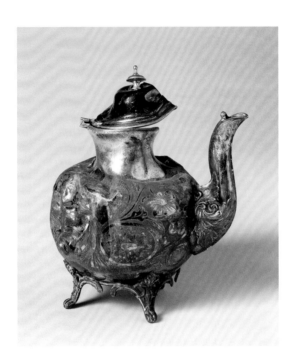

61
Cornelia Parker, *Object That Fell off the White Cliffs of Dover*, 1992

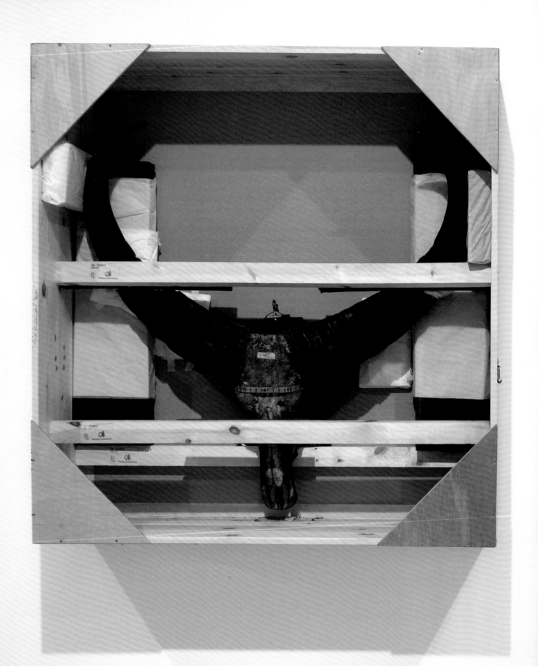

60
Bubalus bubalis arnee, wild Asian water buffalo skull and horns,
shipping crate, date unknown

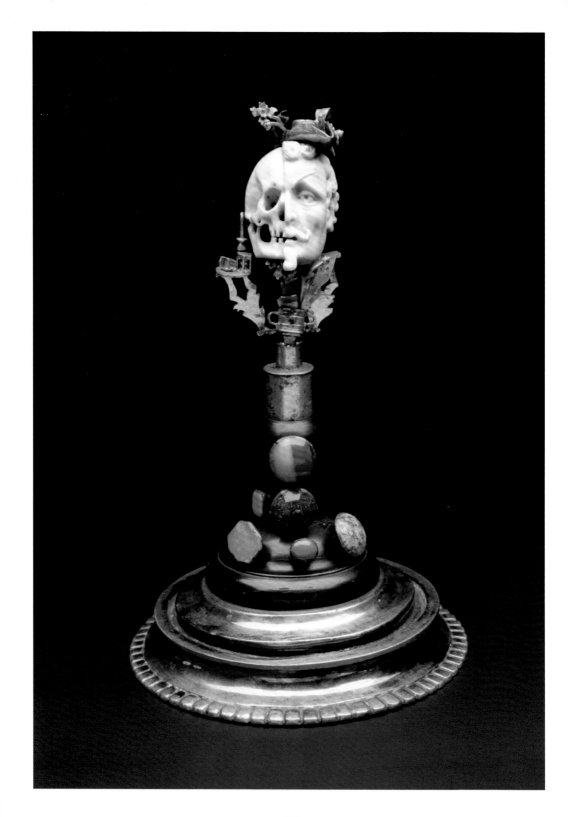

59f

Ivory bust of General Wallenstein, after 1634

59e
Unknown Anthropomorphic figurine, Bronze Age:
Akkadian to Babylonian Period terracotta

59d
Animal figure, standing upright, Bronze Age:
Akkadian to Babylonian Period terracotta

59a
Cast of skull of Piltdown man, made by
R. F. Damon and Co., 45, 1939

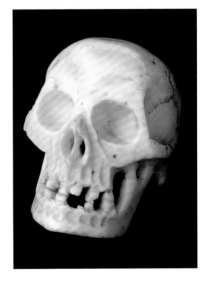

59c
Marble skull, date unknown

59b
Plaster copy of the skull of Johann Sebastian Bach
(1685-1750), Germany, 1900-27

115

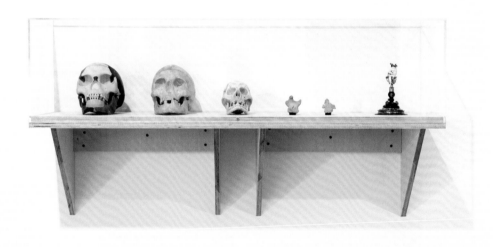

58
Coloured wax models of a gentleman and a lady, half skeletal,
half living and dressed in Regency clothes, English, 1810–50

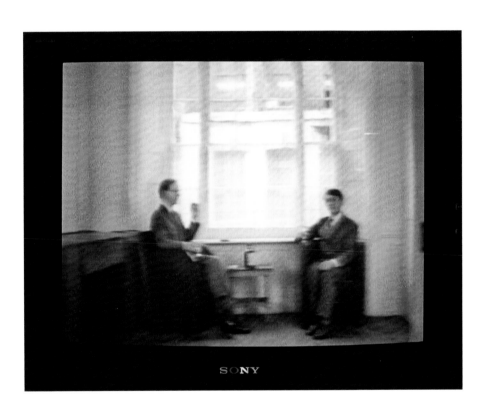

57
Gilbert & George, *Gordon's Makes Us Drunk*, 1972

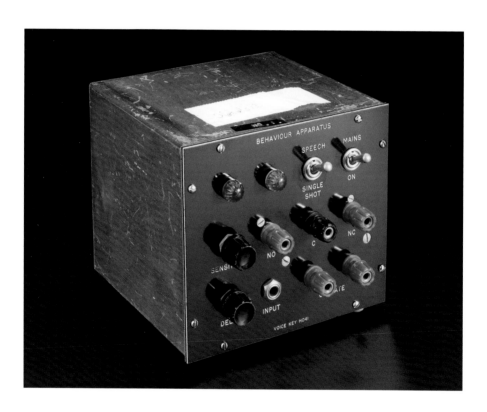

56

Voice key H041, electrical unit made by Behaviour Apparatus Ltd., 1950-75

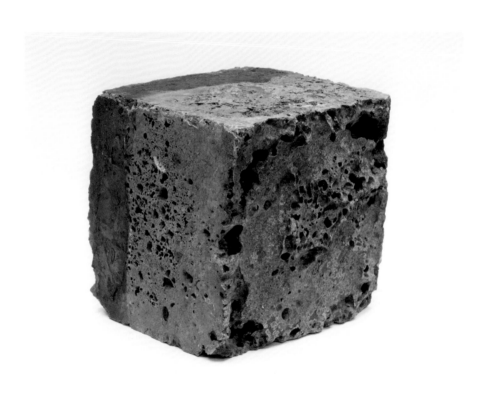

55
Artificial paving stone, made from slag, 21st century

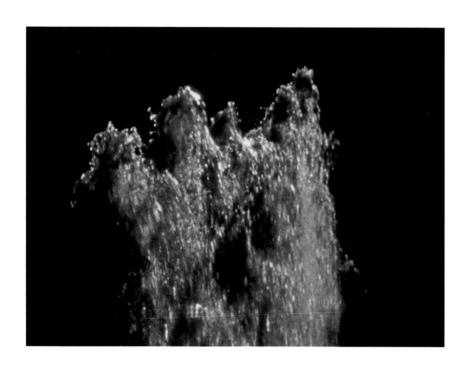

54
Kenneth Anger, *Eaux d'Artifice*, 1953

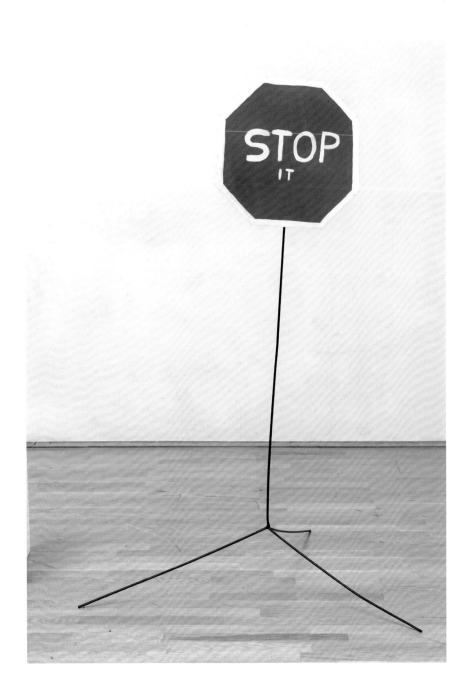

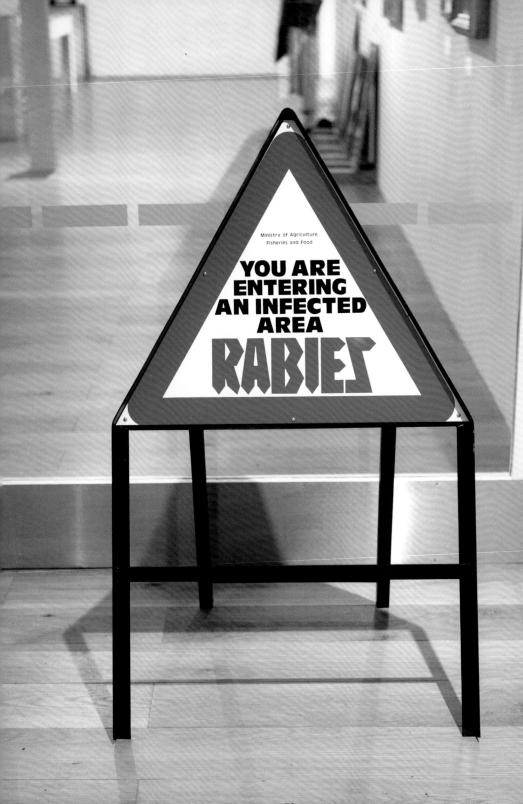

52
Triangular metal rabies warning sign, on stand,
from Ministry of Agriculture, Food and Fisheries, c.1985

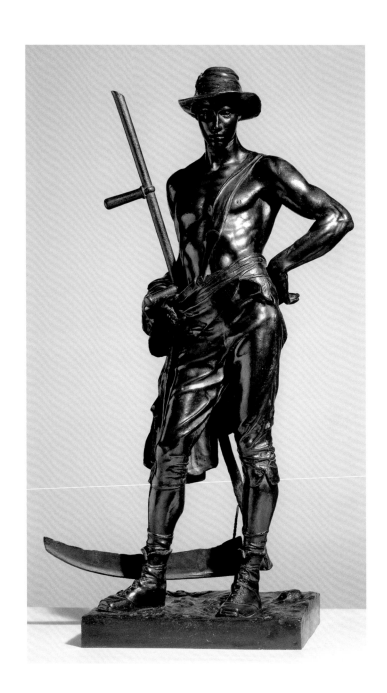

51

Sir Hamo Thornycroft, *The Mower*, 1888–90

49
Jean Painlevé, *L'Hippocampe (The Seahorse)*, 1934

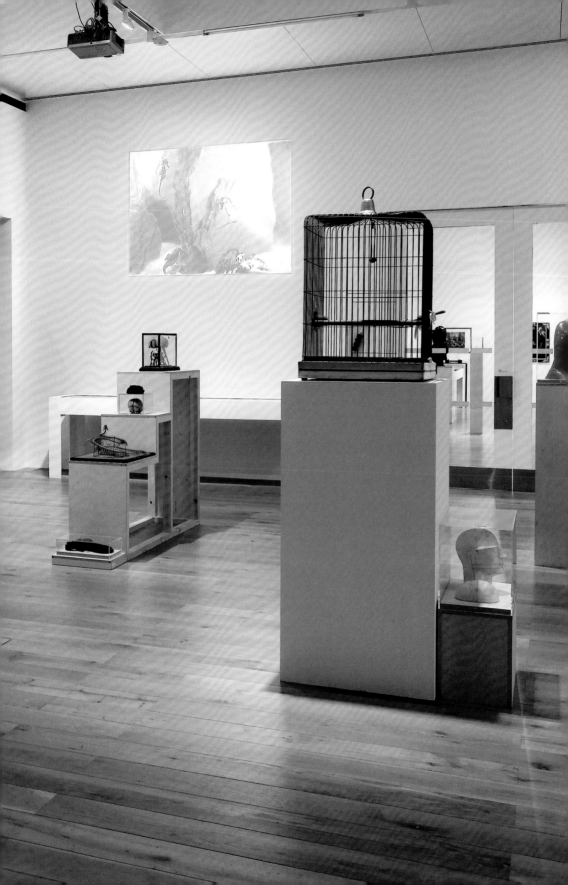

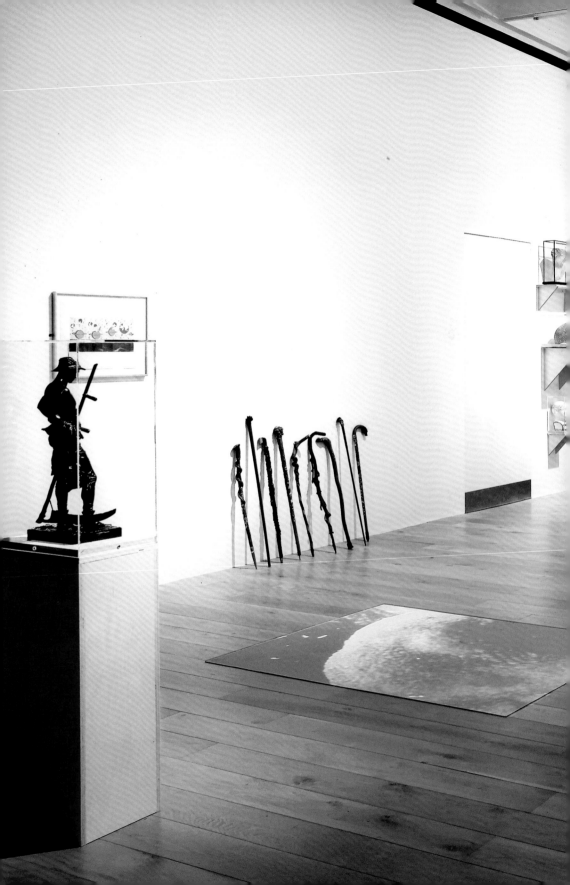

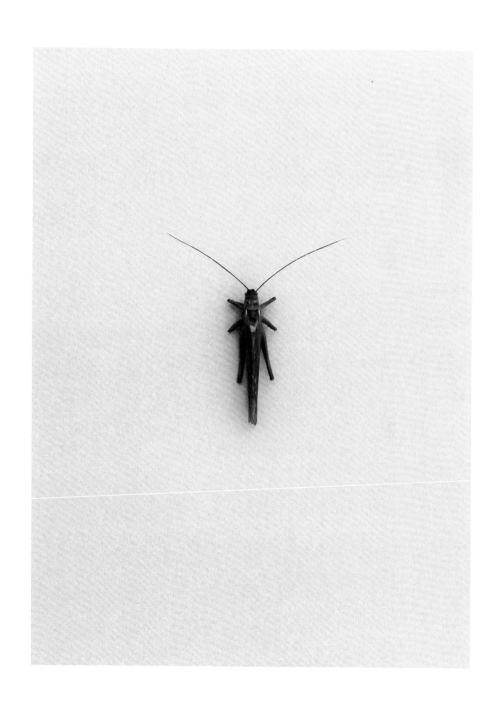

48d
Grasshopper with human hair as feelers

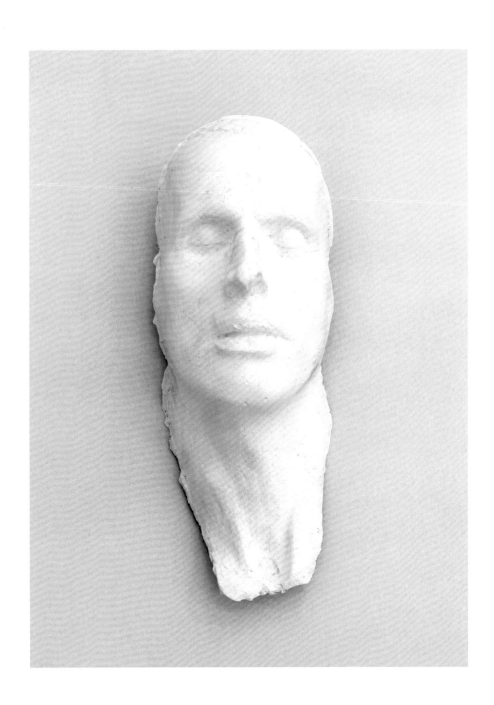

48c
Positive cast of a death mask

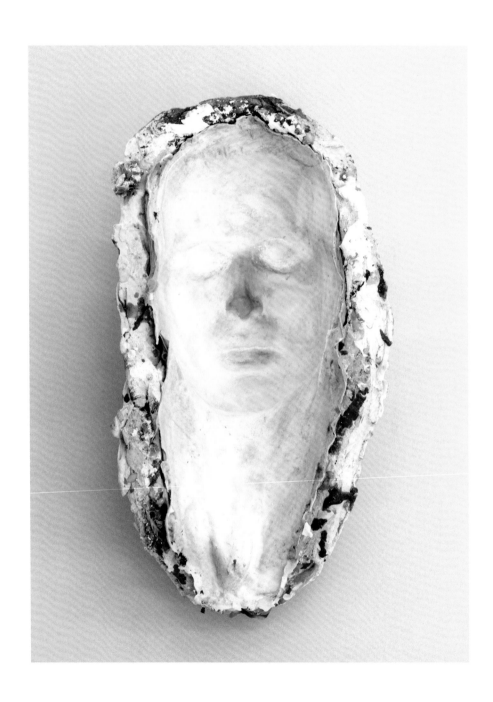

48b

Negative mould of a death mask

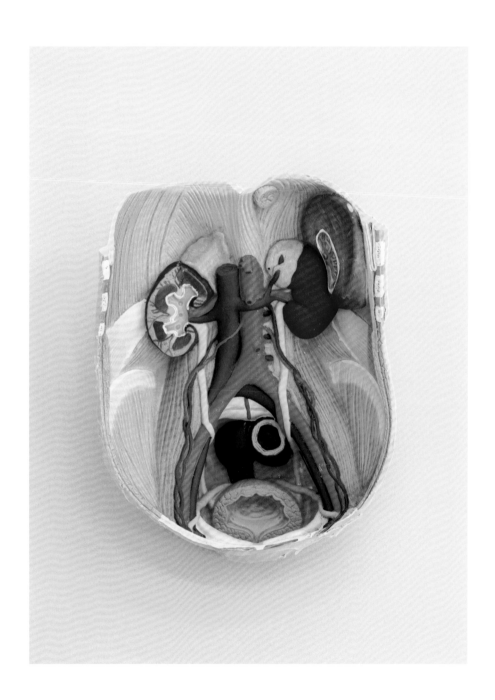

48a
Cut-out abdomen of an anatomical model

48a–d
Klaus Weber, *Untitled vitrine*, 2011

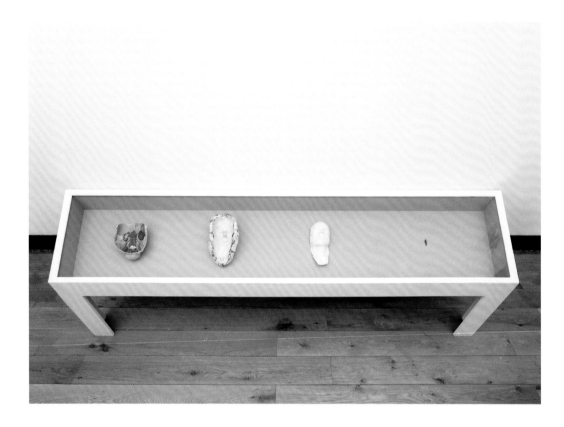

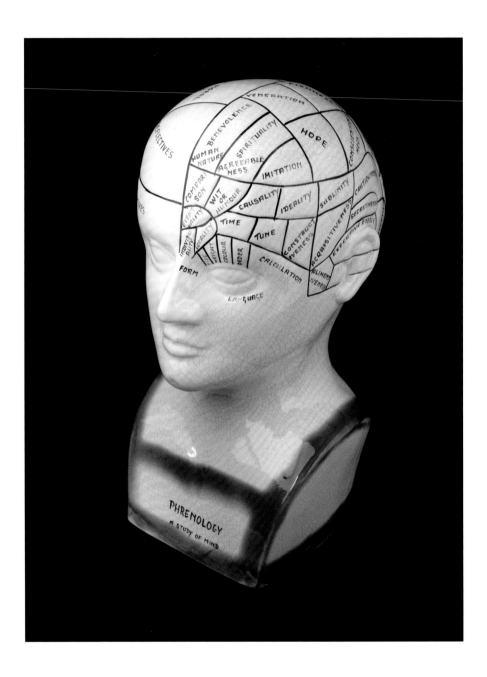

47c
Phrenological bust by Lorenzo Fowler, 1860-1900

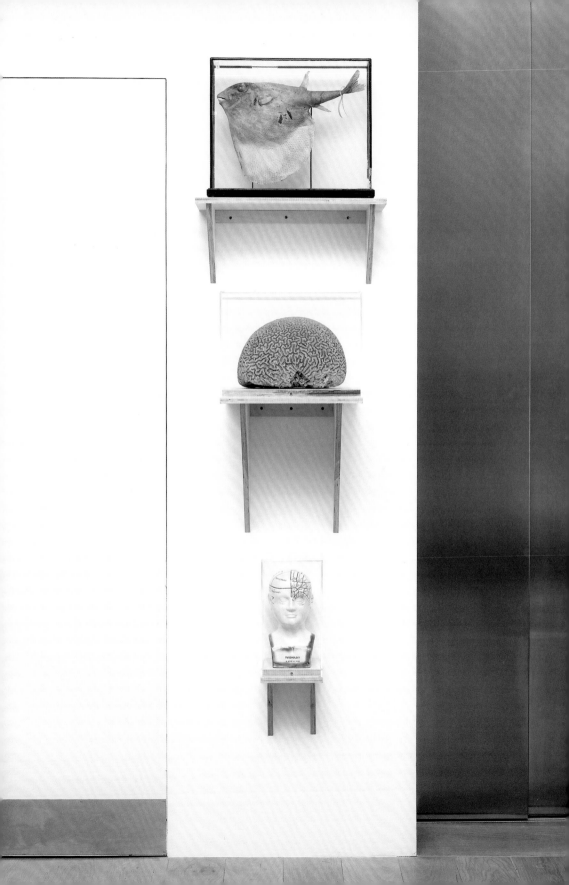

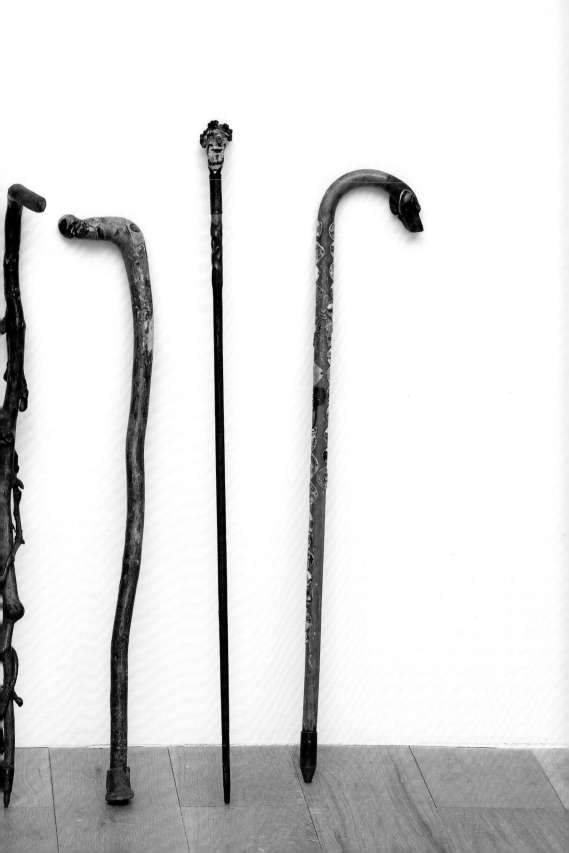

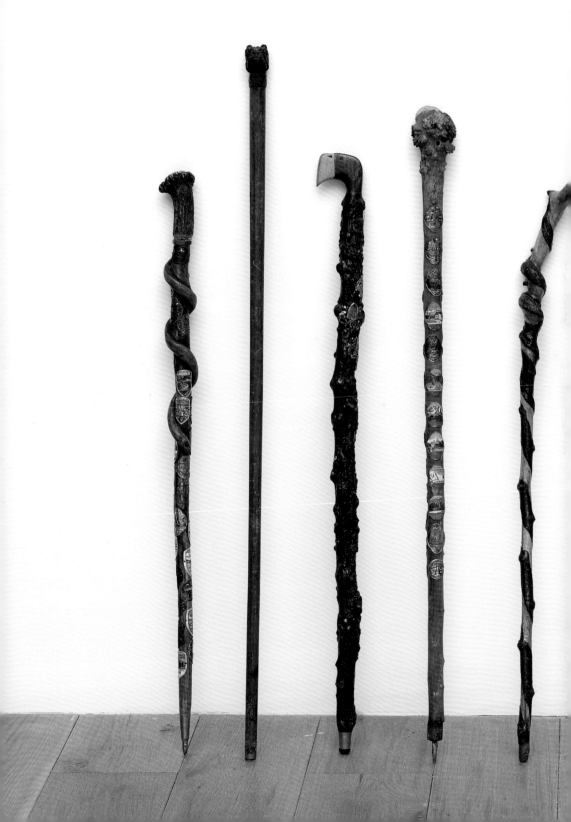

46
Klaus Weber, *Hiking sticks*, 2002–8

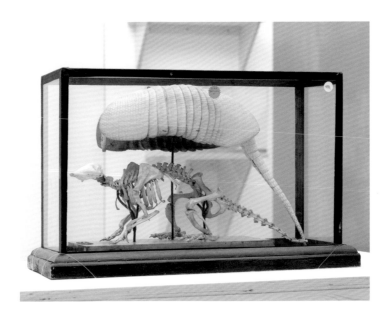

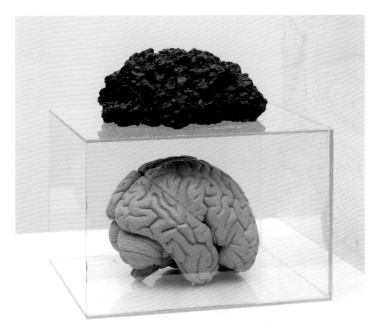

45c

Klaus Weber, *Tarmac Brain*, 2008

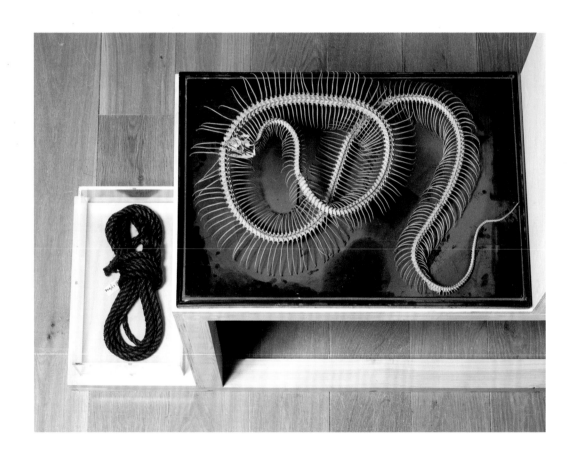

45a
Rope hank for use in reconstruction
of dissecting table, Europe, 1900-30

45b
Python sp., python skeleton,
Grant Museum of Zoology, UCL

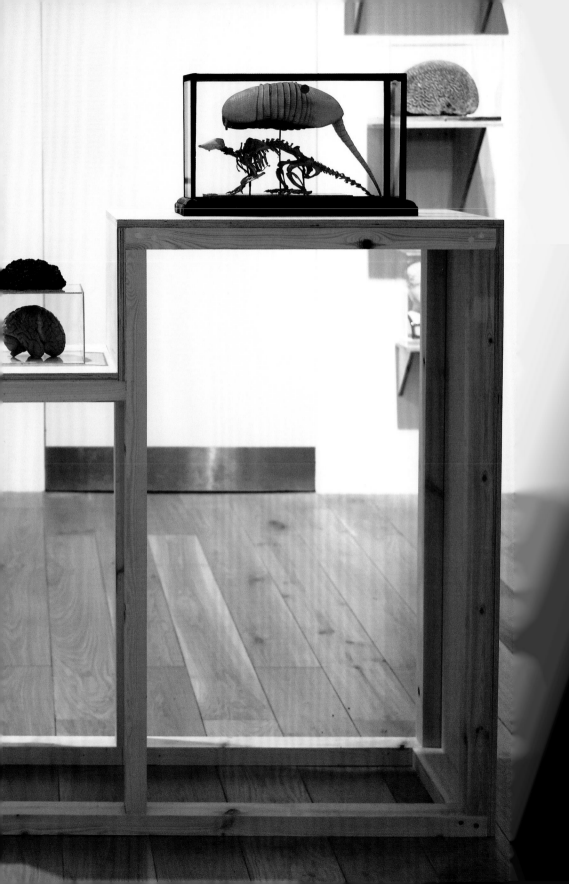

44

Sir Eduardo Paolozzi, *Plaster for 'Mr Cruikshank'*, 1950

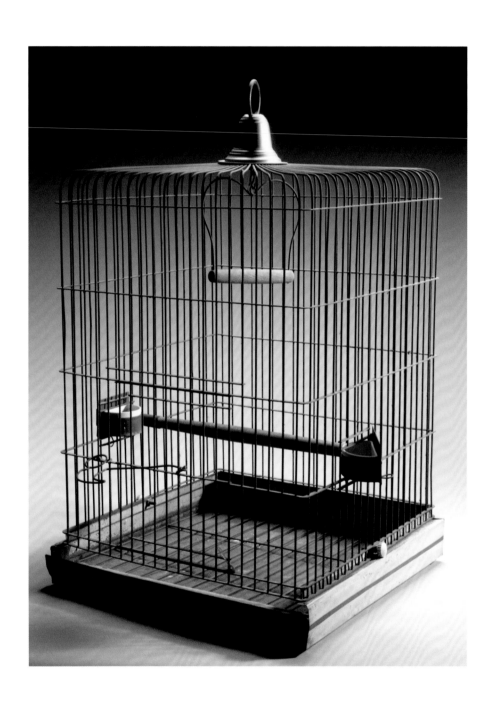

43
Bird cage, from a ward at the Sussex Lunatic Asylum,
Brighton County Borough Asylum, 1859-1939

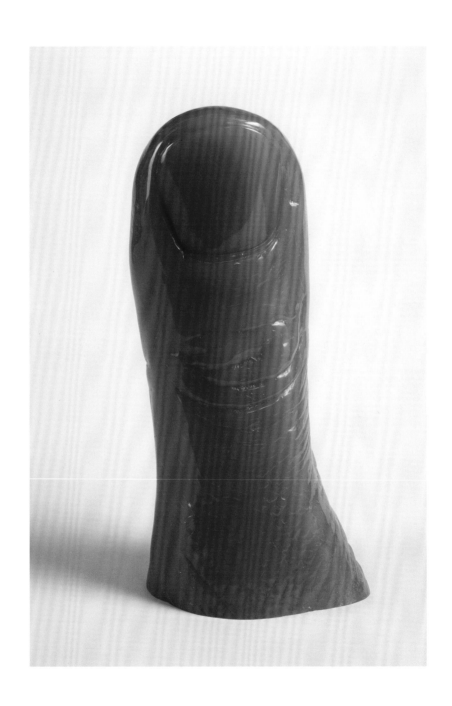

42
César, *Thumb*, 1965

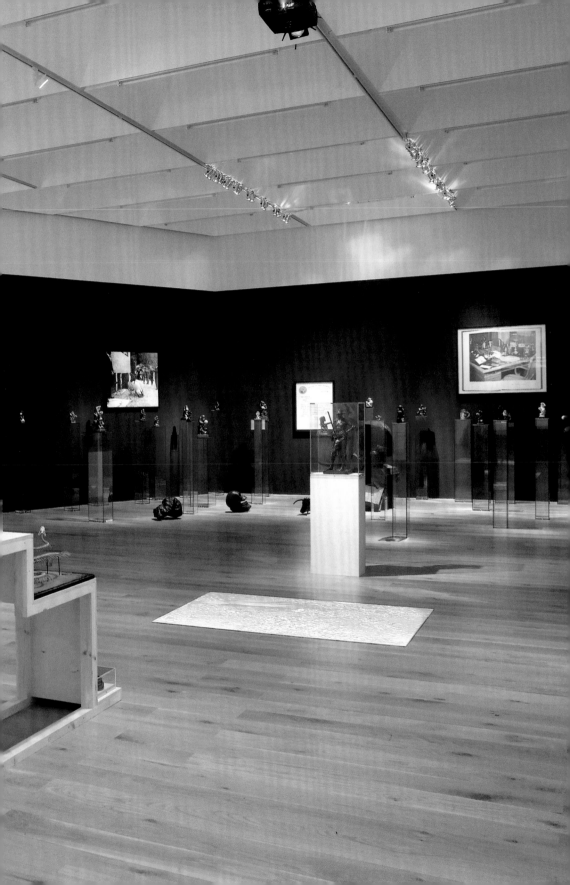

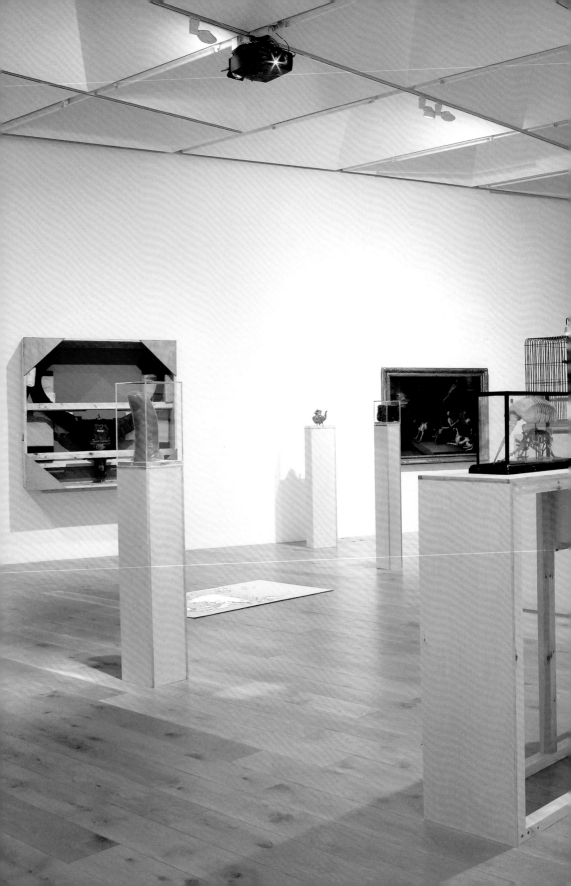

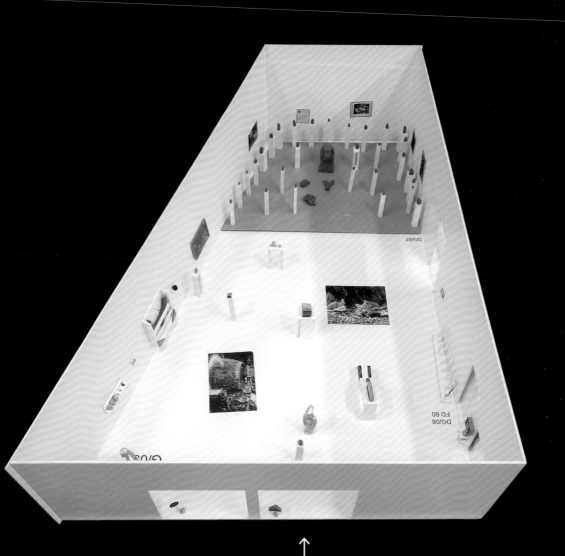

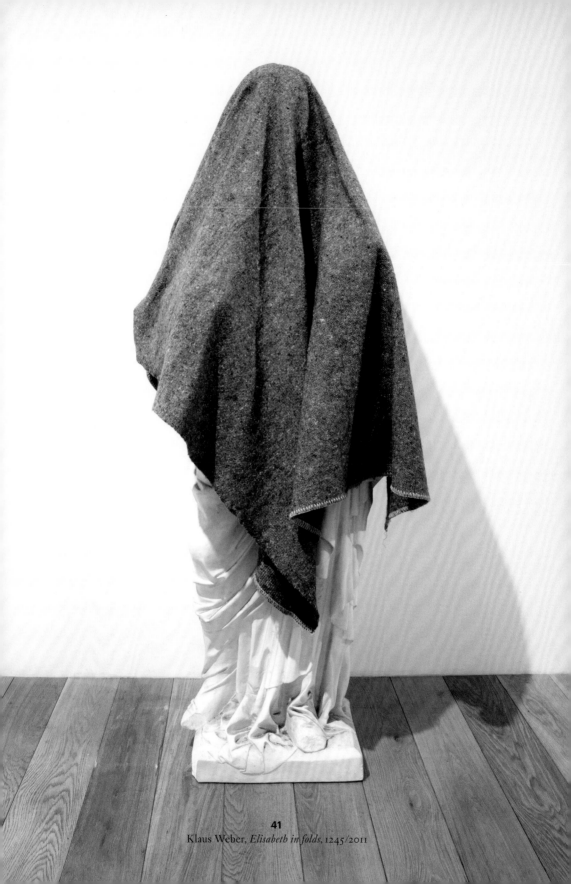

41
Klaus Weber, *Elisabeth in folds*, 1245/2011

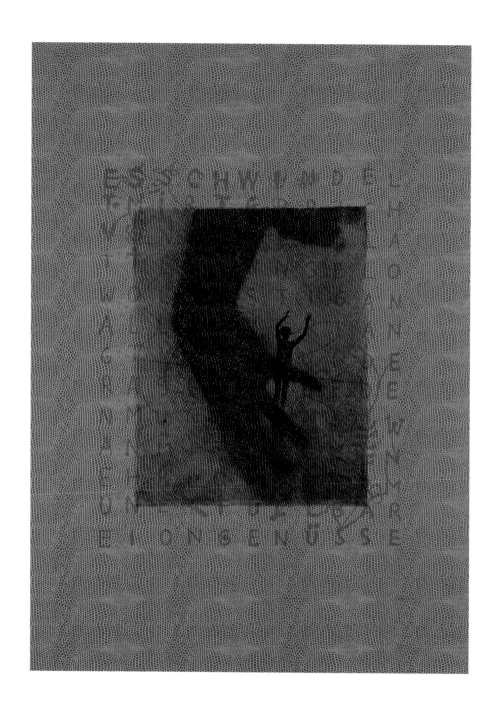

40
Sigmar Polke, *Figure with Hand*
(I Am Made Dizzy by a Carpet of Rose-Petals...), 1973

39
A wiring test, England, 1930-40

38

Sir George Howland Beaumont, title unknown, c.1800

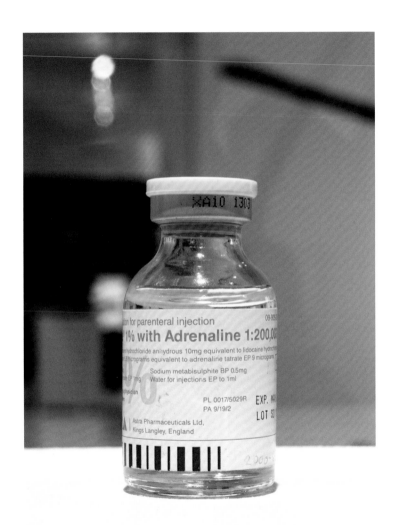

37

Bottle of local anaesthetic containing adrenaline, by Astra Pharmaceuticals Ltd., 1990-4

Andrea Andreani, *Emblematical monument to Death*, 17th century

35
Philip Guston, *Cornered*, 1971

34
John Armstrong, *Tocsin III*, 1967

33

Cristofano Allori, *Studies of a Young Man*, 16th/17th century

32

André Breton, *I Saluted at Six Paces Commandant*
Lefebvre des Noëttes (Poem Object), 1942

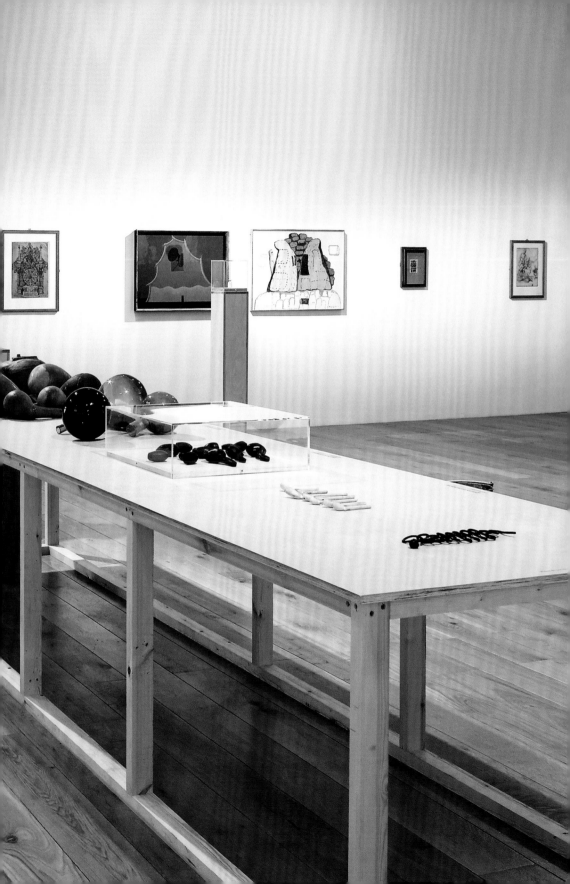

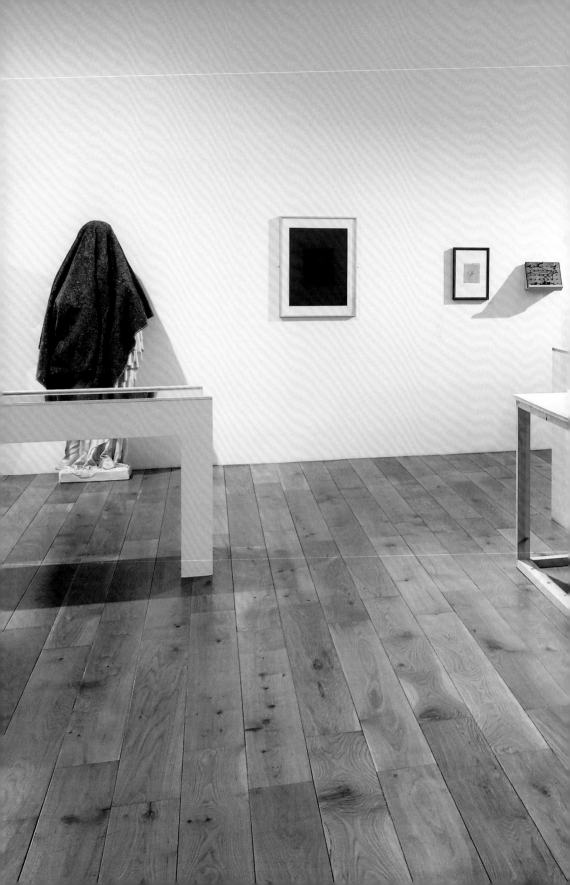

31
Sir William Allan, *Tartar Robbers Dividing Spoil*, 1817

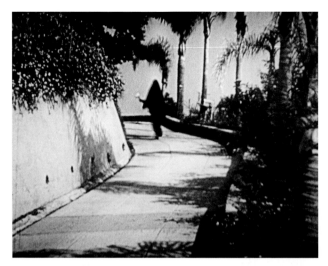

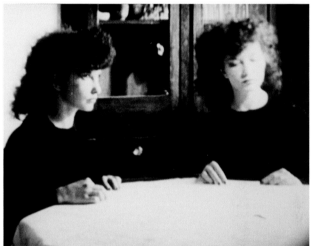

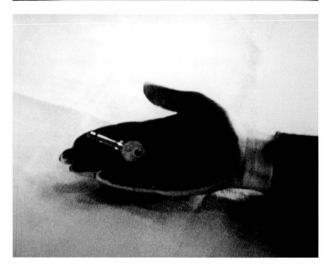

30
Maya Deren, *Meshes of the Afternoon*, 1943

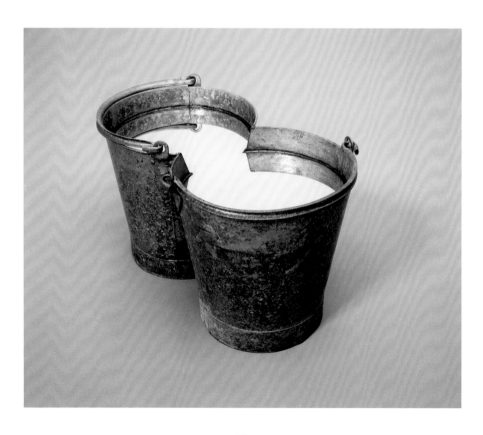

29
Richard Wentworth, *Yellow Eight*, 1985

28
Klaus Weber after Luis Camnitzer,
This is a mirror you are a written sentence (1966–1968), 2011

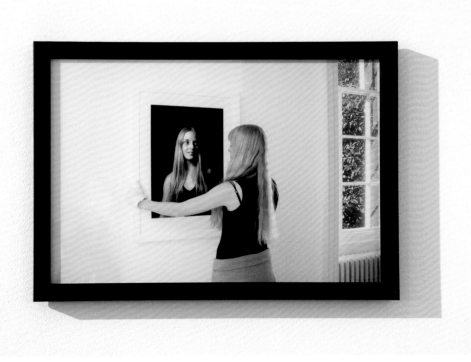

26
Louis Anquetin, *Girl Reading a Newspaper*, 1890

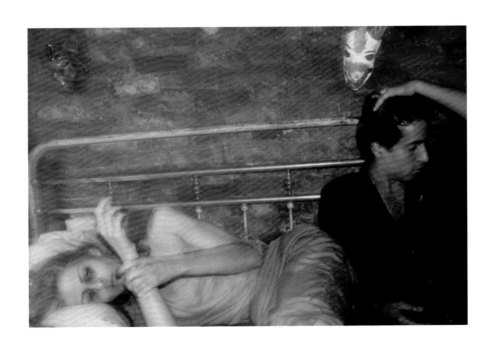

25

Nan Goldin, *Greer and Robert on the bed, NYC*, 1982

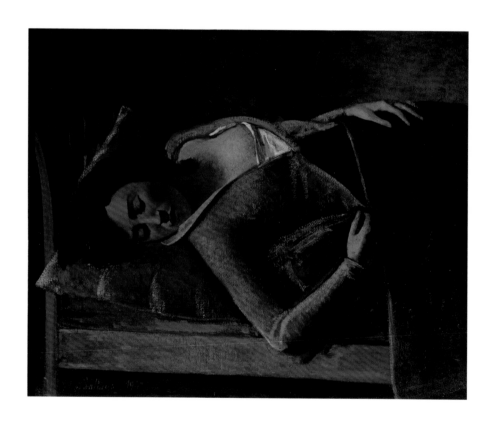

24
Balthus, *Sleeping Girl*, 1943

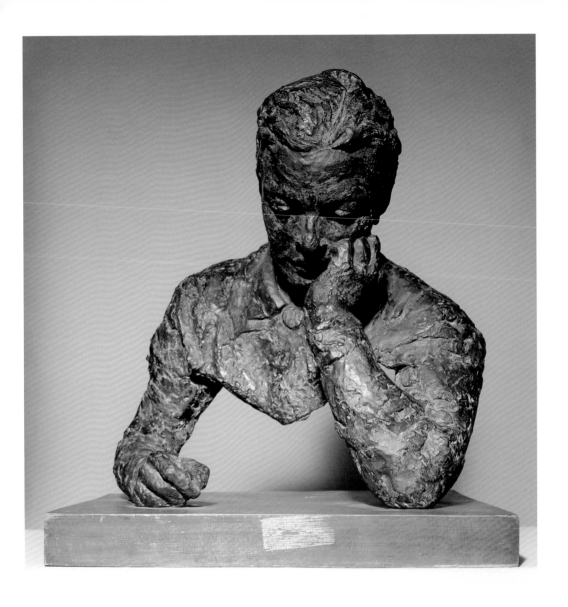

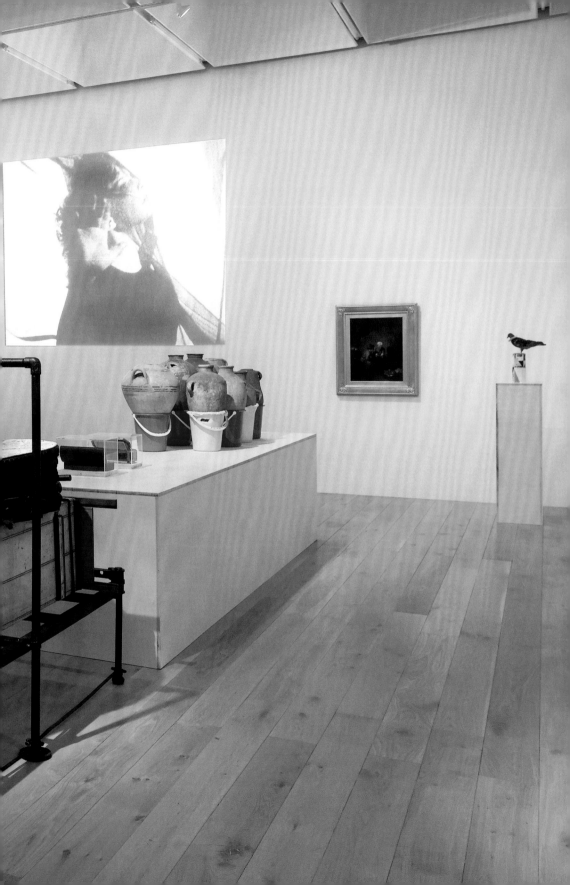

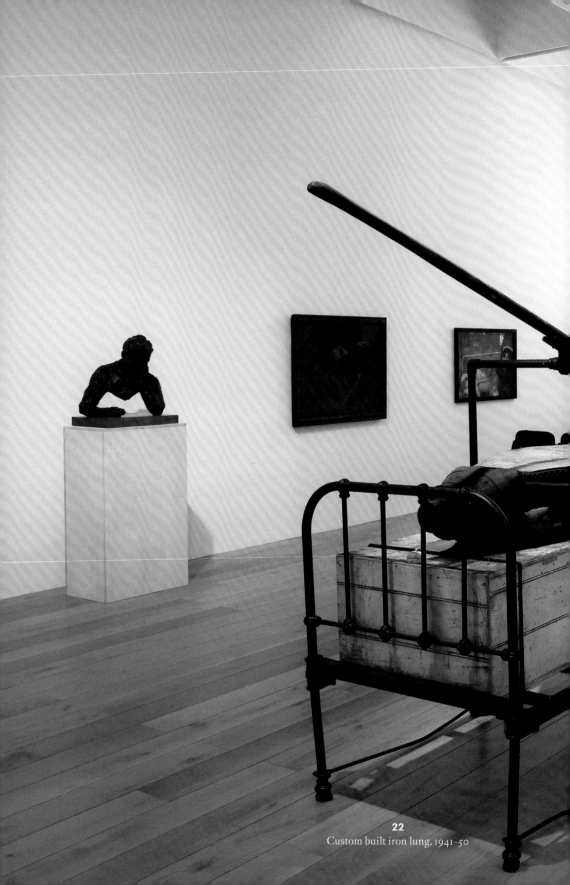

22
Custom built iron lung, 1941–50

21a
Ivory anatomical figure, male, 17th–18th century

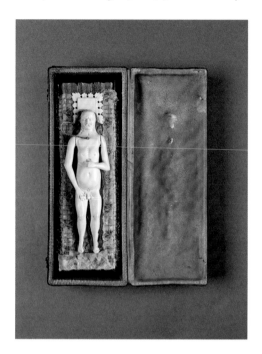

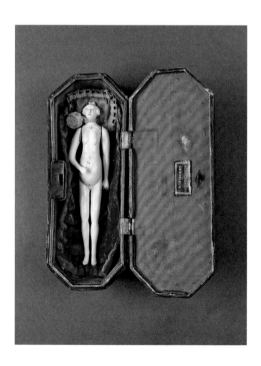

21b
Ivory anatomical figure, a pregnant female, 17th–18th century

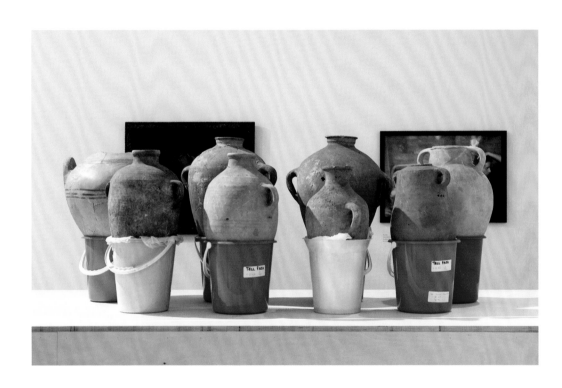

20

Amphorae from ancient Palestine, c.2000–700 BC

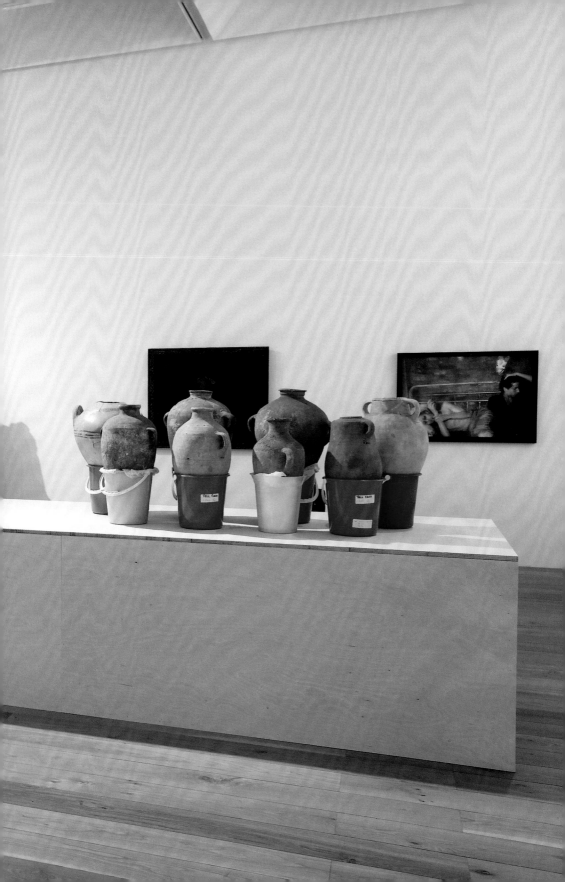

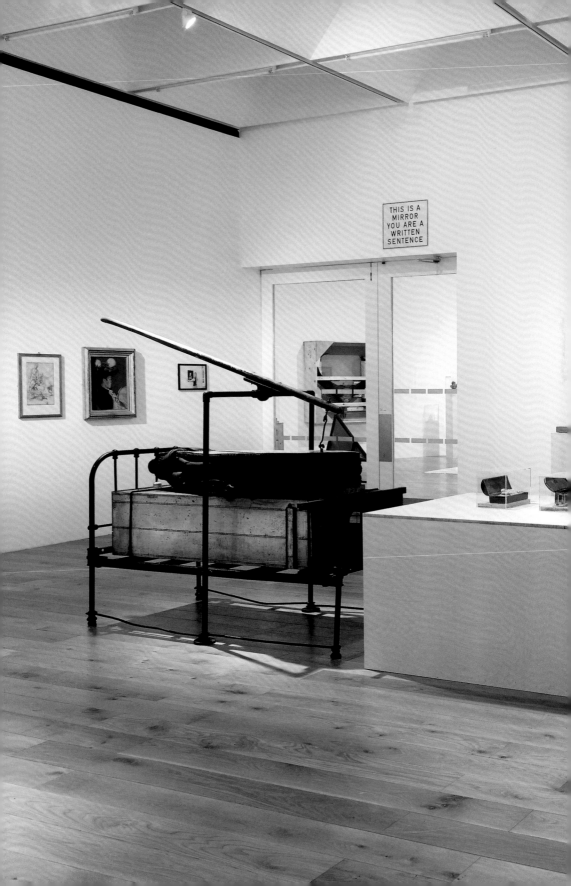

THIS IS A
MIRROR
YOU ARE A
WRITTEN
SENTENCE

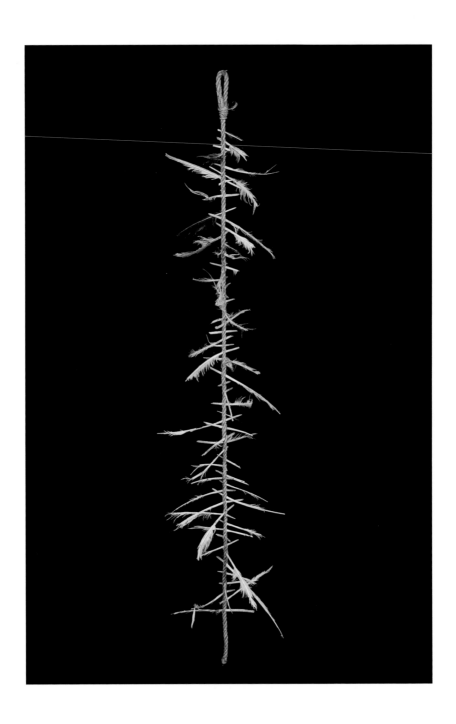

Construction of string and feathers, long said to have been a 'witches'
ladder', now thought to be a deer scarer. Not part of the exhibition.
Courtesy of Pitt Rivers Museum, University of Oxford, acquired 1911.

19

Clive Barker, *Zip I*, 1965

18
Louise Bourgeois, *From Topiary:*
The Art of Improving Nature, Tree with Woman, 1998

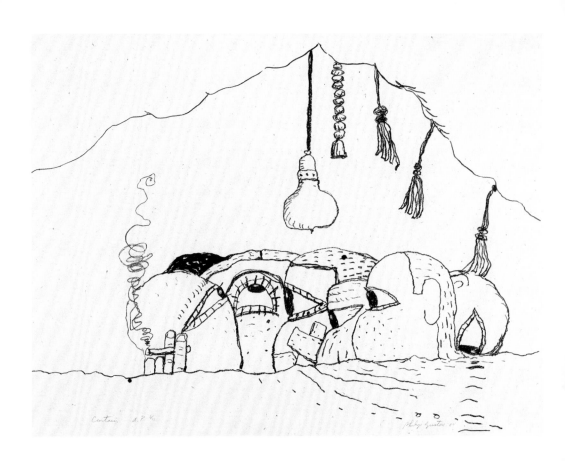

17
Philip Guston, *Curtain*, 1980

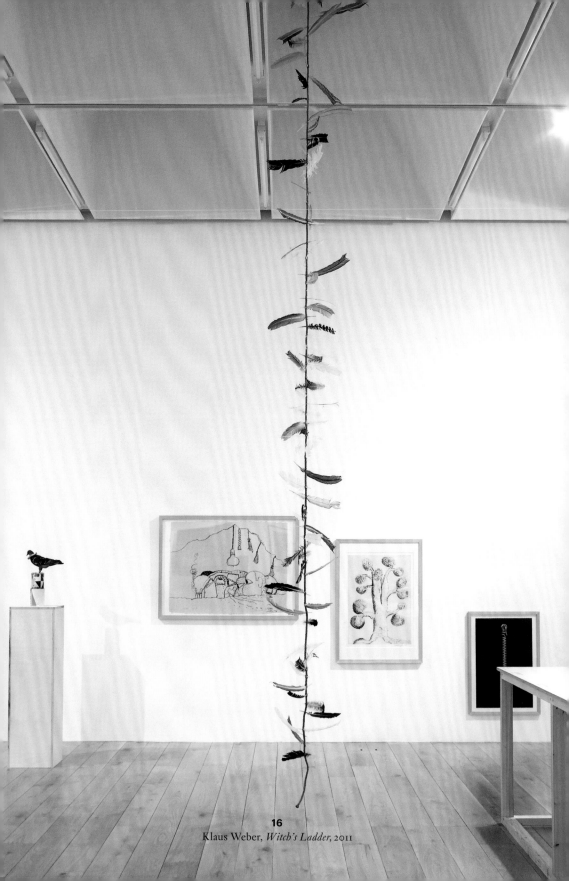

16
Klaus Weber, *Witch's Ladder*, 2011

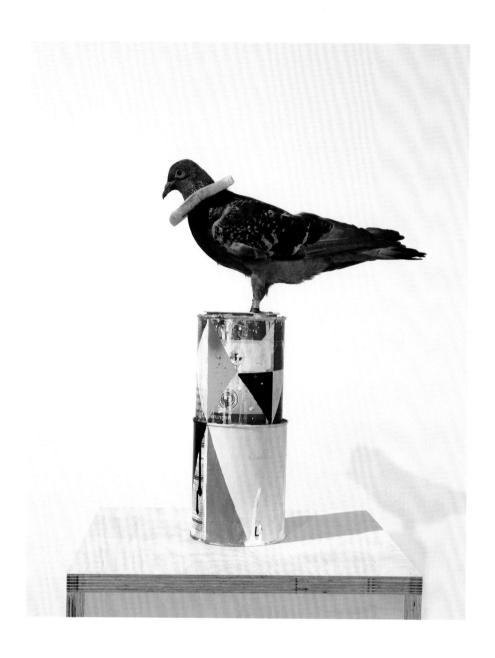

15

44 Lucio Auri, *6.26am, 31.08, Leidesgracht, Amsterdam,* 2010

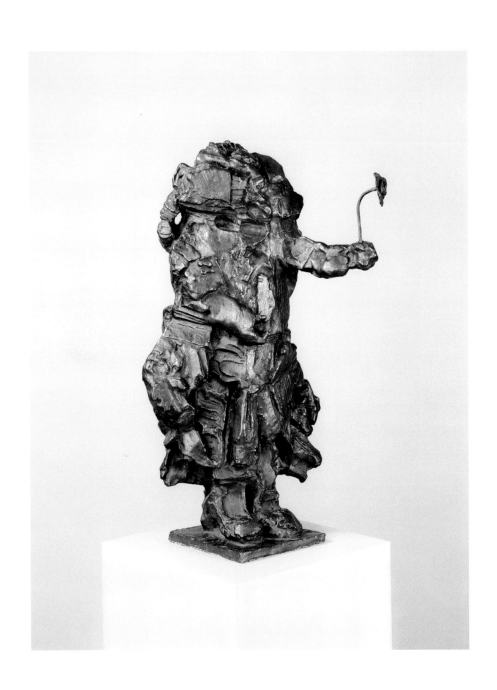

14
George Fullard
Infant with Flower, 1958, cast 1960

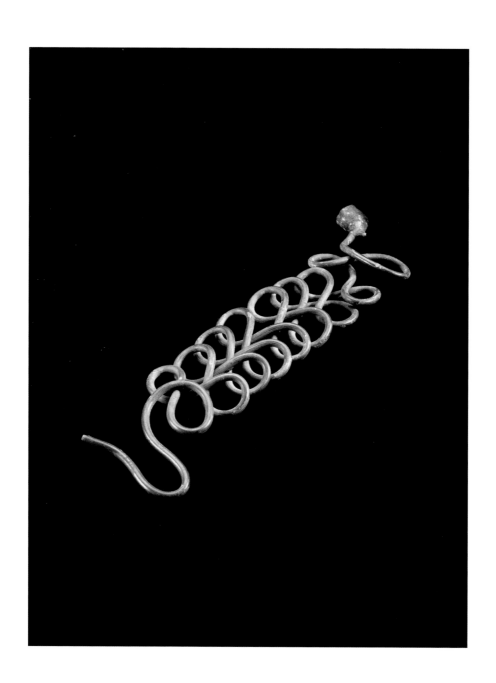

13f
Pewter tobacco pipe, novelty piece,
double loop or coiled stem, English, 1840-90

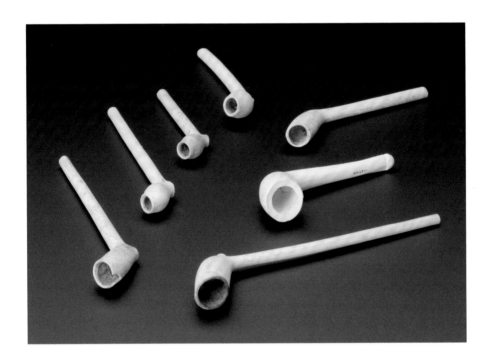

13e
Collection of clay tobacco pipes, English, 1615–1790

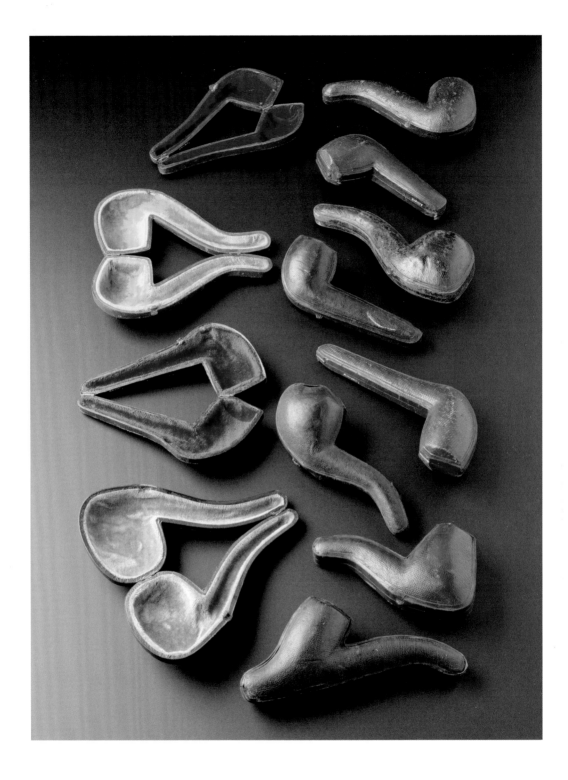

13d
Collection of pipe cases with coloured velvet lining
for meerschaum pipes, Europe, 1850–1920

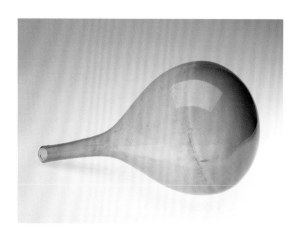

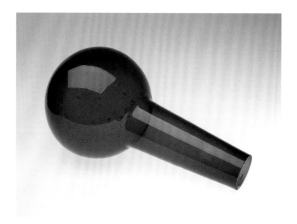

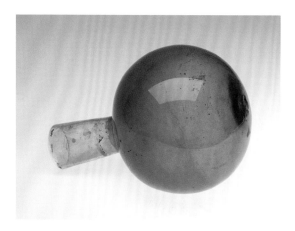

13c
Collection of glass flasks, hand moulded, European, 19th century

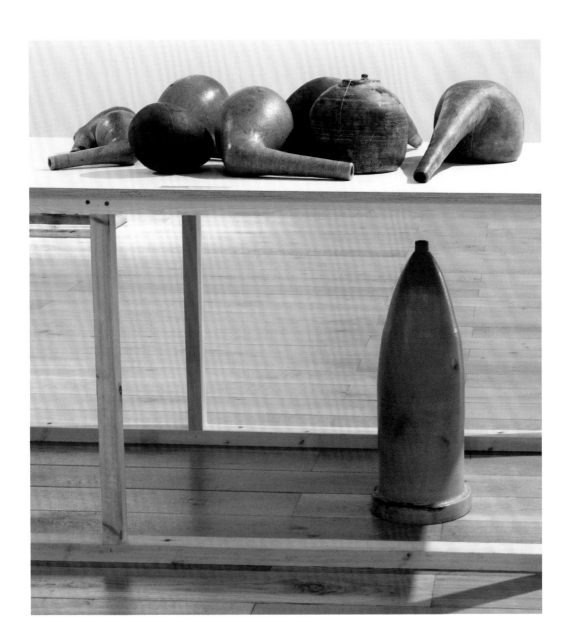

13b
Clay underground water pipe, 21st century

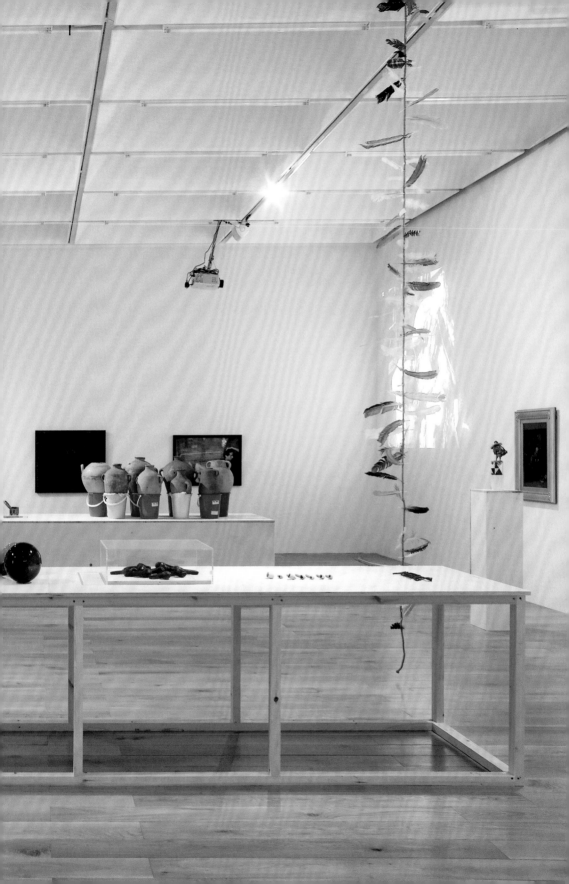

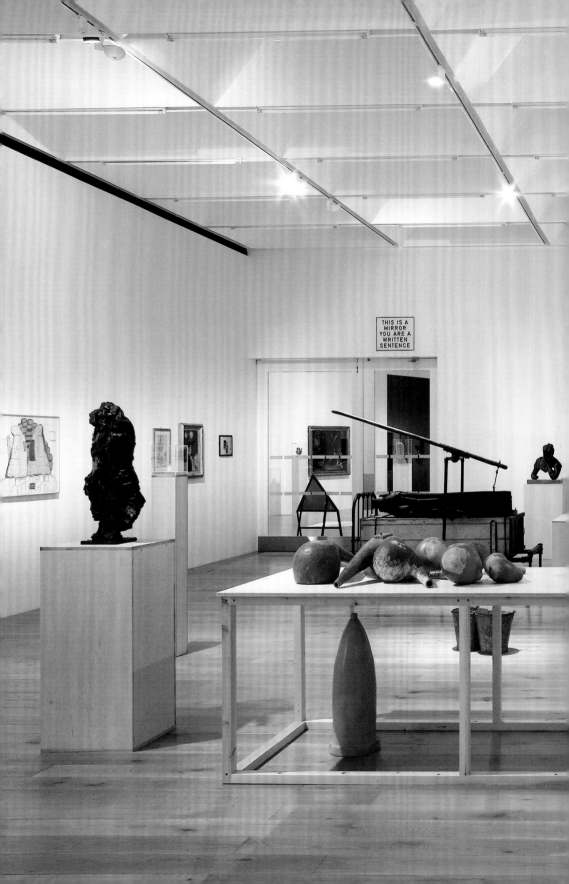

THIS IS A
MIRROR
YOU ARE A
WRITTEN
SENTENCE

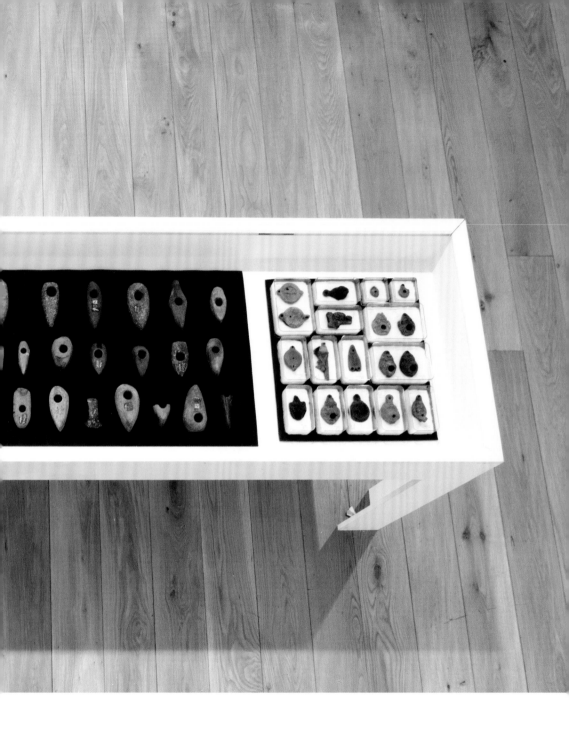

12c
Collection of stone axe heads from Scandinavia
Late Neolithic Era, 7,000–1,700 BC

12d
Collection of ceramic lamps from Egypt
and other locations in the Roman Empire

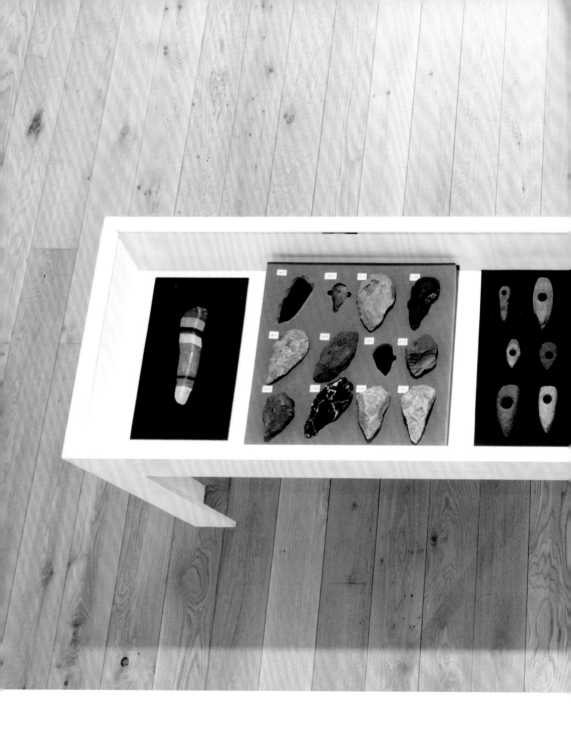

12a
Kurt Schwitters
Painted Stone, 1945-7

12b
Olduvai Gorge lithics, Lower Palaeolithic Era
1,600,000–800,000 BC

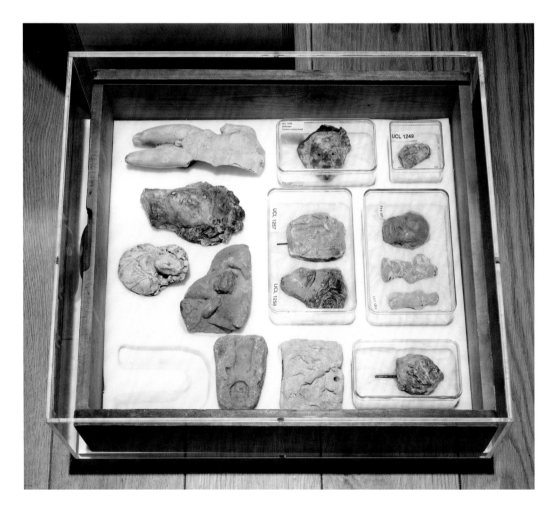

11
Plaster objects, mixed with a ceramic object (date and origins unknown)

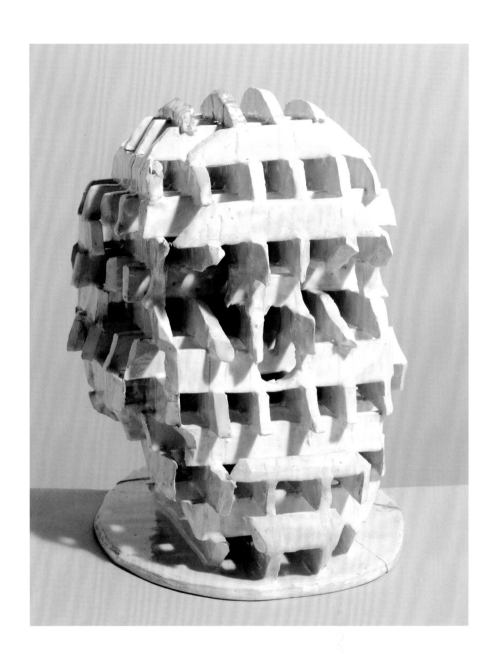

10

Paul Neagu, *Ceramic Skull*, 1973

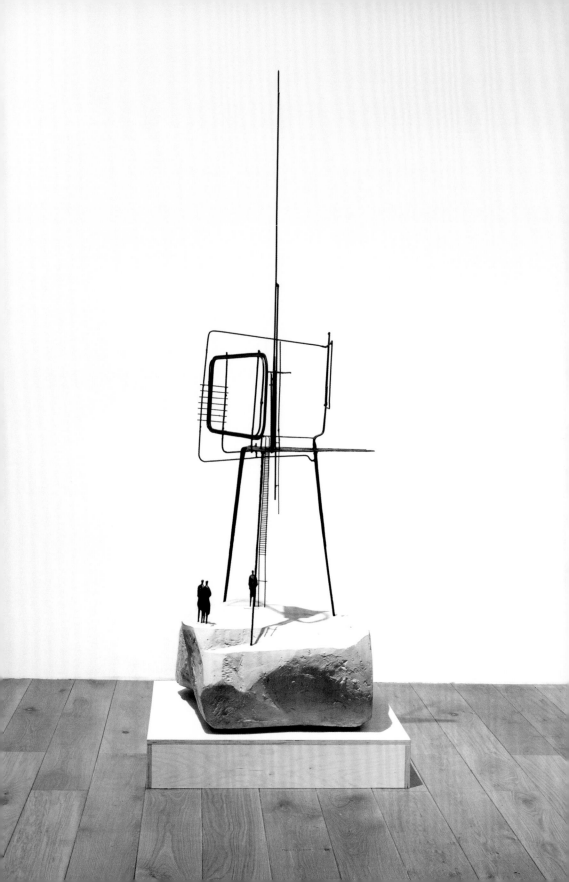

9
Reg Butler, *Working Model for 'The Unknown Political Prisoner'*, 1955-6

March of the Big White Barbarians

Doh doh doh Da! Doh doh doh Da!
Doh doh doh Da! Do doh doh Ha!
Gay Ga Go Ha! Go Ga Gay Ha!
Gay Ga Go Ha! Go Ga Gay Ha!

Bye-Bye leader! Take him away, take him away!
(Bye-Bye leader! Take him away, take him away)
Bye-Bye leader! Take him away, take him away!
(Bye-Bye leader! Take him away, take him away)

Ah Rat-dick-a-suck, dick-a-suck, dick-a-suck,
Rat-dick-a-suck, dick-a-Suck!
A Roni tacky-seek, tacky-seek, tacky-seek
Rolling, tacky-seek, tacky-Seek!
Classical, classical, classical Rock
Classical, classical, Rock!
Casio, casio, casio rock.
Casio, casio, Rock!

Bye-Bye leader! Take him away, take him away!
(Bye-Bye leader! Take him away, take him away)
Bye-Bye leader! Take him away, take him away!
(Bye-Bye leader! Take him away, take him away)

On de, on de, on de, on de, Da-de
On de, on de, on de, Da-de!
Casio, casio, casio Rock.
Casio, casio, Rock!
Take us, a-take-us, a-take-us a ram
Make us, make us a Ram!

Bye Bye leader! Take him away, take him away!
(Bye Bye leader! Take him away, take him away)
Bye Bye leader! Take him away, take him away!
(Bye Bye leader! Take him away, take him away)

Ah Rat-dick-a-suck, dick-a-suck, dick-a-suck,
Rat-dick-a-suck, dick-a-Suck!
A Roni tacky-seek, tacky-seek, tacky-seek
Rolling, tacky-seek, tacky-Seek!
Classical, classical, classical Rock
Classical, classical, Rock!
Casio, casio, casio rock.
Casio, casio, Rock!

Doh doh doh da, Doh doh doh Da
Doh doh doh da, Do doh doh Ha!

Good, good, good Good!
Good, good, good Good!
Good, good, good Good!
Double-Double Good, Double-Double good!

In-one, out-one, do-one, did-One.
In-one, out-one, do-one, did-One.
In-one, out-one, do-one, did-One.
Double-Double good, Double-Double Good.

In-one, out-one, do-one, did-One.
In-one, out-one, do-one, did-One.
In-one, out-one, do-one, did-One.
Double-Double good, Double-Double Good.

Ahh, everything's been eaten, everything's
been drunk. There's nothing left to say.
So I'll just watch the Great White Barbarians
passing by.

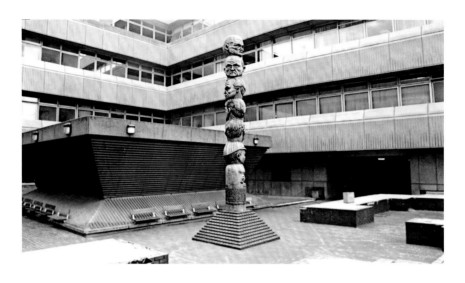

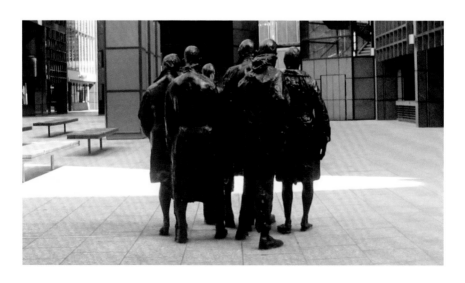

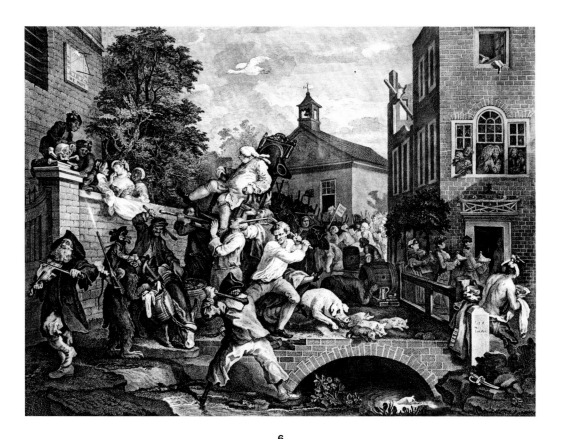

6
William Hogarth, *Four Prints of an Election, plate 4: Chairing the Members*, 1758

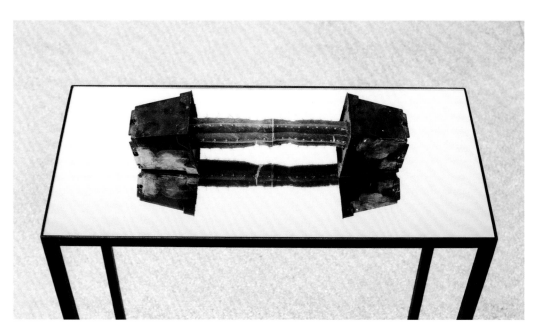

7

Klaus Weber, *Doppelkaktus*, 2006/8

4

Jaensch's picture for Eidetic Imagery, no maker listed

3
Card II from Behn-Rorschach test material made by
Verlag Hans Huber Bern, Switzerland, 1941

2

Federico Zuccaro, *The Punishment of the Prideful*, 1609

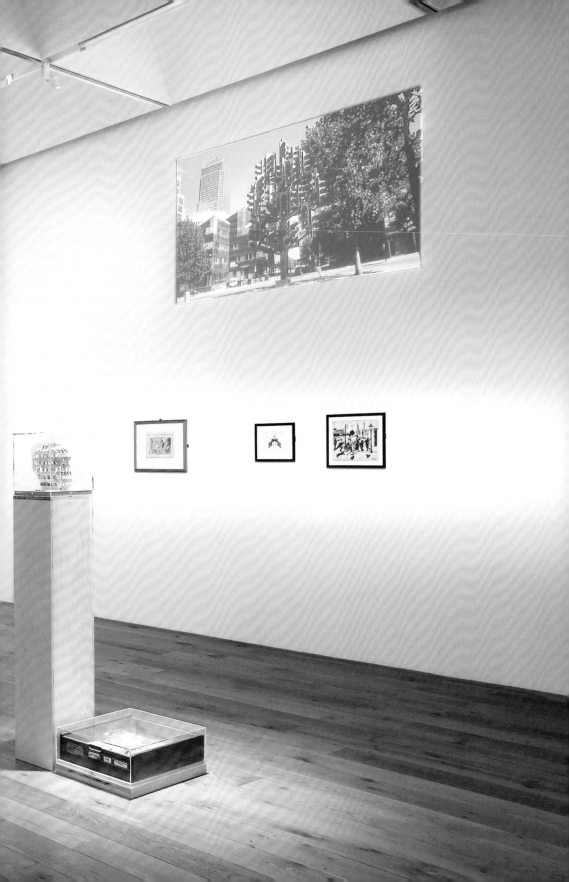

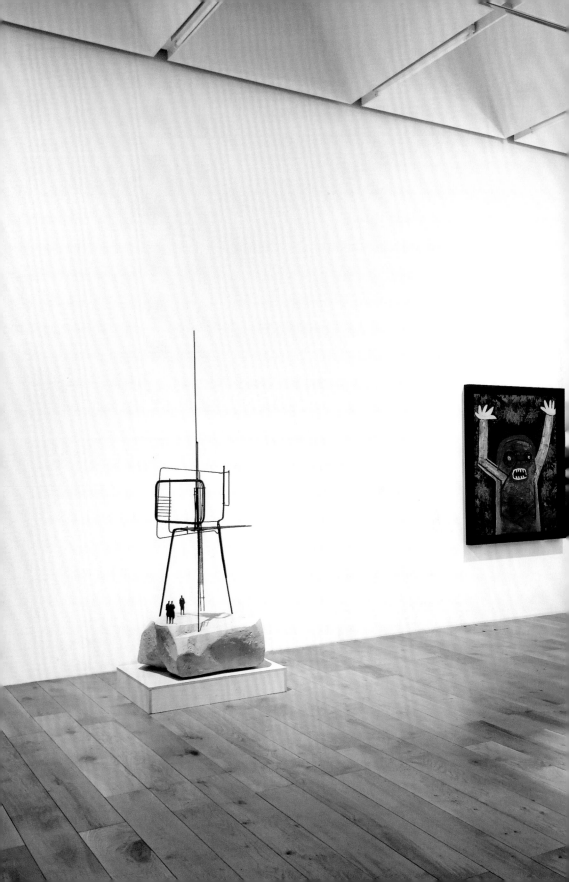

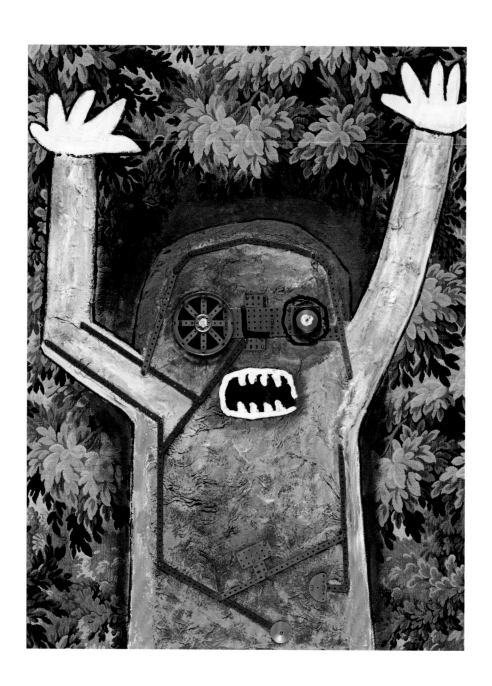

1

Enrico Baj, *Fire! Fire!*, 1963–4

GALLERY 3

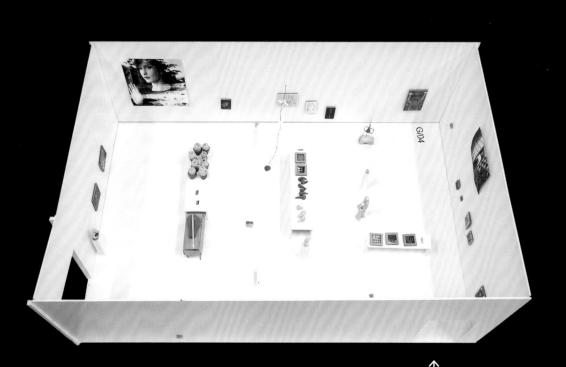

is to say, that is not only metonymically linked to the European milieus of confinement and their history, and hence capable of serving as an illustration in a museum of social history; it is also an object that is metaphorically about confinement and its connection to pigeonholing. In other words, once this object is confronted with a wealth of other objects of unclear or ambivalent status, it becomes a machine, an algorithm, that sifts through the other objects, scanning them for similarities and a basis for a potential match.

Of course, all the objects that have become 'observers' in this way retain, in any one of the observations they perform, their limited points of view, their blind spots. But because they have to try so many of them, because they establish or may establish so many connections, they generate so many of the usual limited results of observation that the limitations of the latter collapse and, indeed, allow for a glance at the emergence of systems, at least as a meta-systemic interim result. Calling objects observers, however, strikes me as permissible because we human- and subject-like observers can always see only some of the initiations of similarity going on, while being compelled to assume that the others do not exist only when we happen to look. This activity we do not observe, this unceasing emission of proposals of similarity and comparability, is at least a very close approximation of the activity of observing.

That 'as art' will remain the most common auxiliary construction the objects use to meet is okay. Not only because there is here indeed a lot of art by Weber and all sorts of other artists to look at, but more importantly because it is artistic knowledge, after all, that has revealed in the first place that objects can be made quasi-responsible for their own ontology by placing them next to others they can communicate with; and what is more, it is artistic knowledge that has initiated the communication between the objects.

1. The most famous description of this dilemma is perhaps the one Theodor Adorno offers in his 1967 essay 'Art and the Arts' (1967). See T. W. Adorno, 'Art and the Arts', R. Livingstone (trans.), in *Can One Live after Auschwitz? A Philosophical Reader*, R. Tiedemann (ed.), Stanford University Press, Stanford, CA, 2003, pp.368–87.

2. It isn't novel in that we may perhaps say that, in an analogue process, questions regarding the institutional frameworks and conditions of art and art criticism were also answered by becoming objects of artistic work itself. It remains to be debated whether institutionality is an instance of systemicity or vice versa.

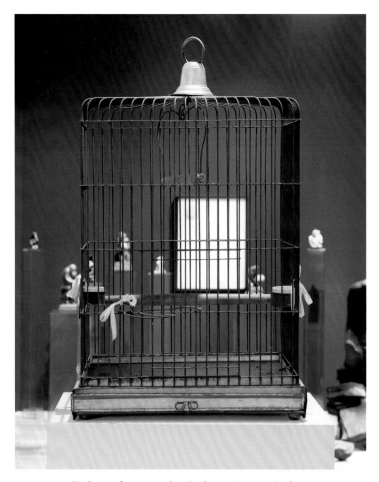

Bird cage, from a ward at the Sussex Lunatic Asylum,
Brighton County Borough Asylum, 1859-1939, Science Museum, London

exhibition—to regard it as an object of visual art. That is most interesting not in readymades whose origins are far removed from art, but in objects that are of themselves almost art. Even more interesting, however, are the instances in Weber's exhibition in which two things want to have something else in common. Art, after all, is a virtually absolute *tertium comparationis* because it can let everything else stand as art as well. Yet Weber also exhibits the opposite: very small *tertia comparationis.*

A birdcage is a generic birdcage. At first glance, it has no external features that would make it comparable to anything else. This birdcage, however, comes from a mental asylum. It is an object, that

The second condition, by contrast, is harder to satisfy, the more so since it seems to contradict the first. After all, art would then be not a specific medium (for systems), but instead not a medium at all, or more than one medium, and hence suitable for the rendition of at least two systems. We might indeed say that we will call precisely that sort of operation 'art' that enables us to mix several perspectives, to blend several observers' standpoints into one another without leaps between completely separate discrete standpoints. There would instead be a sort of blurring comparable to the portraits drawn at once in profile and *en face* that frequently appear in the familiar art of so-called mental patients, or to the way different views of the same object transition into one another in Cubism—yet now not in the medium of painting, whose proposals regarding the blurring or blending of viewpoints have long been superseded by the technical gimmickry of film, but instead quite generally, in the realisation and dissemination of interim results in the observation of different systems.

Dan Graham—among others—has called attention, in various works such as *Two Audiences* (1976), to the fact that reflection on one's own observation is best initiated by observing other observers. Weber takes up the idea but then transposes it from personal observers in the art context to structures. We can perceive a system-like structure in our relation to another only when we are shown how our own observation not only has a blind spot—that is, something we know in theory—but that others can observe our blind spot the same way we observe it in others. There is here, of course, no symmetry between the perspectives, no finite set of observations. Instead, only a very large category that is undetermined with regard to the number of participants and their perspectives—a category such as the public or the public sphere—can comprehend the concrete publics, the audiences.

We can see that all the objects in both exhibitions strive for similarities they don't find in their usual homes. Of course, the most frequent form of similarity an individual object can strive for, and one that is still quite exciting, is that of being art. Which is to say, of demonstrating that we can look at the same object in an entirely different way, that we can see it liberated, decontextualised, and indeed as though under the conditions of a phenomenological *epoché*, once we are encouraged—for example, by the circumstances of an

That would presuppose two things. Firstly, that the visual arts or art as such is (or possesses) a medium in which not only can different systems be represented and compared, but so too can the fact that (and the way in which) they transition into one another. Such transition, after all, is what we can indeed see in Weber's works. But it would also presuppose, secondly, that art is precisely not a system like all others, afflicted as it is with necessary blind spots and hence incapable of generating specifically situated vantage points from which everything else can be seen.

The first condition is fairly easy to satisfy. Art, and contemporary visual art in particular, draws on all conceivable media of representation without making its use of these media dependent on their conventional instrumental and functional environments. Art, as Weber demonstrates most fundamentally by switching back and forth between registers (archive, work, quotation), can do anything anyone else can do, but it can do it as art, which is to say, it does not need to rely on the procedures and aims with which people usually compose operas, design armchairs or undertake sociological studies. It can copy the mechanics of anything without buying into the institution that usually generates the mechanics. It defines different orders, it role-plays different institutional and economic environments. In this context, 'post-studio art', a term that is frequently used to describe contemporary artistic practices, means nothing other than what I have just described: a general approach in which art draws not just on any kind of manufacturing but potentially also on any kind of discipline, context, knowledge.

This general version of the first condition aside, visual or plastic art more strictly conceived—that is, art that fashions images—can also claim both a tradition and a very lively present when it comes to offering itself as a medium of systemicity and as external overview. From the classical world-images of the Renaissance to, say, George Maciunas's system-drawings or the global-conspiracy charts of Mark Lombardi, it seems possible to visualise interconnections, even outside of inventions of visual systems such as perspective or spatiality, in ways that would seem to be superior to the linear description of systems, especially with regard to their systemicity—even if the problem of the specific perspective, the specificity of construction and staging, and their blind spots, cannot be eliminated.

and again inscribed in comparable systems, systems that are not only comparable to one another and exist in multiple instances (exhibitions) but also generate the tools that render unique objects in multiple instances: images, songs, dramas. Here, too, people like to look for a third element that combines both perspectives; the artist's life, for instance—it is unique and yet aggregates many stations, each of which comes in multiple versions and yet preserves something unique as well. Yet the artistic subject bores us no less than the *Gesamtkunstwerk* does.

Weber chooses a different path. It isn't entirely novel, either, but it has never been applied in a sustained fashion to this problem.[2] It consists in an artistic practice that assures itself of the status of what it does not externally—through a manifest declaration of intent, or an institutional or generic framework—but instead by recognisably setting itself an immanent task that is relevant to the problem I have sketched. In less abstract terms: by demonstrating a specific competence, such an artistic practice becomes at least confusable with what usually possesses that competence. Exhibiting the craftsman's skills would contribute to reaffirming traditional notions of the competence of the arts. Weber instead demonstrates that the instruments of exhibiting and installing enable him to work on the difference between systems. Yet that, we will understand, cannot be done with only two sorts of systems.

Adherents of systems theory might object at this point that all Weber does when he works, with the intention to distinguish, on the system-like aspect of art and other systems within the system of art is what is called re-entry: the distinction between art and non-art re-enters into the system of art. That, they would say, is nothing special; it is what (autopoietic) systems do. But is it actually true that what Weber does is solely about the system of art, which would reveal itself for what it is in his works by being recognisably distinct as such from other systems? I would argue that it isn't; it is much rather about performing this very competence of art—or of this specific artistic practice—the competence of being able to address the coexistence and mutual interpenetration of systems. Art, we might frame this hypothesis in order to describe Weber's project in stark terms, cannot merely do meta-art; it can more importantly also do meta-system.

thing is that this aspect—that of monotheism versus polytheism—constitutes not just the trivial distinction of countability; it would seem to be of decisive significance also for the systemic quality of the system. Much of what constitutes capitalism according to most descriptions constitutes it because there is only one capitalism that pervades all molecules of our lifeworld; much of what constitutes the storm system has to do with its resemblance to all other storm systems. It becomes recognisable as a system only because it is not a singularity. Yet this quality is something polytheistic systems generally share with all things that lend themselves to reasonably convenient observation from outside, whereas the pantheistic singularity and uniqueness of capitalism may also have to do with the fact that all of its observers have been compelled to admit that they themselves have been pervaded, determined and colonised by what they sought to observe.

As various theorists have recognised, art does not stand a chance as either sort of system/god.[1] As a system of the capitalism type, unique but universally possible and permeating universality itself, it degenerates into a civil religion with potential *Gesamtkunstwerk*-style secondary damages and fatal ideological inclinations; as the recurrent representative of something that exists in several instances ('the arts'), it becomes banal, like craftsmanship or sport: something you either have a talent for or don't, in which case you can turn to another representative of the same thing, the concert flute or dance or *verre églomisé*. Many attempts have been made to solve the problem by making art become something else altogether, some third thing. I have mentioned religion, the most inviting pitfall; other popular candidates include politics and, most recently, research, although that is hardly a new idea—even in the 1950s Hans Magnus Enzensberger wanted to make lyric poetry the work of engineers.

The problem of art or of the arts as such returns in the forms of their presentation. The latter either exist in multiple instances and can generate forever new representatives (the case of language and imagery), or they are unique, bathed in the aura of the single real moment (as in photography) or a single human being (the trace of the author: painting, recording) they are linked to, or they are so rare as to be virtually singular. Yet these incomparable objects are now time

The word 'system' enables us to describe complex processes, which are scattered across time and are difficult to survey in space, as an identifiable object. It is the word we need here. A system, then, is either an individual or an instance of a species. Capitalism, for instance, would be a unique individual modelled on monotheism: it is everywhere and in everything, and yet one and the same. A storm front moving up from the Caribbean toward Florida, by contrast, would be an instance of a species: complex and composed of the most diverse processes, impossible to comprehend in one vision, scattered and difficult to perceive as a single coherent phenomenon—but not unique. The next one of its kind is not far off.

Weber is interested in different sorts of systems and in opportunities to compare them, but also in their limitations and in the question of whether there are places or methods that would enable him to take up a meta-position with regard to them. *RAINISACAGE YOUCANDRIVETHRU* (2008) is a work that plays the driver/ observer off against his environment. It carries the species of the storm front piggyback, as it were, rendering the rain seemingly ubiquitous. As long as the driver does his job—which is to say, as long as he drives—he is incapable of observing and assessing the weather conditions from outside: he cannot see the edge of the weather front precisely because he might believe that he could escape it by driving.

RAINISACAGEYOUCANDRIVETHRU, working drawing, 2008

Yet if we can distinguish systems the way we distinguish the objects of classical religions, we have already gained an observational advantage over this driver, since he doesn't know that there is an end to the rain, nor where that end is: there are systems that exist only once, and systems that exist in multiple instances. Yet the strange

But the question calls for a third answer. What is at stake in Weber's art is the relationship between ascriptions of meanings, objects, constellations of objects, and their statuses/qualities on the one hand, and on the other hand the modes of the ascription of meaning, and the (anti-)institutional and other formats of artistic subjectivity itself. We might say that Weber's goal is not just to examine the grammar, the syntax, the semantics, the phonetics or the morphology of arranging and assembling visible objects in space, but rather to make the entire language his object. Of course, this examination does not (yet) proceed in any systematic fashion; for what seem best at being systematic are the traditional sub-disciplines of exhibition-making, where demand is steady and the division of labour has long been settled. A meta-perspective stands no chance against this head start in terms of self-evidence, the more so since there are too many things it must take into account at the same time. The primary goal is instead to solve the central problem, to raise the question: from what vantage point can different orders be observed in such a way that anyone—whoever that may be—can be provided with meaningful information about them?

The answer is: not so much by mixing the different orders as rather by making them interpenetrate such that their semantically active components incessantly observe the others while being observed in turn by yet others. The original plan also called for the two exhibitions *If you leave me I'm not coming* and *Already there!*—which is to say, the show of the artist's own work and the show of curated works by others—to blend into each other or interpenetrate. I don't know whether this idea was dropped because implementing it would have pointed up this one transgression—between artist and curator—too distinctly, thereby devaluing many other transgressions and interpenetrations taking place within the exhibition. But the capacity for mutual observation is in fact not limited to things that sit next to, and look directly at, one another; on the contrary, it is often spatial separation that allows for the emergence of a new perspective. Yet since the exhibitions are, in my humble opinion, precisely about that, about the emergence of a perspective by virtue of separation and the critical examination of the same perspective through active observation and being observed, it is important that there be clear separations as well. At this point, dear reader, we need to introduce another crucial word.

or whether the wealth of functional transgressions is connected to the specific contents of his practice, which notoriously patrols the boundaries between the visual arts and the natural sciences—a practice that has allowed him to produce evidence, among other things, that bees can produce Tachist paintings.

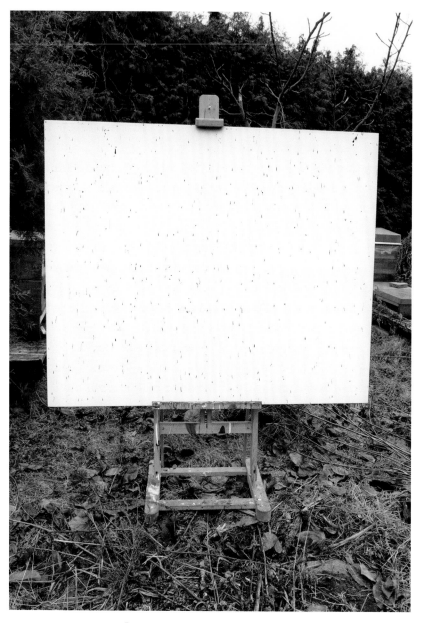

Bee painting, 2009–11, work in progress

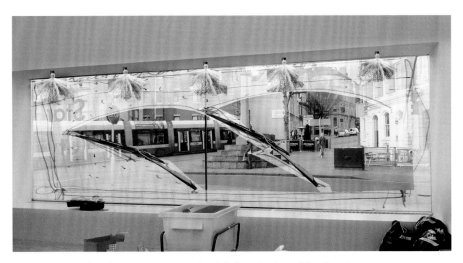

If you leave me, I'm not coming (window wiper), working drawing, 2011

them together with another order in which they take on another kind of meaning. We might say that he mixes contexts, cultural conventions and apparatuses. But mixing is a much more desultory process that ultimately doesn't care, or at least makes no conceptual disclosure about, how the parts being mixed relate to one another once the mixing is complete. It offers no indication, moreover, of how those parts of the original context that were of any significance for the formation of the first meaning may still be recognised or reconstructed in the second context, or whether we are looking at nothing more than magic tricks that may have baffled art audiences back in the era of the early readymade. Furthermore, Weber mixes not only things but also forms of action. He appears as a producing artist, he curates the work of other artists, he gathers objects of highly diverse statuses and functions from other collections and assembles them to create new arrangements. In recent years, other artists have likewise taken the liberty to produce such mixtures, but what they—Mike Kelley, Willem de Rooij, Albert Oehlen, Florian Pumhösl, Cosima von Bonin, Claus Carstensen, Alice Creischer, Andreas Siekmann, and many more—present are always extensions of things into one other, a second functional space. In Weber's case, by contrast, the number of spaces, as I have already suggested, is much greater, raising the question, of course, of whether this is a mere accumulation of 'unauthorised assumptions of authority'

Diedrich Diederichsen

In the object-oriented contact yard

Things meet in Klaus Weber's work that do not belong together. They do not otherwise meet. And we usually encounter them in different contexts—contexts that give them new meaning, such as a collection of ordinary objects like pipe bowls in a museum of everyday life. They then serve to illustrate a given historic form of ordinary life. Or they are simply among their own kind, which at least determines the ground with regard to which their respective similarity can be ascertained: the definition of the species. Or they are historically unique objects, ones of a kind, whose uniqueness, however, is neither symbolically nor indexically tied to an artist, but rather linked to a historic circumstance or a figure in history. Rather than serving to illustrate a form of everyday life, that kind of object would then allow us to think and imagine how unique events or persons interrupt the same everyday life. We know, of course, that pipes in particular are so charged with meaning in the eyes of people who are involved with art that it has become virtually impossible to conceive of them in an everyday context. But to take up a familiar line from Freud: sometimes a pipe is just a pipe (and not not a pipe).

During Weber's exhibition at Nottingham Contemporary, a sprinkler system with oversized windscreen wipers is installed on the front window. We may well read this the way a certain kind of art criticism loves to, as an allegory of penetrability; although, rather than meaning solely how desirable transparency is, it would seem to illustrate, more dialectically, that the clear view through a freshly wiped car window benefits immensely from the raindrops or steam fogging the remainder of the window. We might say that Weber takes things that develop one sort of meaning within an order and brings

the collections, down in the basements, devoid of natural light, looking into countless spaces, shelves and lockers. Down there you lose a sense of time. And when you emerge, you are surprised to find the world still spinning. The experience reminded me of the 1966 sci-fi film *Fantastic Voyage* (in which a submarine crew are miniaturised and injected into the body of a scientist to repair his blood clot). Though in my case it felt ghost-like moving through the architecture of human culture, going deep down into the basement of unconsciousness. It was a truly fantastic, but also a disturbing voyage. Following this path of dissecting, categorising and decontextualising, it felt obvious that something is fundamentally wrong with such a possessive way of approaching and reflecting the world.

When it came to searching through the enormous Tate Collection, we did not send our bodies, but our minds. Tate has a great website. You can move from image to image from A–Z instead of accessing it by search criterion. Many other museums organise their website search through keywords which already reduces your approach to an academic lingual sense of ken. When I started to go through the collection, I planned to do it in chunks of two hours. However, I started one afternoon and carried on until 5am without a break. I discovered many works that I didn't even know existed, while others were like an unexpected encounter with an old friend at the traffic lights. It is the best way to meet people if you are open enough to change your daily plans—to hook up with your friends in the Café of Benevolent Knowledge.

Klaus Weber

Preface

There is a 'certain Chinese encyclopedia' in which it is written that 'animals are divided into: (a) belonging to the Emperor, (b) embalmed, (c) tame, (d) sucking pigs, (e) sirens, (f) fabulous, (g) stray dogs, (h) included in the present classification, (i) frenzied, (j) innumerable, (k) drawn with a very fine camel hair brush, (l) et cetera, (m) having just broken the water pitcher, (n) that from a long way off look like flies.' (Michel Foucault quoting Jorge Luis Borges quoting Dr Franz Kühn)

My name is Weber, Klaus. In group exhibitions, I am usually at the end of the artists list. That is, if neither Wilhlem Ferdinand Xylander nor a zebra is part of the show. For *Already there!* in dialogue with *If you leave me I'm not coming*, I have set up an exhibition from a wide range of sources: artworks from the Tate collection and friends of mine, objects from the archives of the Science, the Ashmolean, the Zoology and the Archaeological Museum and all sort of things from my own studio.

To select these things from such an expanded field, I decided not to search but actually to find them. Or you could even say to be found by these things. This way you have to be more open, trusting your wits and your direct reflections on what you discover. It doesn't matter if you are confronted with textual labels, names, listings or the materiality of the objects. Open the gates! This can be more joyful and complex than following your script. (I read in an Ethnobotanical book that certain South American cultures who consume 'magic mushrooms' in religious rituals, also consume the small, wild funghi before they go out searching for it. This way the funghi is sort of calling them to be found and they have more luck in finding it.)

So, Abi Spinks (Curator, Nottingham Contemporary) and I wandered with museum staff through the storage areas of

Already there!

solitude, having absolutely [...] in [...]
other bourgeois flora.

He permitted himself to feel a certain interest and
flowers enfeebled by their [...] by the winds of
poor quarters. In revenge [...] detested the [...]
cream and gold rooms of [...] tile roses; he
reserved those distinguished [...] from
distant lands and whose lives were sustained
artificial equators.

But this very choice, this [...]
changed under the influence of his [...]

[...] licas faithfully exe[...]
[...] rubber and wire; [...]
[...] of a marvelous co[...]
[...] artists who knew
[...] g the flower as a
[...] its decline, read
[...] nuance—the mos[...]
[...] wn and closes af[...]
[...] ed by the wind o[...]
[...] its matutinal co[...]
[...] der the burden
[...] when cal[...]

leaves fall to the ground.

...gnificent and

...one of his ...collection of ...turgid hairy ...no one leaf

...inale seemed ...the Alb ...been cut... ...coloura... the ...r of a pi... ...dame Mame ...parodied... ...ing a hue of ...ined by dr... ...white and red ...Bosphor... ...ched calico in ...green; sti... ...lis, displayed ...color of ra... ...sides, violet ...ves from wh...

...the Auror... ...notes of ...poplexy and...

...ght still other varieties which had the appearance of ...with false veins, and most of them looked as though ...s and leprosy, for they exhibited livid surfaces of flesh...